ANN ARBOR

VISIONS OF THE EAGLE

*As an eagle views the world
from its lofty perch,
so does Dale Fisher
photograph a subject
from his own domain,
capturing its beauty and detail
with a keenness of vision
matching that of the majestic bird.*

The Photographic Art of
DALE FISHER

Creative Flying by Brian McMahon and Pat Mullen
Text and Creative Direction by Mary Beth Fisher

Eyry of the Eagle Publishing

Text & Creative Direction: Mary Beth Fisher
Graphic Design: Pat Truzzi

Printed in Michigan, USA
by ImageMasters Precision Printing

ISBN 0-9615623-4-X
Library of Congress Catalog Card Number 96-097071

Address all inquiries to:
Eyry of the Eagle Publishing
1916 Norvell Road
Grass Lake, MI 49240

(517) 522-3705
FAX: (517) 522-4665

Other books by Dale Fisher:

DETROIT (1985) Out of Print
Hard cover, 178 pages, 139 color photographs

MICHIGAN: From the Eyry of the Eagle (1986)
Hard cover, 146 pages, 119 color photographs – $60

Mackinac Island
Soft cover, portfolio of 16 frameable 9 x 12 prints – $15

DETROIT: Visions of the Eagle (1994)
Hard cover, 176 pages, 160 color photographs – $50

All images in this book are available as
framed photographic art in sizes from
16"x20" to 36"x48"or in murals up to
eight feet long. An extensive collection
of other Open and Limited Edition
photographic art from Arizona, Florida,
Hawaii, Michigan (including Detroit)
and New York is also available.
For current prices and information,
contact:
Dale Fisher Gallery
1916 Norvell Road
Grass Lake, MI 49240
(517) 522-3705
FAX: (517) 522-4665

**To my father
Charles H. Fisher
who has been building bridges for others
all of his life**

*An old man going a lone highway
 came in the evening, cold and gray,
to a chasm vast, both deep and wide.
 The old man crossed in the twilight dim,
the swollen stream was naught to him;
 but he stopped when safe on the farther side
and built a bridge to span the tide.*

*"Old man," said a fellow pilgrim near,
 "you are wasting your strength in labor here:
your journey will end with the closing day,
 you never again will pass this way.
You've crossed the chasm deep and wide,
 why build you this bridge at eventide?"*

*The laborer lifted his old gray head
 "Good friend, in the path I have come," he said
"there follows after me today
 some youths whose feet must pass this way.
This chasm which has been naught to me
 to those young lives may a pitfall be.
They, too, must cross in the twilight dim.
 Good friend, I am building this bridge for them."*

Author Unknown

Foreword from a Native Ann Arborite

It was around six in the morning, on a wonderful fall day, that I found myself jarred awake by the sound of an engine loud enough to drown out all the sounds of Ann Arbor as it comes to life on a football Saturday. I jumped up to see what it could possibly be but couldn't see anything through my window, so I decided to move out to the balcony of my downtown apartment. There it was, just to the left of my view, and it didn't take me a second to know that my friend Dale Fisher was at it again, photographing from a helicopter swooping through the sky. There he was, committing to film all the familiar buildings that register home town in my mind, but from a different view—from higher, or farther away—so that you can enjoy the beautiful architecture, the abundance of magnificent trees, and the intertwining streets that make up the city that I love so much. The generations of houses, the magnificent University of Michigan, buildings both historic and grand, contemporary and innovative. In my kitchen I could watch even more carefully as the helicopter circled, stood almost still and even sometimes looked like it was backing up to get just one more photograph.

I have lived in Ann Arbor almost all my life. I spent a few years in New York City, but somehow I never could give up my love for this unique Midwestern town. I was born here too many years ago, and I suspect that I will die here, too. I raised my sons here, enjoyed all the things that are just a reach away, and yes, took all that was Ann Arbor for granted.

This town is so full of memories. I went to The University School back in its prime. South University, Wikel's Drugstore, Miller's Ice Cream Store, Washtenaw, the old UofM Skating Rink and Mrs. Hamer's Dance Studio above the Michigan Theatre were almost my whole world in those days. The rock, now covered with two decades of sometimes attractive, but mostly ugly, quickly splashed-on paint was, to me, halfway home from school. Along with my sister Susie, I'd sit on that rock many afternoons, accompanied by our old and wonderful friend Hildred Willis. We called it the whistling rock—not because it made any sounds, but because on the rock is where both Susie and I learned to whistle. From Mrs. Hamer's studio, we not only worked hard but watched the crowd at the premier of a movie at the "Michigan," and the enormous fire at Haven Hall, a block-and-a-half away. My first football game in the giant Michigan Stadium was a childhood thrill. The first time I went to Hill Auditorium I heard the incredible Philadelphia Orchestra. One evening during May Festival I was invited to a party and met Eugene Ormandy. He was a giant wonderful talent, but a dear miniature man. He looked up at me and said, "Miss Towsley, if we are going to have a conversation, I think that you should sit down so we can look each other in the eye." I often think about the wonderful days at WAAM radio, Ann Arbor Civic Theatre, the Gilbert and Sullivan Society, but most of all this town so full of friends, so full of projects to be conquered and experiences to be shared. So full of memories. Who would have ever thought that one day I would get married at the Michigan Theatre. Memories.

You see, Ann Arbor holds the best memories, the saddest memories, the most exciting memories in the palm of her hand. I suspect that she holds me as well as many of you, too. So thank you, dear friend Dale, for letting your camera and your eye bring so many memories back into focus. Aren't we lucky!

Judy Dow Rumelhart

4

Foreword from an Adopted Ann Arborite

It now seems odd that for the entire time of our first stay in the United States, which was planned for two and lasted twenty-one years, Ann Arbor was known to my family by name only. It was an attractive name, and we knew Ann Arbor to be a place of good things. It was the home of the much respected University of Michigan, and, given my own interests, I knew that Parke-Davis had its principal research laboratories there. We even were fortunate enough to meet some born and bred, and some adopted, Ann Arborites who carried the quality of their heritage in fine style all the way to North Carolina. Yet in 1981 we returned to the United Kingdom with an image mainly of a pretty name.

In truly "out of the blue" fashion, if you'll excuse the pun, in 1988 we found ourselves accepting an offer to return to the United States, and to live in Ann Arbor. The timing of the offer was inappropriate. The opportunity to visit and explore was not realistic. The upheaval was almost unimaginable. Yet there was somehow a feeling linked to the name and reputation of Ann Arbor that made for an easy and confident decision, and we were off to our new home, sight unseen, after seven exciting years in London.

This magic book, conjured up by Dale and Mary Beth Fisher, captures the charm, the splendor, the tradition, the vitality, and the dynamism of a very special place. The town itself is permeated, and perhaps even dominated, by the University—the sheer variety of its architecture, its renowned institutions, and its legendary arenas. To stop and just look at that, however, is to miss the essence of Ann Arbor. The relationship of town and gown give Ann Arbor a concentrated quality of living that is truly remarkable, and so readily accessible to all.

In New York in the sixties, and even more so in London in the eighties, we had enjoyed very special qualities of living, but in both cities you had to put forth some labor for the feast. In Ann Arbor it is all so available that you have regularly to be prepared to "push yourself away from the table."

Ann Arbor is blessed also in being truly the home of some of the finest of people—people who never stop giving of their time and their substance for a yet better Ann Arbor of tomorrow. Their enthusiasm for their home, infectious in nature and intense, is accompanied by good manners and a welcoming spirit.

One final special quality for me is the immediate access to the countryside that so warmly seems to embrace the community. This is vividly captured by *The Eagle* in all its seasons and in all its variety. Even the chill of winter displays its own magic image.

We owe a very special thank you to Dale and Mary Beth for capturing from their own unique perspective the essence of the Ann Arbor we are lucky enough to know and love.

Ann Arbor is a lot more than just a pretty name.

Ronald M. Cresswell, Ph.D.
Chairman, Parke-Davis Pharmaceutical Research

Introduction

Ann Arbor evokes a depth of emotion and loyalty few other cities can generate. For Dale, capturing all of the stirring and wonderful sights of his beloved home town on film has been an ongoing adventure. His unique perspective from a helicopter transforms even well-known places into something fresh and new. Many scenes are instantly recognizable, others may be unfamiliar, but even the familiar show geographic relationships perhaps not seen before. As expressed in the subtitle, the tour of Ann Arbor that you are about to see is the view of a majestic eagle as it soars, swoops and circles over the city and surrounding area.

Because of the nature of this photography and the space limitations of a single volume, we are not able to show every one of the wonderful attractions, beautiful neighborhoods and impressive commercial projects that Ann Arbor and the area offer; rather, we have endeavored to portray the highlights and to give an overview of the natural beauty, varied architecture, history and events that embody our wonderful town.

Along with factual captions, we have added personal commentary from area residents— past and present—who love Ann Arbor's treasures and know the subject best. Some names you may recognize, others you may not, but all describe a city of strength, beauty, tradition and caring people. Whether you read the words of a lifelong resident or a recent arrival, what you will hear is a description of *feelings*, not merely words about a town.We are also fortunate to have Forewords that express eloquently the sentiments of natives and newcomers and that capture the spirit of Ann Arbor.

Dale and Mary Beth Fisher

Corporate Sponsors

Allen & Kwan
Ann Arbor Associates, Inc.
Ann Arbor Carpets, Inc.
Ann Arbor Chamber of Commerce
Ann Arbor Commerce Bank
Ann Arbor Convention & Visitors Bureau
Ann Arbor Transportation Authority
Atwell-Hicks, Inc.
AVFuel
Beacon Investment Company
Jim Bradley Pontiac, Cadillac, GMC Truck, Inc.
Concordia College
Cybernet Systems
Domino's Pizza, Inc.
Judy Dow Associates
Ford Motor Company, Electrical & Fuel Handling Division, Ypsilanti Plant
Glacier Hills Retirement Center
GT Products
Hall and Deer
ImageMasters Precision Printing
IMRA America, Inc.
KeyBank
Lovejoy-Tiffany & Associates, Inc.
Lucent Technologies, Inc.
Malloy Lithographing, Inc.
Marten-Davis Realtors
Marty's Menswear
McKinley Associates
M-Den
NSK Corporation
Occasionally—Gift Baskets & Balloons
O'Neal Construction, Inc.
Parke-Davis Research Division
Philips Display Component Company
Pittsfield Products, Inc.
Plumbers & Pipefitters Local Union No. 190
Plumbing & Mechanical Contractors Association of Washtenaw County, Inc.
Precision Photographics
St. Joseph Mercy Hospital
Edward Surovell Co./Realtors
Sylvan Learning Center
The Anderson Associates
The Moveable Feast
The University of Michigan
UMI
University Bank
Van Curler Associates, Architects + Planners
Washtenaw Community College

The Photographer

Dale Fisher is perhaps the only artist photographer working exclusively from a helicopter. Born in Ann Arbor and trained in aerial reconnaissance photography by the Navy, he has been perfecting his art since 1954.

Dale combines the vision of an artist with his perspective from above to capture unique images of the world below. Using color, light and shadow he creates dynamic cityscapes, tranquil landscapes, maritime and wildlife scenes from all seasons of the year—and all the while, skimming over his subjects at ground speeds up to 120 miles per hour! Dale shuns special filters and photographic gimmicks, using a normal lens and slow speed film for most of his work, with a telephoto lens or panoramic camera reserved for unusual situations. With special gyro equipment, his shutter speeds can be as slow as a fifteenth of a second for early morning or late evening scenes.

Dale resides with his wife, Mary Beth, on the *Eyry of the Eagle Farm* in Grass Lake, Michigan, where a collection of his open and limited edition photographic art hangs in two Dale Fisher Galleries, one a restored 100-year-old barn and another new facility opened in May, 1996. His work also hangs in the collections of many U.S. corporations, institutions and individuals. Previous books include *Detroit* (1985), *MICHIGAN: From the Eyry of the Eagle* (1986) and *DETROIT: Visions of the Eagle* (1994).

The Pilots

Brian McMahon, owner of McMahon Helicopter Services, has worked with Dale for almost 20 years. Together they have mastered the intense concentration, coordination and other skills required for creating photographic art from a helicopter. For example, the pair developed a technique to photograph from a helicopter in very low light with shutter speeds as low as one-fifteenth of a second, enabling Dale to create intensely dramatic nighttime images.

Pat Mullen, chief pilot at McMahon Helicopter Services, began his flying career as a teenage combat helicopter pilot in Vietnam, serving in the same unit with Brian McMahon. He switched from an earlier career in health care to pursue his passion for flying. In the seven years that Pat has worked with Dale he has developed great skill as a photographic pilot. In addition to many commercial photographic projects, this is the second book in which Pat has been involved.

The Author/Publisher

Mary Beth Fisher, President of Eyry of the Eagle Publishing and Executive Director of Dale Fisher Gallery, relies on her years of experience in business, photography and marketing communications to oversee Gallery business and provide art and framing consultation to clients. Partnering her talents and expertise in writing and editing with Dale's art, Mary Beth authored the text and directed all creative and production aspects of this book as well as Dale's 1994 book *DETROIT: Visions of the Eagle.* Born and raised in Detroit, she worked for several years in the Washington D.C. area before returning in 1980 to her home state to work for the University of Michigan. Mary Beth has been an adopted Ann Arborite for the past 16 years.

The Producers

Pat Truzzi, an award-winning graphic designer, illustrator and watercolor artist, has created elegant design solutions to complex communications problems for more than twenty-five years. Her uncommon level of experience and expertise has contributed to the success of numerous businesses and organizations, both locally and nationally. In addition to this book, Pat designed *DETROIT: Visions of the Eagle* and several marketing communications pieces for the Fishers.

Chuck Edwards has been a custom color photographic technician at Precision Photographics since 1978, in addition to running his own business called Edwards Special Event Videos. A graduate of the U.S. Air Force Photography School and Washtenaw Community College photography program, Chuck is, in Dale's estimation, the finest color photographic printer he has ever known. Chuck produced the custom reproduction prints for this book from which the color separations were made.

Ken Guldi has worked for ImageMasters Precision Printing since 1993, beginning with various prepress positions. For the past two years he has been perfecting his extrordinary color separation skills and, in addition, this year was promoted to Production Manager, supervising all aspects of print production. In Mary Beth's estimation, Ken is the consummate professional—talented, hardworking and unflappable under pressure.

Production Information
Color Separations, Total Prepress and Print Production by ImageMasters Precision Printing using: *Crosfield Magnascan Plus High Resolution Color Scanner, Scitex Dolev 800 Image Setter at 300 lines per inch, Mitsubishi 3F 40" Waterless 6-color Press, Negative Waterless Plates by Toray.*
Stock from Seaman-Patrick Paper Company: *Gleneagle 80# Gloss Text.* Binding by Rand McNally.

Acknowledgments

Without the support, advice, expertise and hard work of many, many people this book would not have become a reality. To all of them we owe our heartfelt thanks. Although there were legions who contributed in some way or another, far too many to name each and every one, there are some whose critical assistance we would like to recognize.

To Judy Dow Rumelhart and Dr. Ronald Cresswell whose enthusiasm and support gave us the start we needed. To Richard and Deanna Dorner, Mary Kerr and Jim Kosteva who advised us and put in many hours on our behalf. To all of the Corporate Sponsors (*see list on page 7*) whose commitment to this book enabled it to be printed. To all the terrific authors who sent us inspiring thoughts and memories about Ann Arbor, including those that were used and those for which, unfortunately, there was not adequate space. To the many individuals throughout the University of Michigan and from churches, companies and other institutions who supplied and verified information for the captions. To Karen Anderson whose enthusiastic and able assistance with the captions enabled us to meet our critical deadline. To readers Bob Jones, Cheryl Orris, John Woodford and Carol Kent who spent hours reviewing text, catching errors and making valuable suggestions. To Tim and Janice Donovan who provided gracious hospitality during round-the-clock printing sessions. To others who assisted us in a number of different ways: Pat Drabant, John Paul, Cary and David Wolfinger.

Special thanks go to those talented and hard-working individuals and organizations who faithfully translated the artist's images and brought this work to print. To our graphic designer Pat Truzzi for accomplishing a monumental task beautifully within tight deadlines, and with unending patience and good humor. To her husband, Marcello, for his assistance and understanding. To our photographic color printers, Chuck Edwards and Kathleen Rakow, whose darkroom artistry produced superb reproduction prints. To Mike Wolf and his staff at Precision Photographics who met our tight deadlines with grace and excellence. To Ken Guldi, whose extraordinary talent and diligence produced exceptional color separations from reflective art (an especially difficult challenge); to ImageMasters Precision Printing staff who invested themselves personally in making this book the best that it could be, especially Joe Brandimore, James Meredith, Fred Grobbel, Jeff Chapple, Duane Canapini, John Nawrocki, Dave Barnes, Jim Trevor, Mike Dickey, Tom and Gary Bomek, Todd Aker, Frank Jett, Mike Sabuda and Heather Robinson. And finally to Jeanne Stiles, Scott Edwards and the Rand McNally staff for their valuable assistance and beautiful binding.

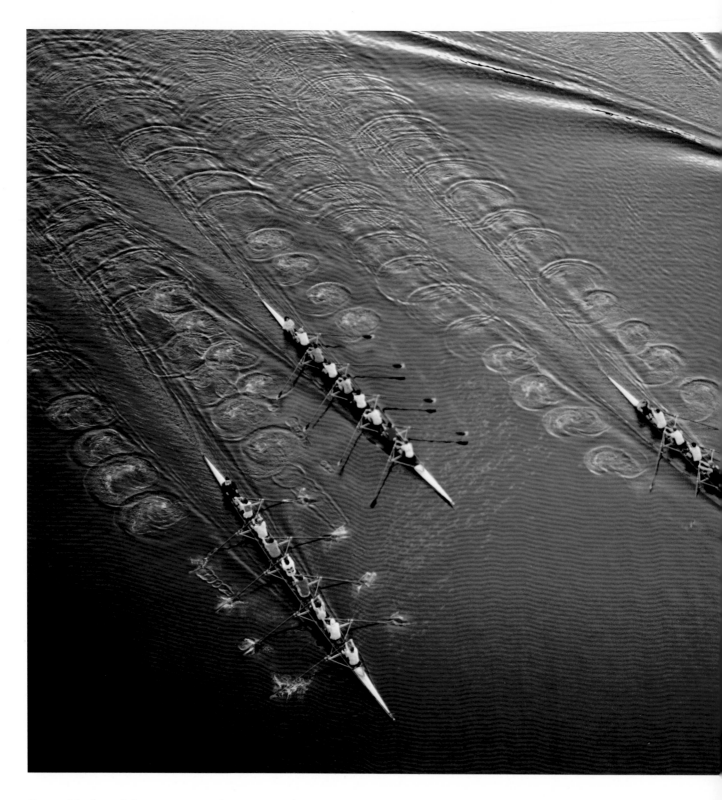

Expert bladework by University of Michigan crew forms artistic patterns as the oarsmen glide their racing shells through the Huron River, northwest of downtown Ann Arbor.

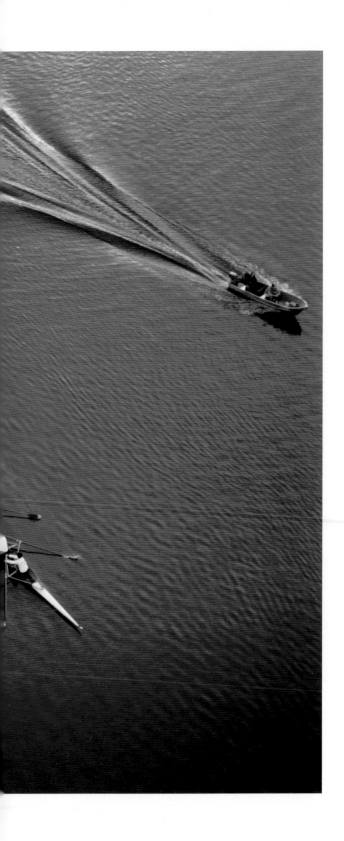

Northwest

"Ann Arbor is a special place — a place for living, a place for working, and a place for being. It's an easy place to come to and a very hard place to leave. The people are special. They give to those who need, and those who can, give back. Can you think of a better place to live?"

Ronald Weiser
C.E.O., McKinley Associates, Inc.

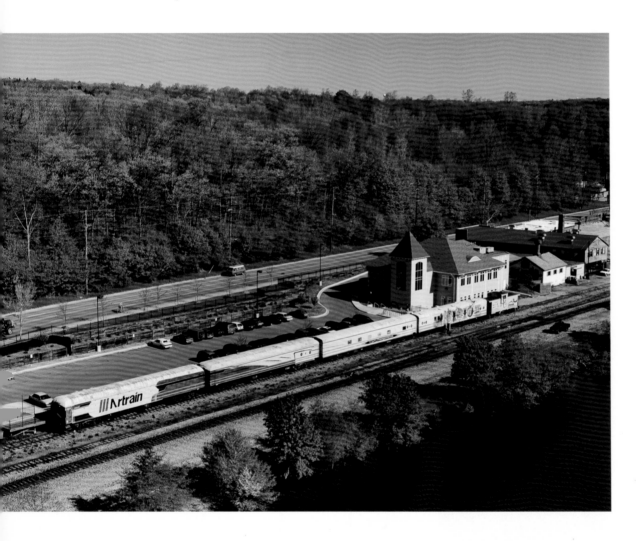

In May of 1824, founders John Allen and Elisha Rumsey filed their plan for the village of Annarbour, reportedly named to honor their wives and the generous stands of burr oaks in the area. Strategically situated along the Huron River *(right)* and Allen's Creek, the village quickly grew and prospered, prompting the State Journal to predict in 1837 "our village, we trust, is destined to be the pride and ornament of Michigan."

Today's Ann Arbor is a fulfillment of that prediction. Flourishing with world-renowned institutions and businesses, 'Tree Town' nonetheless retains its friendly small-town charm and an abundance of green. Always a trend-setter, Ann Arbor boasts the nation's only traveling Art Museum on a train. Artrain *(above)* brings world-class artwork to thousands of Americans who may not have access to traditional museums. For example, its 1996-98 Chrysler Corporation-sponsored national tour, featuring 34 contemporary artworks commissioned by The Smithsonian Associates, is expected to reach 500,000 people in 100 communities in 40 states.

Another unique concept, the NEW (Nonprofit Enterprise at Work) Center *(also above)* originated with the McKinley Foundation of Ann Arbor. In 1993 the Main Street expanse of rusting metal, old tires and industrial castoffs known as Lansky's Junkyard was transformed into 11,000 square feet of gleaming new but affordable space for nonprofit organizations. NEW is a venue where diverse fledgling nonprofits can learn from each other, share resources, develop leadership skills and benefit from ongoing education. Its current 19 tenant organizations span arts and culture, social services, education, community development, environmental awareness and health and wellness.

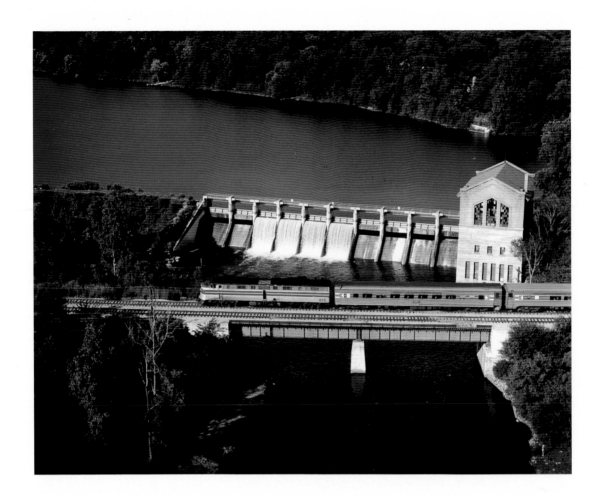

"Whether I want to feel the buzz of a city, or hear the soft hum in quiet country, Ann Arbor gives me the choice…every day, every night. That is its magic."

Barbara Willett Hartnagel
Rochester, MI (Ann Arbor resident for 8 years)

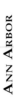

Barton Dam and Powerhouse *(above and right)*, one of four dams along a ten-mile stretch of the Huron River, was constructed in 1912 by the Eastern Michigan Edison Company to generate hydroelectric power. The ready availability of electricity then stimulated industrial growth, bringing important companies such as Hoover Steel Ball to Ann Arbor. All four dams (Barton, Argo, Geddes and Superior) are now owned by the City and provide impoundments used for water supply, wastewater dilution and recreation. In 1985 Barton and Superior dams again began to provide hydroelectric power to Ann Arbor.

Adjacent to the Dam is Barton Park *(right)*, the city's second largest, which has more than 100 acres for picnics, nature walks and fishing. Two new bridges and a walking path were added in 1992, creating the first pedestrian access to the park. Foster Prairie, a recently discovered grassy area east of Foster Bridge, offers a peek into Ann Arbor's past as one of the early prairies that still exists today.

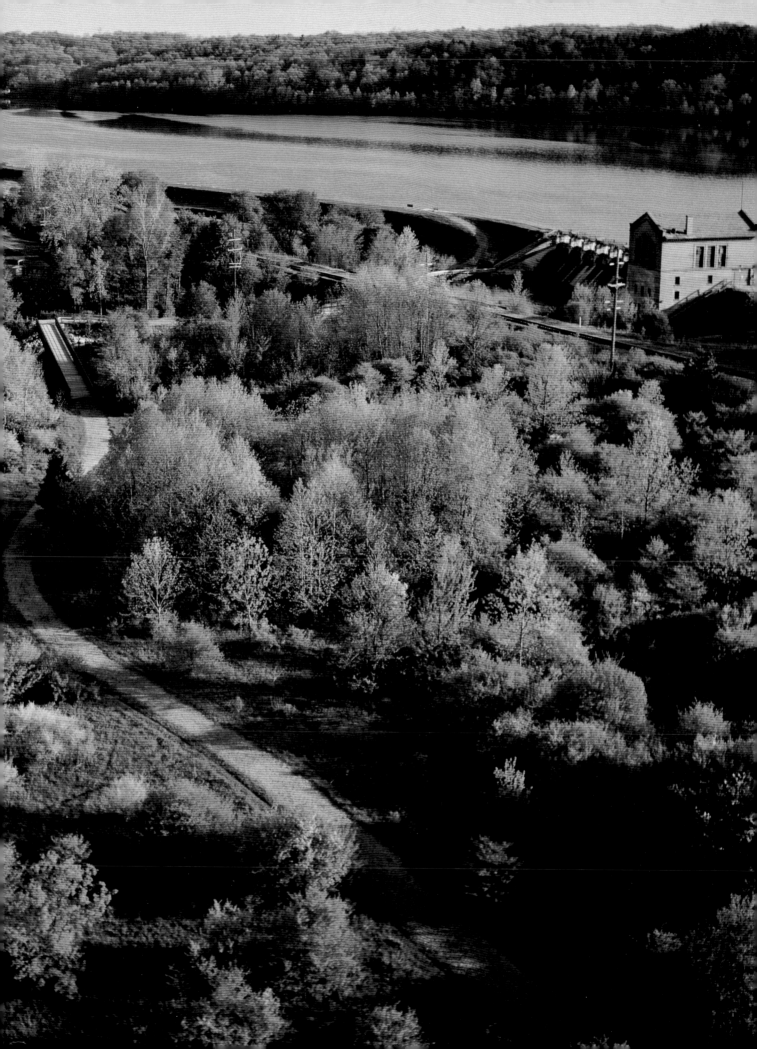

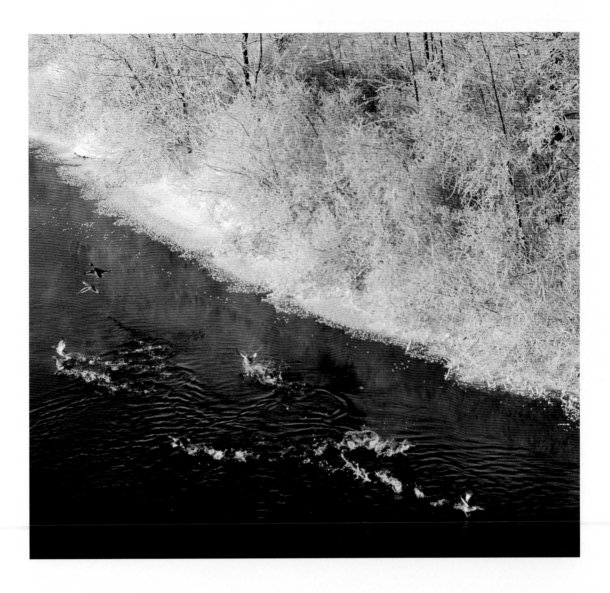

"Ann Arbor is a marvelous place to live. The community is loaded with fascinating people and affords endless challenging opportunities—for compensatory work and for public service activities. Amazingly for a city its size, the whole cultural world comes here, due to the presence of the University of Michigan. Within minutes of downtown you can escape city sounds and explore the area's diverse flora and fauna or enjoy hunting and fishing. And when you're in a big city mood, Detroit is just a short drive down the expressway. Top quality athletics—for the spectator or participant, the best medical treatment and governmental services; I could mention hundreds of reasons why I feel so fortunate to have settled here."

Mark W. Griffin
Bodman, Longley & Dahling

Tucked among several Ann Arbor residential districts are havens of natural beauty where wildlife abounds. Deer *(opposite)* find sanctuary in the many woodlands such as this one near Barton Hills. Wild ducks regularly visit the Huron River *(above)* and the area's numerous other bodies of water.

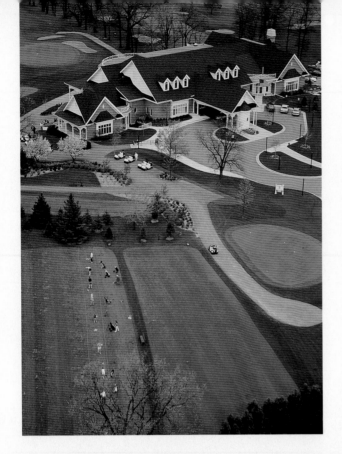

Alex Dow and William E. Underdown provided the early driving force behind development of Barton Hills Country Club in 1919. Later, in 1922, Club members hired famed golf architect Donald Ross, renowned for his course designs at Pinehurst NC and Oakland Hills in Birmingham, to create a new 18-hole course that would be one of the best in the country. A new clubhouse *(opposite and left)* that overlooks the 18th hole was constructed in 1992. Barton Hills has hosted many local and state events over the years, and will be the site of the U.S.G.A. 1998 Women's Amateur Championship.

An October snowfall *(below)* adds an unusual frosted touch to Barton's beautifully manicured course.

Overleaf: In 1825 founder John Allen wrote "Our river (is) the most beautiful I have beheld." In those early years of growth, the Huron's running waters and tributaries were important to the city's commerce, supporting three saw mills, two breweries, tanneries, flour mills and a paper mill. Parks, canoe liveries, bicycle paths and playing fields line its banks now, providing Ann Arbor residents with beautiful vistas and abundant outdoor activities that contribute to their superb quality of life.

"My membership in Barton Hills Country Club has brought me a lifetime of unequaled golf and friendships."

Ellwood L. Cushing
Honorary Life Member, Barton Hills Country Club

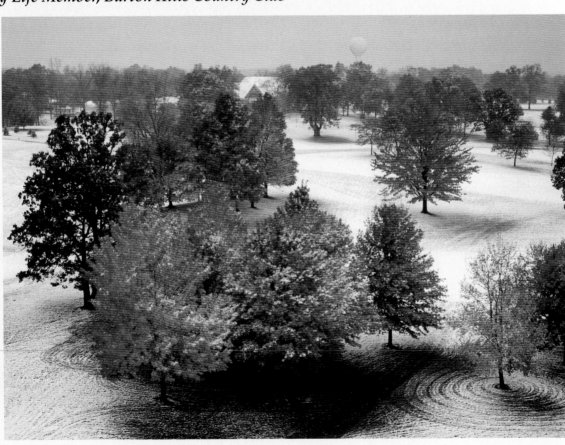

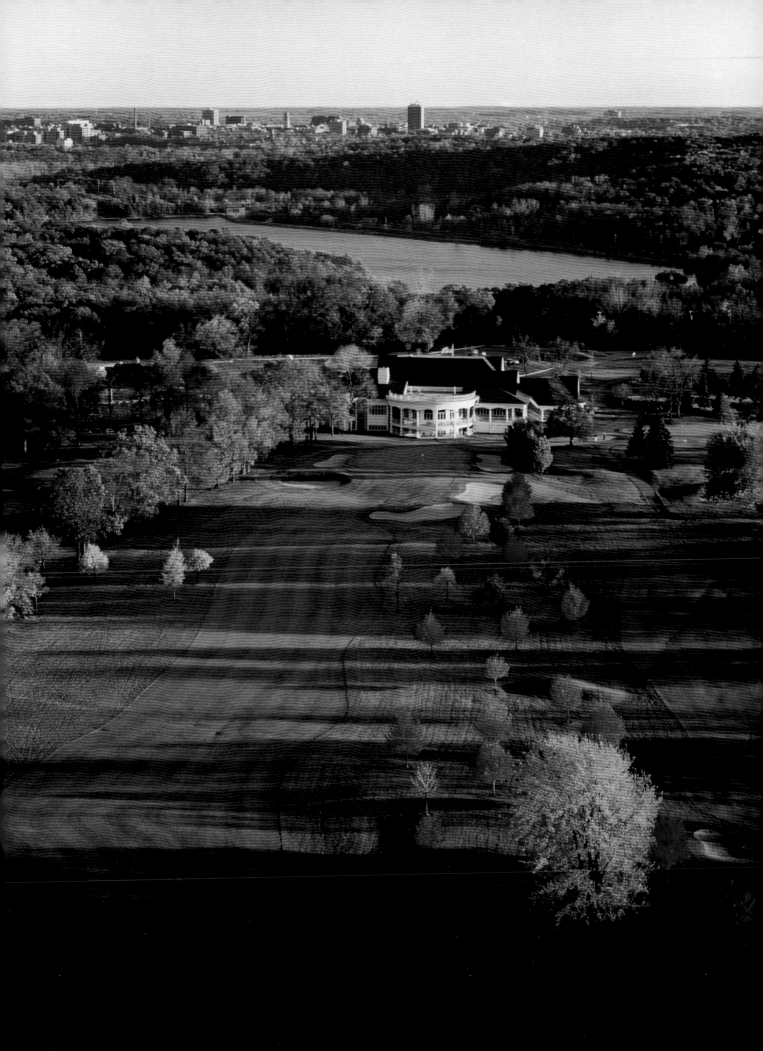

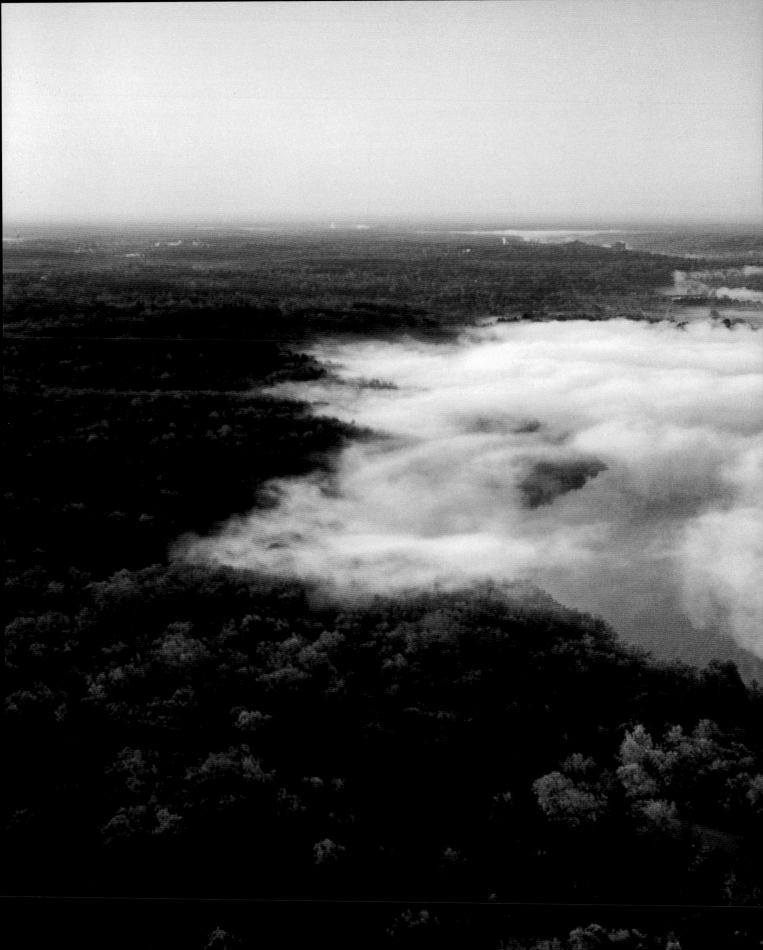

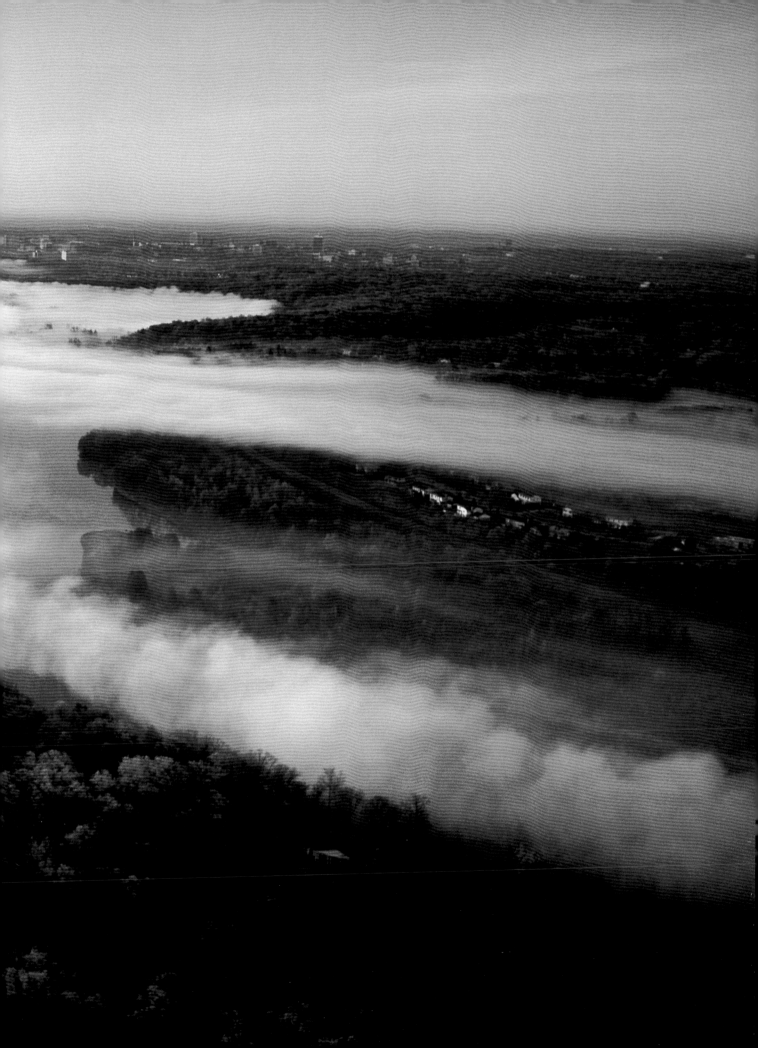

"Ann Arbor's high quality of life has repeatedly won it awards as a safe, clean and family-oriented place to live (which has) drawn a sophisticated, younger-than-average population of highly-educated, moderately affluent baby boomers and younger retirees, almost all of whom are exceptionally health-conscious and into physical fitness and other health-enhancing activities."

Norman D. Ford
The 50 Healthiest Places to Live and Retire in the United States (1991)

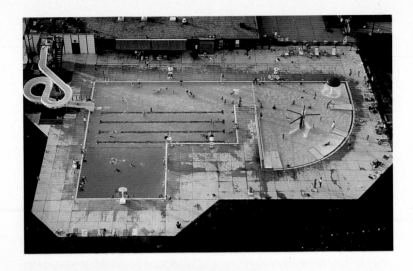

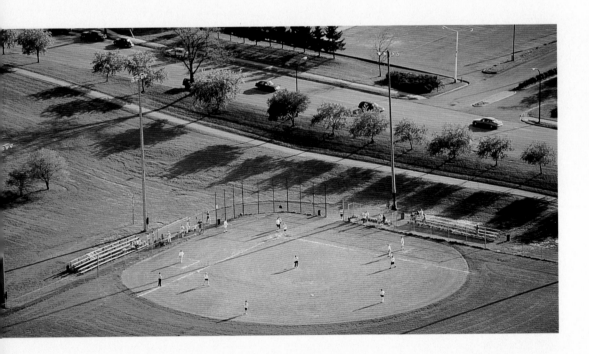

A parade of flowering crab trees lining Sequoia Parkway near Maple Road *(opposite)* adds a spectacular touch to this family-oriented west side neighborhood. Ann Arbor's fine housing, extensive park system, and cultural opportunities contributed to its ranking by Mr. Ford as the 'third healthiest place to live in the United States.'

The five lighted ballfields *(above bottom)* at Veterans Memorial Park regularly draw large crowds to its twilight softball and baseball games. With 40 acres of year-round activities, including lighted tennis courts, playground, outdoor grills and picnic tables, skateboard ramp, sledding hill, and indoor ice rink, 'Vet's Park' is a proud centerpiece of the Old West Side. The newly-renovated swimming pool *(above top)* features a water slide and other interactive play equipment for children.

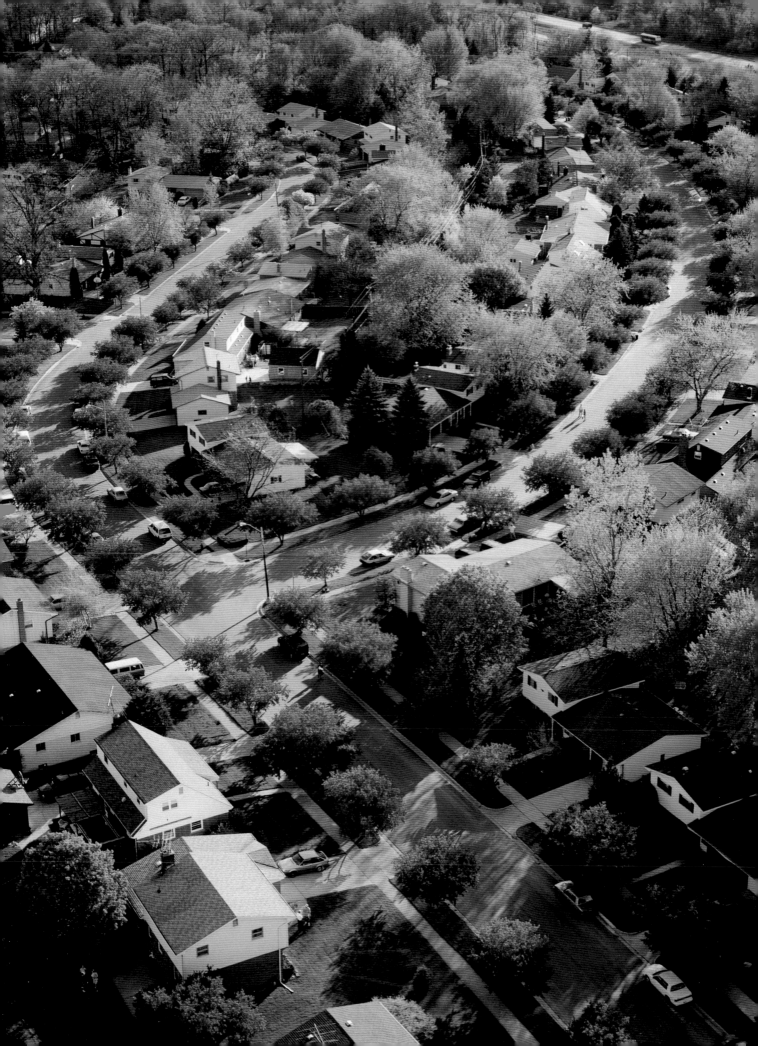

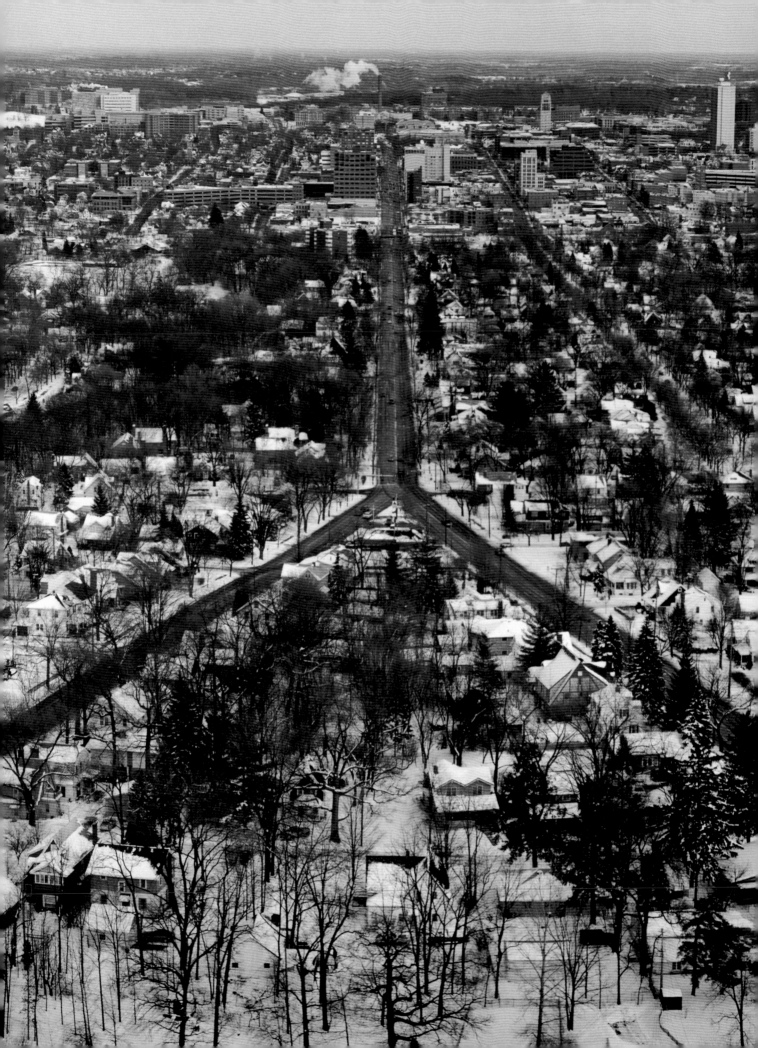

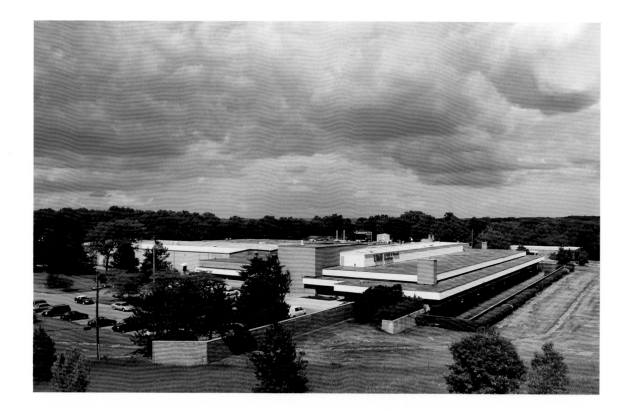

"My wife and I have spent most of our lives in the Philadelphia metropolitan area. While we miss our families and friends on the East Coast, our relocation to Ann Arbor has enriched our lives both personally and professionally. The quality of life in Ann Arbor is outstanding. I feel very fortunate that UMI is part of this growing and vibrant community."

Hank Riner
President & CEO, UMI

(Opposite) **West Huron Street splits into Jackson Avenue and Dexter Road on the city's Old West Side. Modest late 19th and early 20th century homes, originally owned largely by German working-class residents, predominate the peaceful tree-lined neighborhoods in this area. Several noteworthy historical homes, such as the 1861 Italianate brick John N. Gott mansion, the magnificent 1888 Martin and Helena Noll Queen Anne house and the 1859 Gothic Revival home of John M. Wheeler, are located along West Huron Street. A small Greek Revival house on Dexter Road at the "forks," built in 1850 by Norman Covert for his mother-in-law, Eunice Baldwin, has become a landmark in Ann Arbor.**

"The Father of Scholarly Micropublishing," Eugene B. Power, founded University Microfilms, Incorporated (UMI) *(above)* **in Ann Arbor in 1938, based on his revolutionary idea of "editions of one." He saw that traditional print publishing was designed to produce large quantities of a single title, but microfilm publishing could produce single copies of a large number of titles. Today UMI, now a publicly held Bell & Howell Company, is an international multimedia information publisher whose products and systems can be found in virtually every library and information center worldwide. Its state-of-the-art ProQuest Direct online system enables users to access UMI's vast archives via modem or the Internet.**

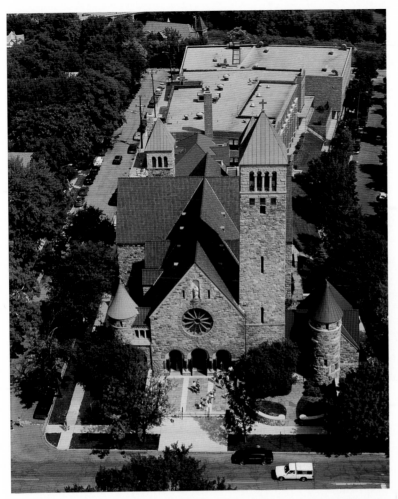

"As far back as 1831, a citizen of Ann Arbor wrote home to her family in Connecticut that there are four churches in the city, all held regular meetings 'upon the Sabbath' and all had 'very good preachers.' Across the decades those regular meetings, the faithfulness of the religious community and the dedication of the clergy have bequeathed to Ann Arbor a rich legacy of faith and service. The many houses of worship in Ann Arbor are signs to the entire community of a continuing commitment to worship, education and social justice."

The Rev. Robert L. Hart
Interim Rector, St. Andrew's Episcopal Church

St. Andrew's *(opposite)*, the second oldest Episcopal parish in Michigan, was organized in 1827. The current church, in which its members have worshipped since 1869, is the oldest such building in continuous use in Ann Arbor. Designed by English-born architect Gordon W. Lloyd, St. Andrew's is regarded as one of his finest achievements in the Gothic-style which he favored. St. Andrew's parish has a tradition of involvement in community efforts for human welfare, justice and peace. Good music and drama are also significant parts of St. Andrew's life, with several performances each year open to the public.

A growing Irish population led to the founding of St. Thomas the Apostle Parish in 1835, and in 1842 the parish erected the first brick church in Ann Arbor. By 1891 parish membership had swelled and included many prominent German Catholics, leading to construction of the current handsome Romanesque building *(above)* which is reminiscent of Italian hill churches. St. Thomas opened its first parochial school in 1868, followed by construction of new and larger schools in 1886 and 1930. Today the parish continues to focus on education and family life, along with its community ministry activities.

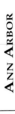

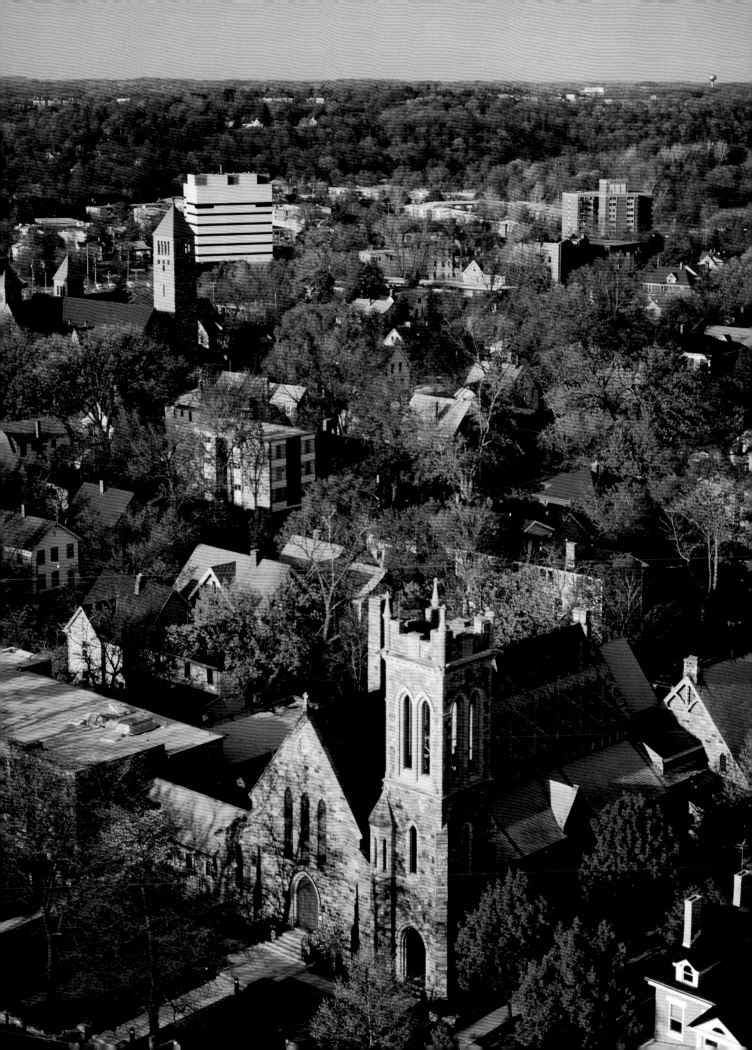

"We are fortunate that Weber's Restaurant is located in Ann Arbor. It is a town with continuing controlled quality growth in a location close to Detroit Metro Airport. We have a strong downtown area and stability from the fine universities and hospitals nearby. Ann Arbor has the activities of a larger city but the residential feel of a strong community."

Ken Weber
President, Weber's Inn

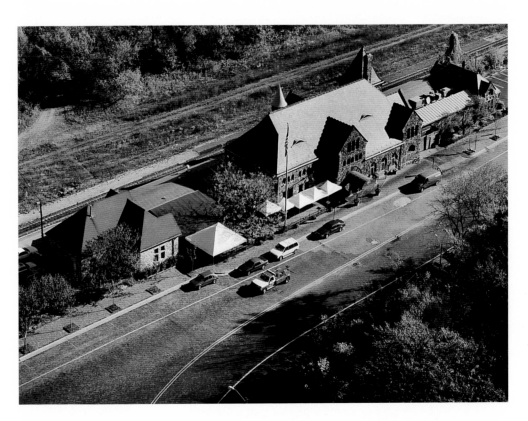

Consistently rated four stars in the Mobil Travel Guide and Four Diamonds by AAA, Weber's Inn *(opposite)* has also housed one of Ann Arbor's most popular restaurants for decades. Herman Weber and his brother, Rheinhold, founded the business in 1937 (at a different location) as the one-room Hi-Speed Inn with two gas pumps out front. At its present location since 1963, Weber's today is a luxury, 160-room hotel with a fine restaurant, including several poolside suites and ten banquet rooms seating up to 600, still owned and managed by Herman Weber and his family.

Designed in 1886 by Spier and Rohns in the popular Richardsonian Romanesque style, the elegant train depot *(above)* was considered to be the finest station on the Michigan Central Line. Stained glass windows, red oak ceilings, French tile floors and two large terra cotta fireplaces embellished the interior. Politicians from William Howard Taft and Teddy Roosevelt to John F. Kennedy and Richard Nixon, performers from around the world and students from across the country received their first impression of Ann Arbor at the depot. In 1970, the C. A. Muer Corporation purchased this historic showpiece, renovating the main building into the distinguished and popular Gandy Dancer restaurant, named for the laborers who once maintained the tracks. Specializing in fresh seafood, choice meats and house-made delicacies, the Gandy Dancer has provided culinary excellence to Ann Arborites for more than twenty-five years.

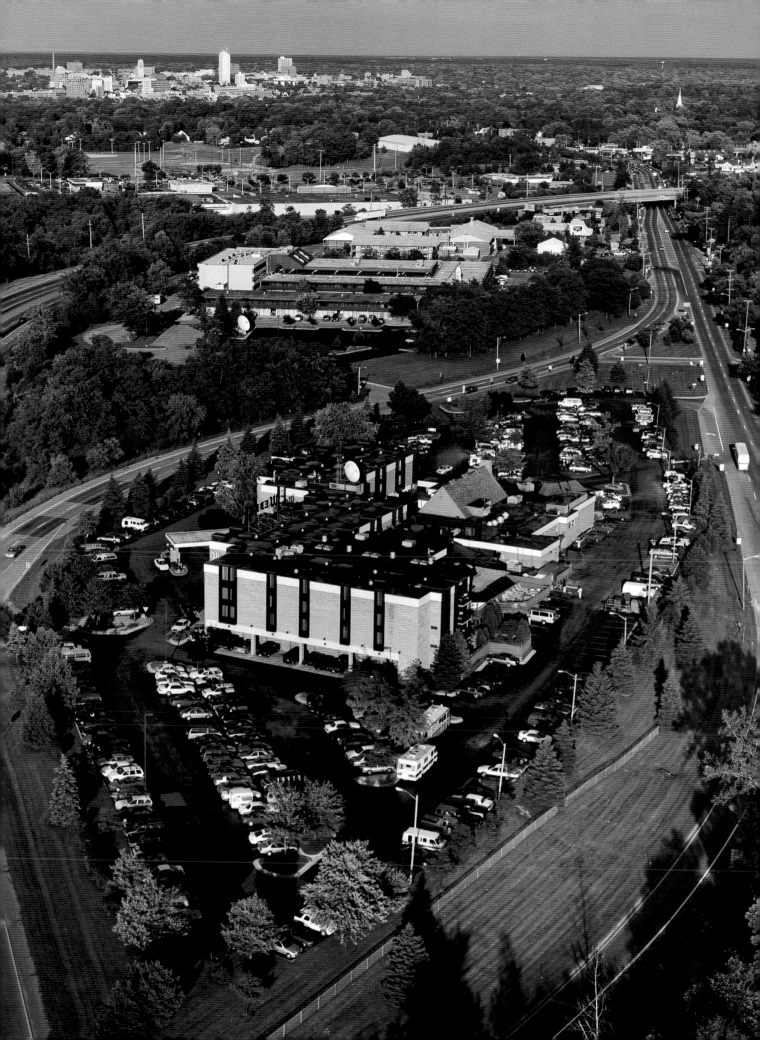

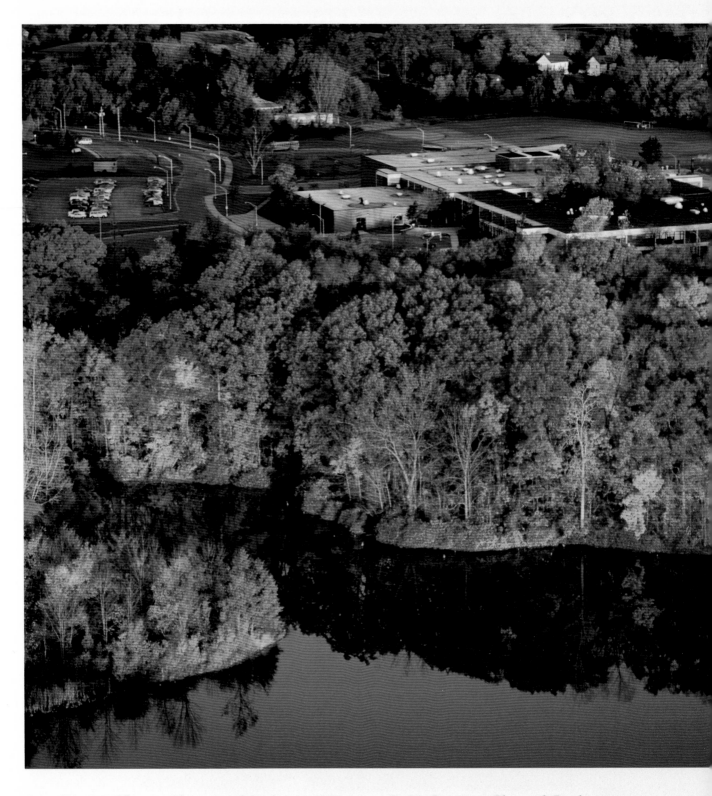

Opened in 1963, Thurston Elementary School sits on 24.8 acres on Prairie Street near Plymouth Road.
The Nature Center, a joint project of the school and its neighborhood, enhances the education of Thurston's
approximately 300 students.

Northeast Ann Arbor

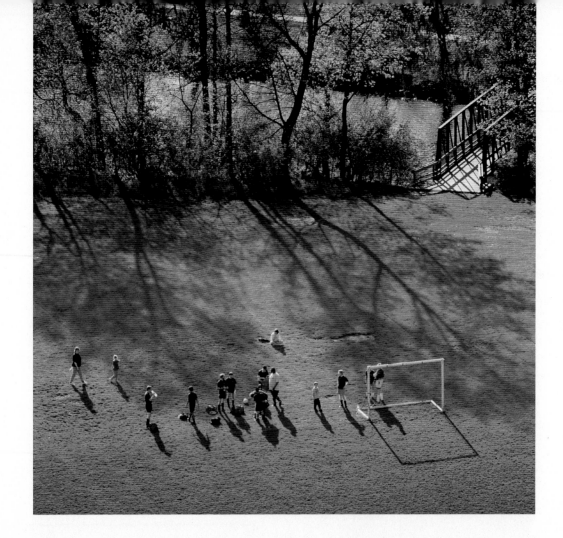

Along the banks of the Huron near the U-M Medical Center lies Island Park *(opposite)*, one of the city's oldest. Its Greek Revival Building has long been a popular site for weddings and other ceremonies. Originally designed and built by John Koch in 1914, the building was restored in 1995.

A bridge connects Island Park with Fuller Park *(above)*. With several soccer fields, four tennis courts, two sand volleyball courts, and a swimming pool, Fuller Park provides 65 acres of outdoor activities for the whole family. The Mixer family also developed a children's play area in the park to commemorate Scott Mixer and his son who were tragically killed in an automobile accident.

(Overleaf) Parke-Davis Research, one of the oldest names in biomedical science, is a world-class discoverer and developer of pharmaceutical and biological products for human health. Headquartered in Ann Arbor, its scientific community of more than 1,500 works in collaboration with Parke-Davis professionals in Morris Plains, NJ, as well as with scientists in Canada, Europe and Japan.

"When people inside and outside Parke-Davis pass our complex on Plymouth Road, they should look with pride on our achievements. The first treatment for Alzheimer's: developed here; leading-edge drugs for epilepsy: invented by Parke-Davis Research; cardiovascular therapies that will save or improve millions of lives: invented here. The people of Parke-Davis Research have both thrived in Ann Arbor and helped make this city one of the world's best-known in medical science. That's great—but even better—we know our greatest discoveries lie ahead."

Ronald M. Cresswell, Ph.D.
Chairman, Pharmaceutical Research, Parke-Davis (Overleaf)

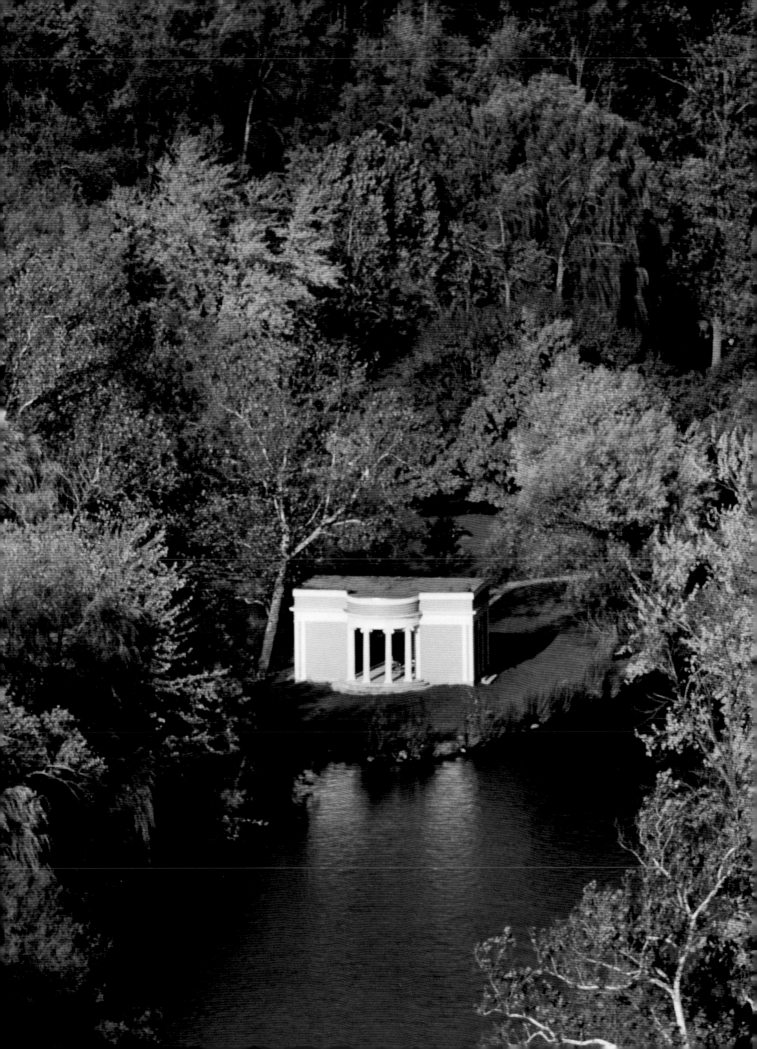

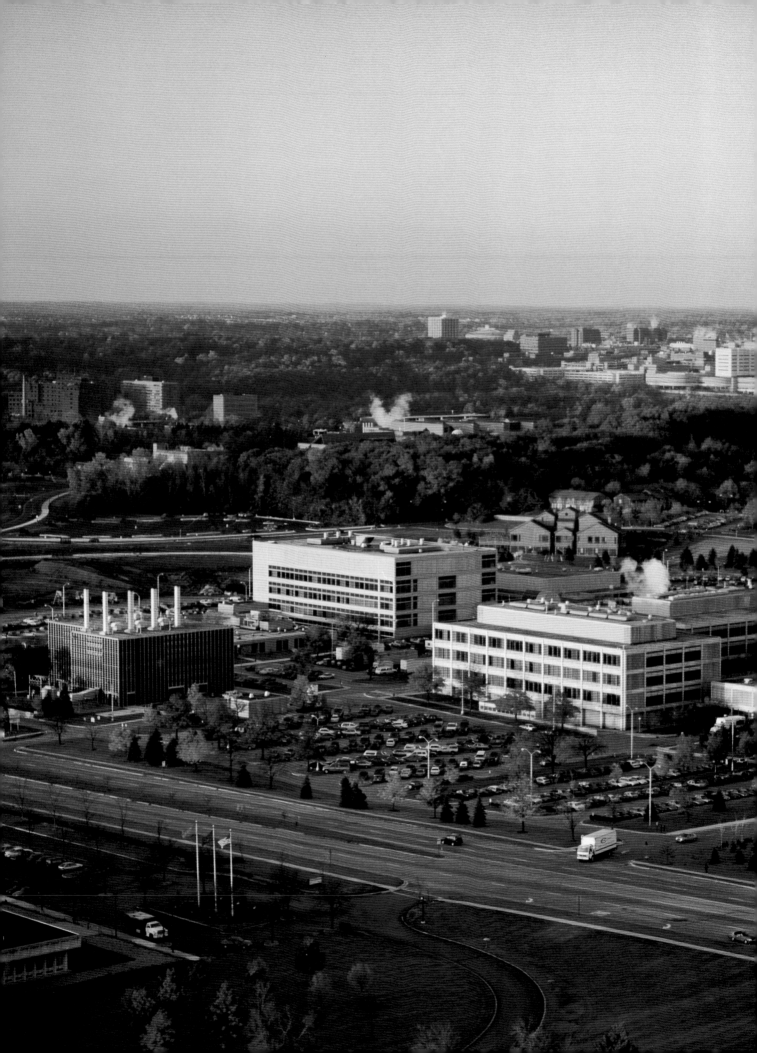

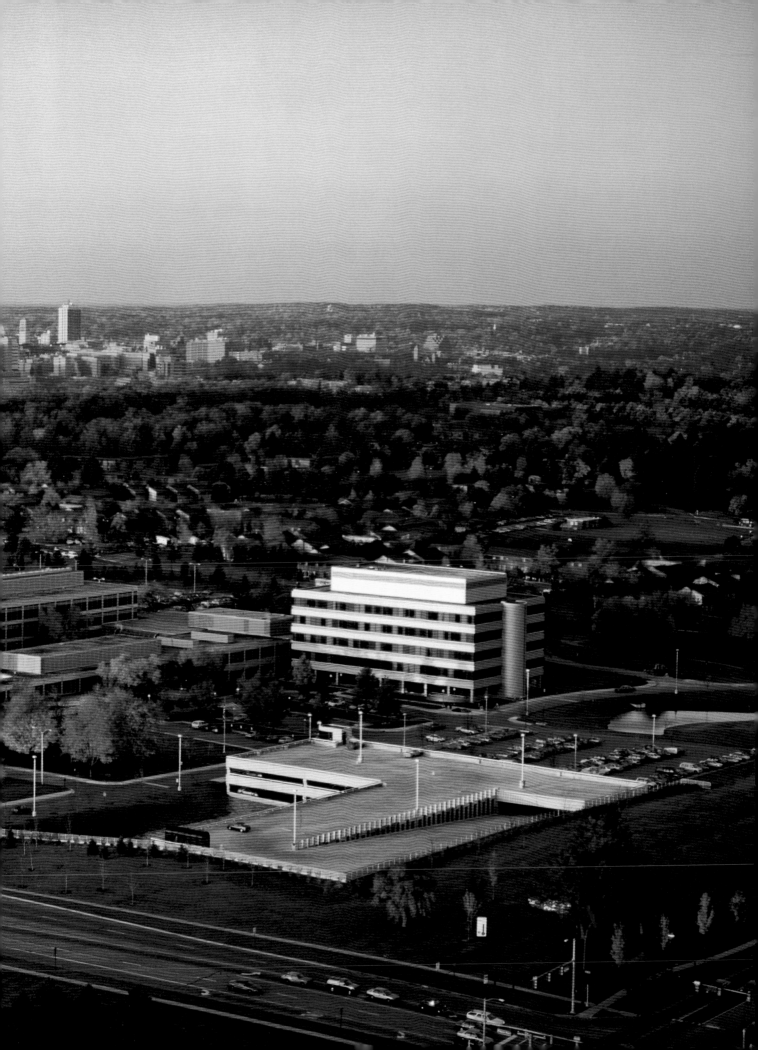

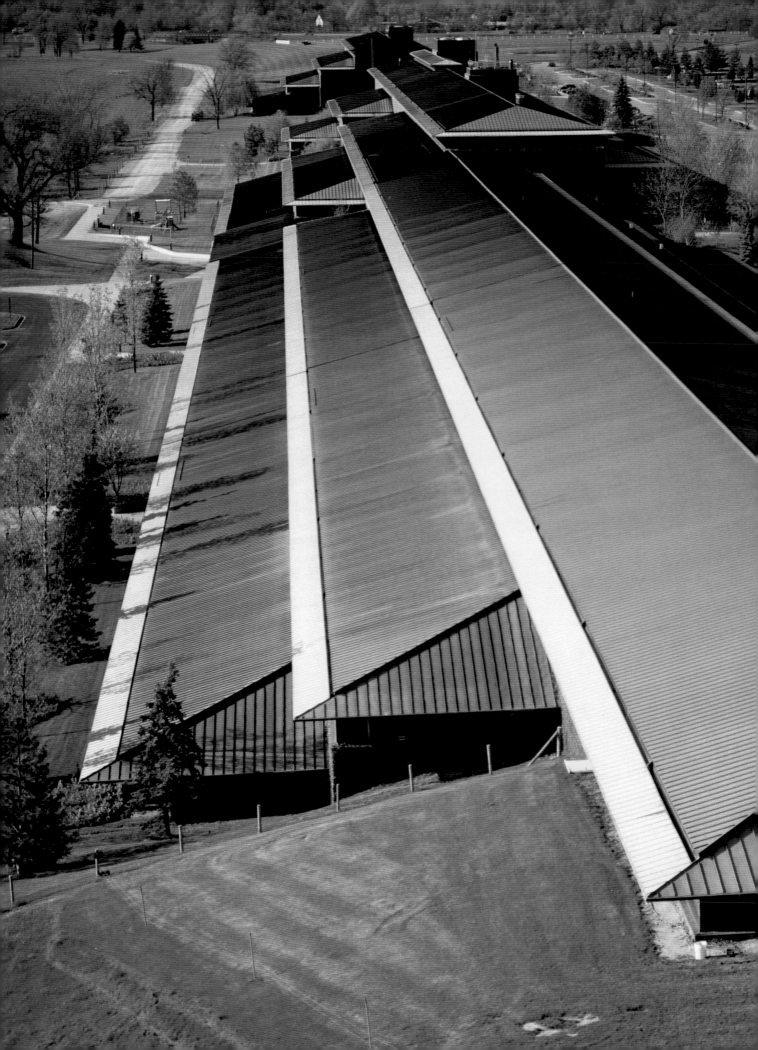

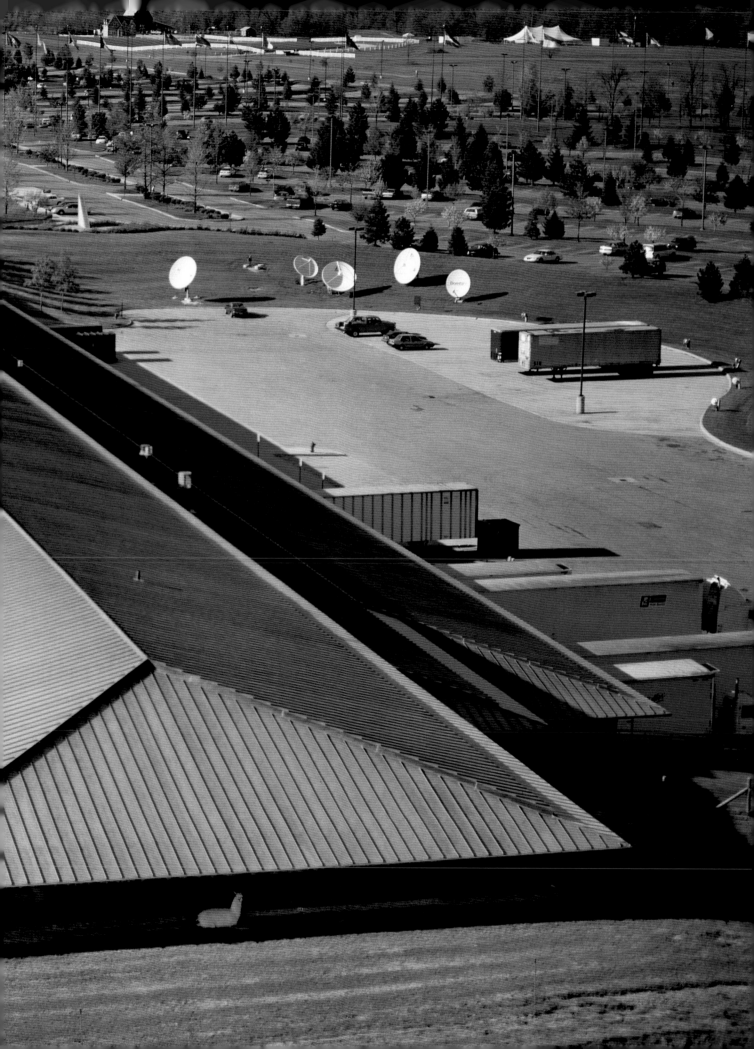

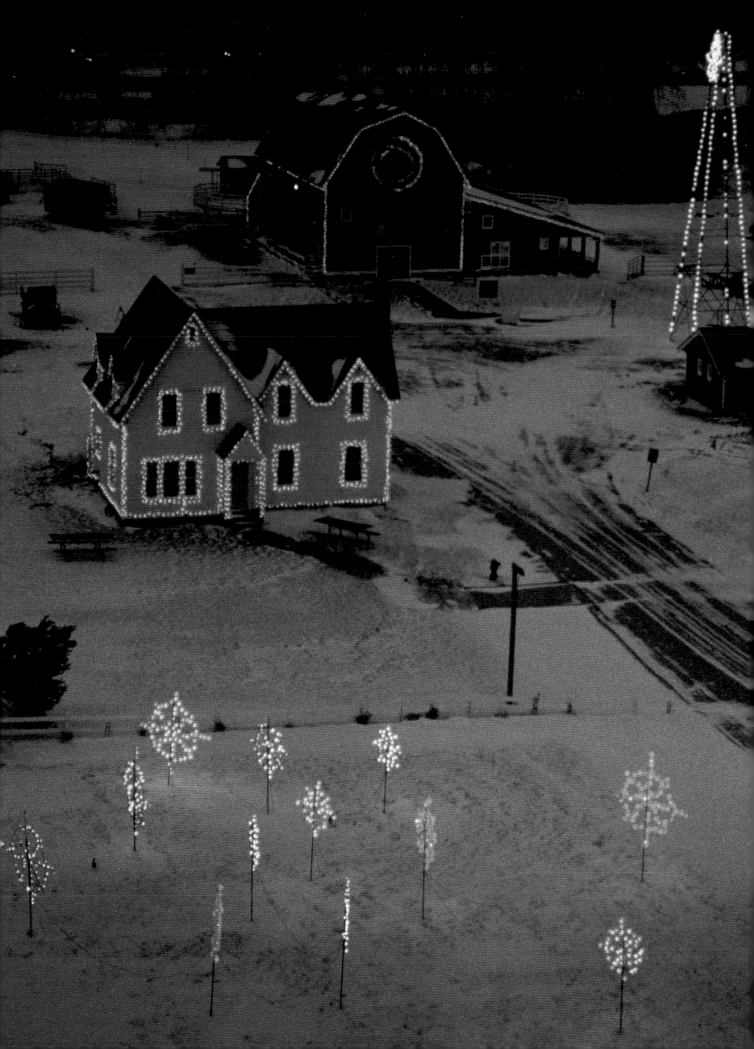

"Our goal at Domino's Farms is to create a stress-free environment. It should be one that encourages creativity and makes work seem a little more enjoyable. We think we have achieved that goal because of three major factors. First is our careful attention to details; second, the special care we have taken to capture Frank Lloyd Wright's regard for nature; and third, is the way we have combined a serious corporate environment with a friendly, campus-like design. We invite you to come and enjoy Domino's Farms with us."

Thomas S. Monaghan
Founder and CEO,
Domino's Pizza, Inc.

Domino's Farms *(opposite and previous pages)* **is the World Headquarters of Domino's Pizza, Inc. The Prairie House headquarters building** *(previous pages)* **is a tribute to the work of American architect Frank Lloyd Wright. In addition to Domino's, 49 other companies occupy this unique structure surrounded by 300 acres of rolling farmland. Opened in 1984, Domino's Petting Farm** *(opposite)* **is a working farm with crops consisting of fruit trees, sunflowers, canola and hay to feed its animals. Children of all ages enjoy visiting the Farm's llamas, goats, sheep, horses, longhorn cows, peacocks and chickens, but may be surprised to also see a herd of Bison roaming the property. Since 1986, Domino's has presented an elaborate Christmas light show** *(opposite)* **to raise funds for charity. Featuring more than 800,000 lights depicting religious themes, this spectacular display draws 200,000 people annually over a 40-day period.**

Domino's Pizza, Inc., founded in 1963 in Ann Arbor by Tom Monaghan, is recognized as the world leader in pizza delivery. With 1,200 franchisees, Domino's operates more than 5,200 stores throughout the United States and in 46 international markets. Its 1995 sales reached $2.65 billion, accounting for more than 225 million pizzas and 306 million individual Buffalo wings sold that year.

ANN ARBOR

41

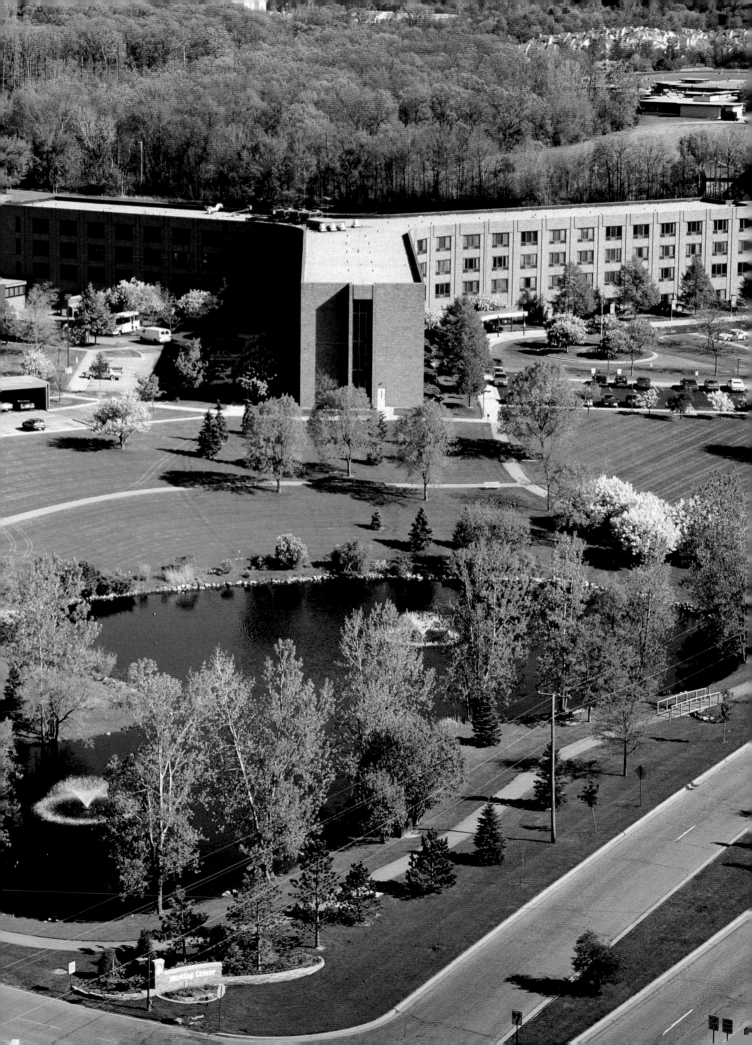

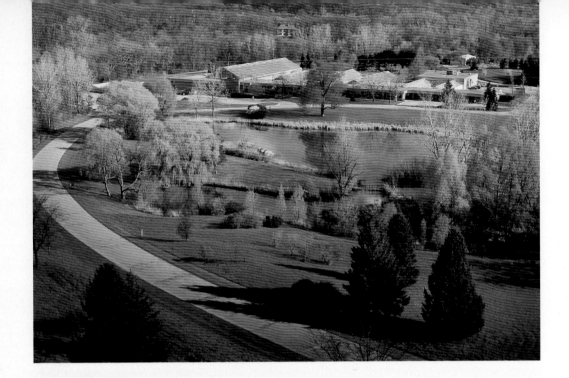

"My parents came from Germany and met and married here, so we spoke German at home. When my oldest sister went off to school, she couldn't speak English and had to learn. I was the youngest of four girls, so by the time I went I could speak both. We used to go uptown to run an errand for our mother and when we came home we'd say, 'Oh, Mama, Mama, we saw five automobiles on the street today.'"

Bertha Welker (Age 100)
Life-long Ann Arbor resident who resides at Glacier Hills

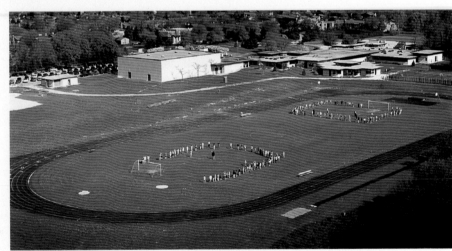

Glacier Hills *(opposite)*, a Lifecare community, is located on 34 acres of beautifully landscaped property that includes graded nature paths. Residents of the 170-unit retirement center live independently in apartments with amenities such as a beauty shop, library and several levels of health care available on the premises. Patients in Glacier Hills' 163-bed skilled nursing center benefit from the academic relationships with nearby leading research and educational institutions that keep it at the cutting edge of geriatric care.

Known as "Greenhills," the Earhart Farm just north of Glacier Hills produced fruits, grains and vegetables for most of this century. In 1968, the land became the campus of Greenhills School *(above bottom)*, an excellent independent college preparatory school for the greater Ann Arbor area.

Nearby Matthaei Botanical Gardens *(above top)* presents four nature walking trails and a wide variety of gardens to fill the senses and calm the soul. The indoor Conservatory contains tropical, warm temperate and desert plantings. Outdoor visitors find specialty gardens such as perennial, rose, herb knot, woodland wildflower, wetland and shade, as well as a native Michigan prairie.

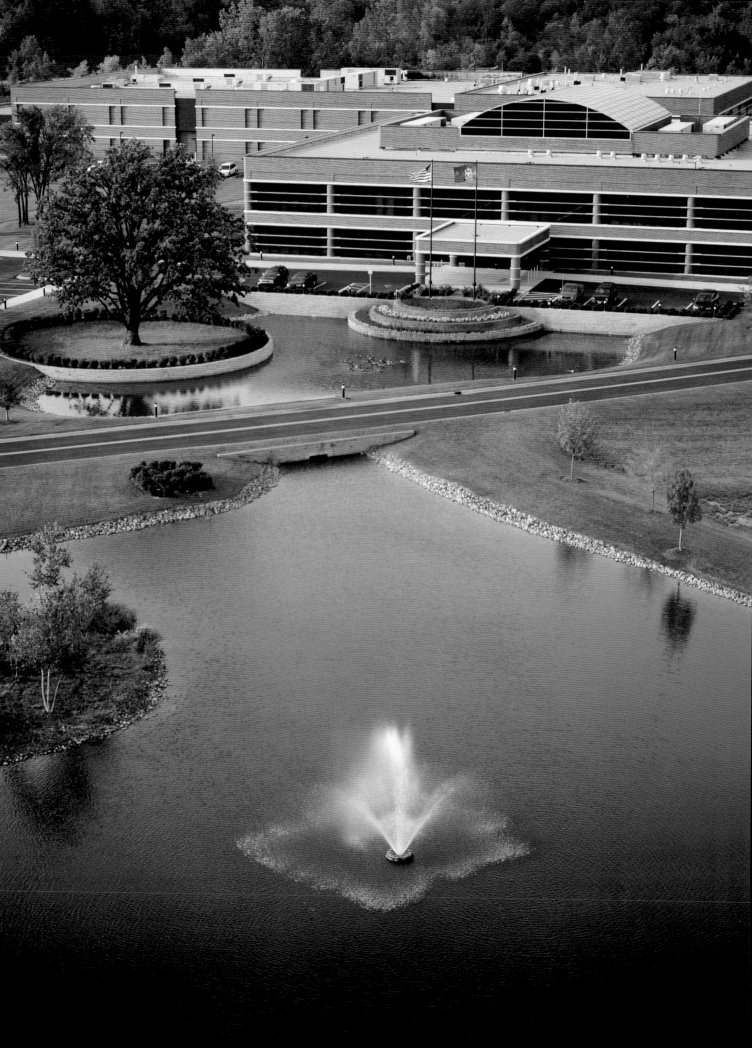

"Ask anyone about Ann Arbor and sooner or later they'll mention education. For over thirty years, Concordia College has been part of Ann Arbor's mix of higher education choices. At Concordia we're proud to offer the opportunity of a Christ-centered liberal arts education in a town synonymous with quality education resources."

James Koerschen, Ph.D.
President, Concordia College (Overleaf)

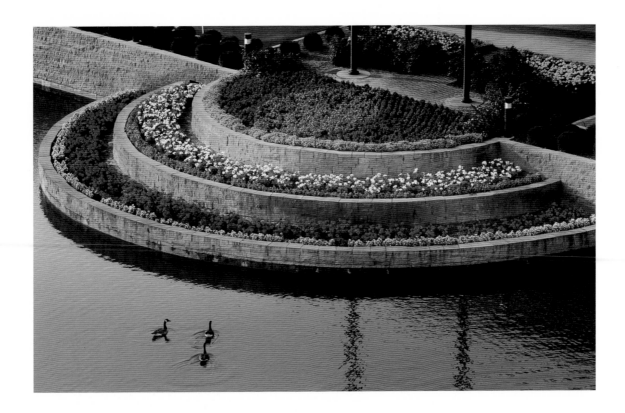

Toyota Technical Center, U.S.A., Inc. (TTC), Toyota's U.S. automotive research and development operation, is headquartered in Ann Arbor *(opposite and above)* with facilities in California and Arizona. Founded in 1977 primarily to conduct emissions testing in California, TTC today plays an important role in the design-engineering and development of Toyota products, particularly those developed for the North American market. TTC works with North American suppliers to evaluate parts and materials, conducts powertrain evaluation and emissions certification, handles prototype development and technical research, and performs all aspects of vehicle evaluation and fine-tuning.

(Overleaf) Concordia College opened in 1963 as a private Christian junior college on 234 scenic acres of rolling, wooded hills. The College overlooks the Huron River on land that was formerly the estate of philanthropists Mr. and Mrs. Harry Boyd Earhart. The original land patent, bearing the signature of President John Quincy Adams, can be traced to Elnathan Botsford, who arrived in Ann Arbor in 1825. Affiliated with the Lutheran Church-Missouri Synod, Concordia received accreditation in 1976 as a four-year liberal arts college and currently grants Bachelor of Arts degrees in more than 20 programs and majors. The approximately 600 students receive supportive individual attention from a faculty dedicated to one-on-one teaching.

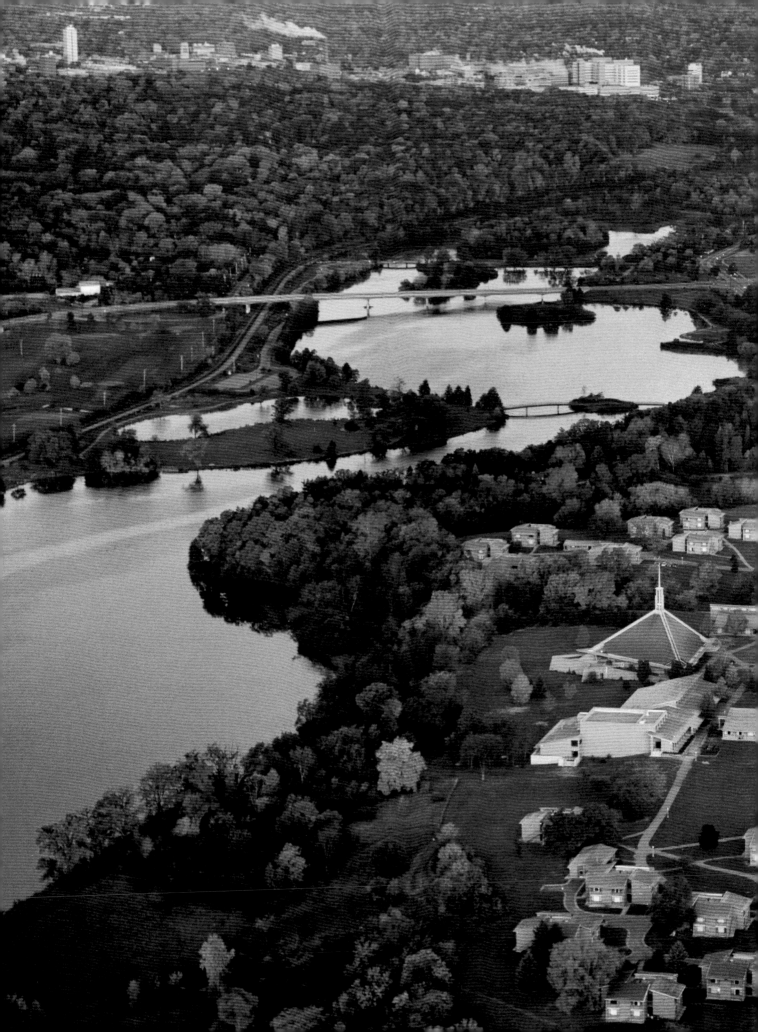

"Our highly-valued park system is a key element of Ann Arbor's quality of life. We have a collection of diverse environments that have been planned and protected through the vision, dedication and involvement of our citizens and elected officials. The park system is professionally managed and maintained by dedicated employees working closely with the citizen's Park Advisory Commission. It gives us great satisfaction to see so many people enjoying our parks."

Ron Olson
Superintendent, Ann Arbor Parks and Recreation

Huron Hills *(opposite and above)* **provides 118 acres of year-round outdoor family recreation. Its 18-hole public golf course is designed for beginners. In the winter, the rolling wooded terrain is popular for cross-country skiing and sledding. Experts say you can slide for a quarter-mile if you do it just right!**

(Overleaf) **Ann Arbor offers exceptional educational opportunities, with a strong public school system, outstanding private and parochial schools, and five institutions of higher learning within a 10-mile radius of downtown. Huron High School was opened in 1969 on 55.5 acres of park-like land near the Huron river. It serves nearly 1,700 students from Ann Arbor's Northeast, East and Southeast areas. Huron's mission is "to provide students with the environment and educational experiences that will empower them to take responsibility for their lives, their learning, and the world in which they live."**

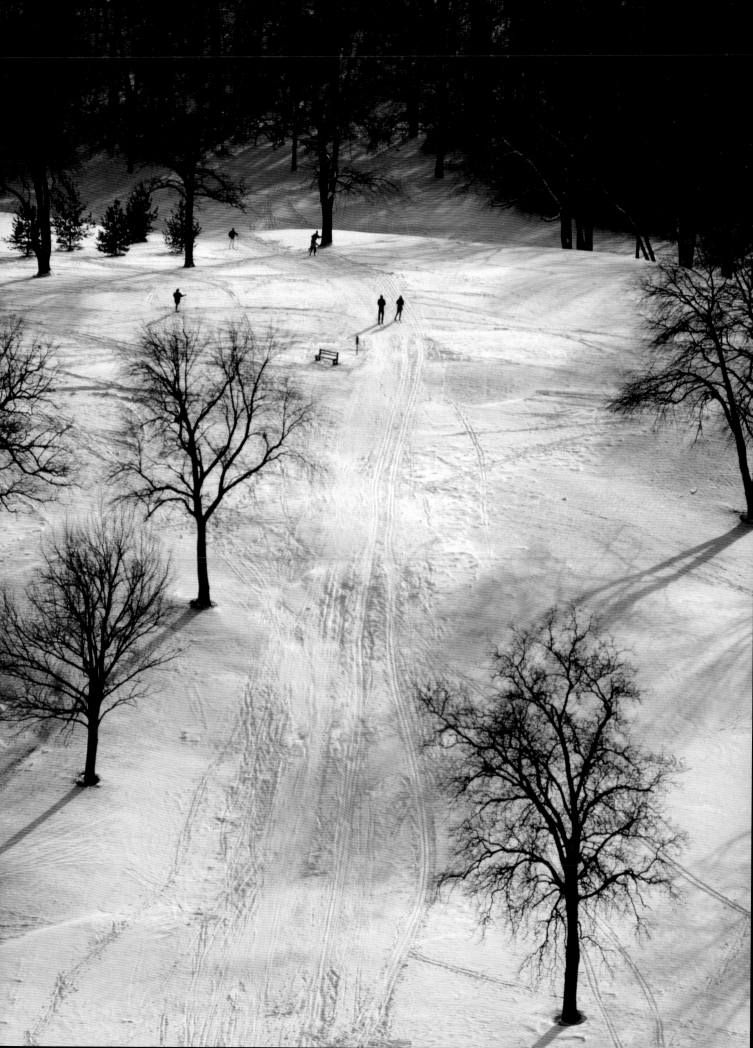

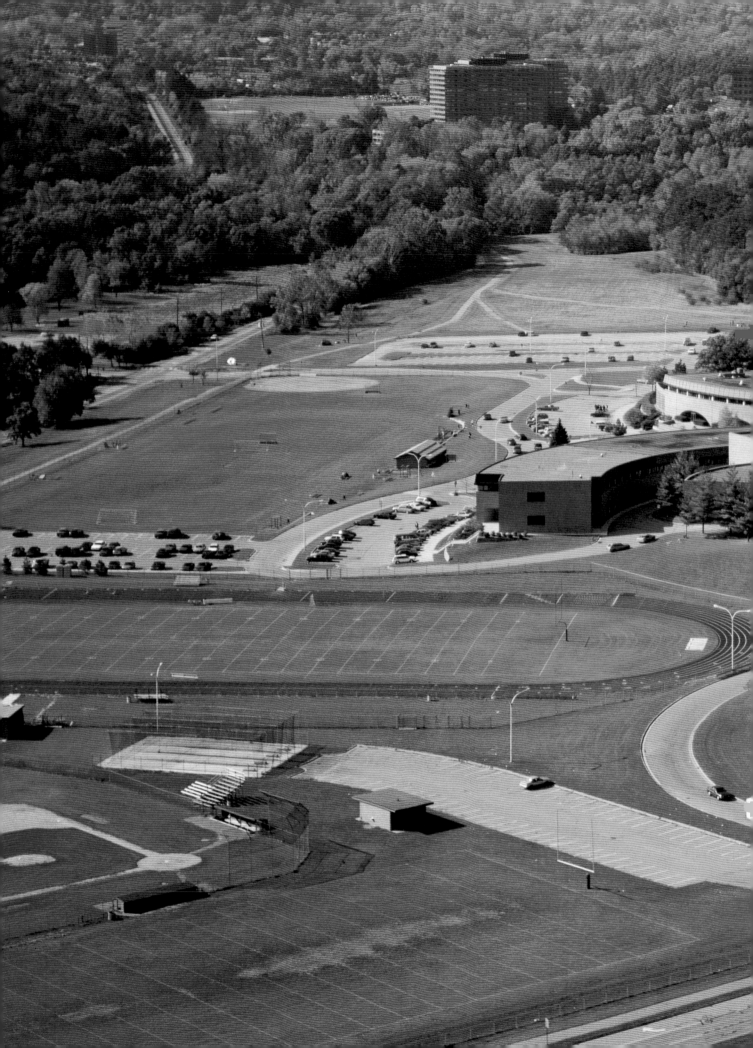

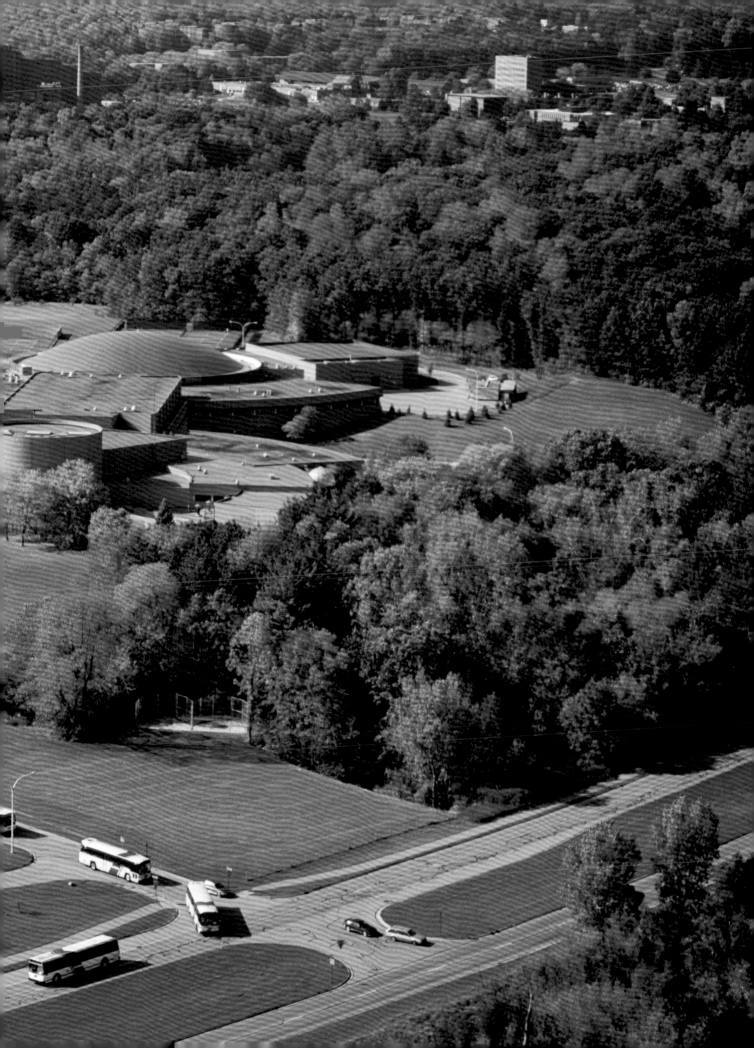

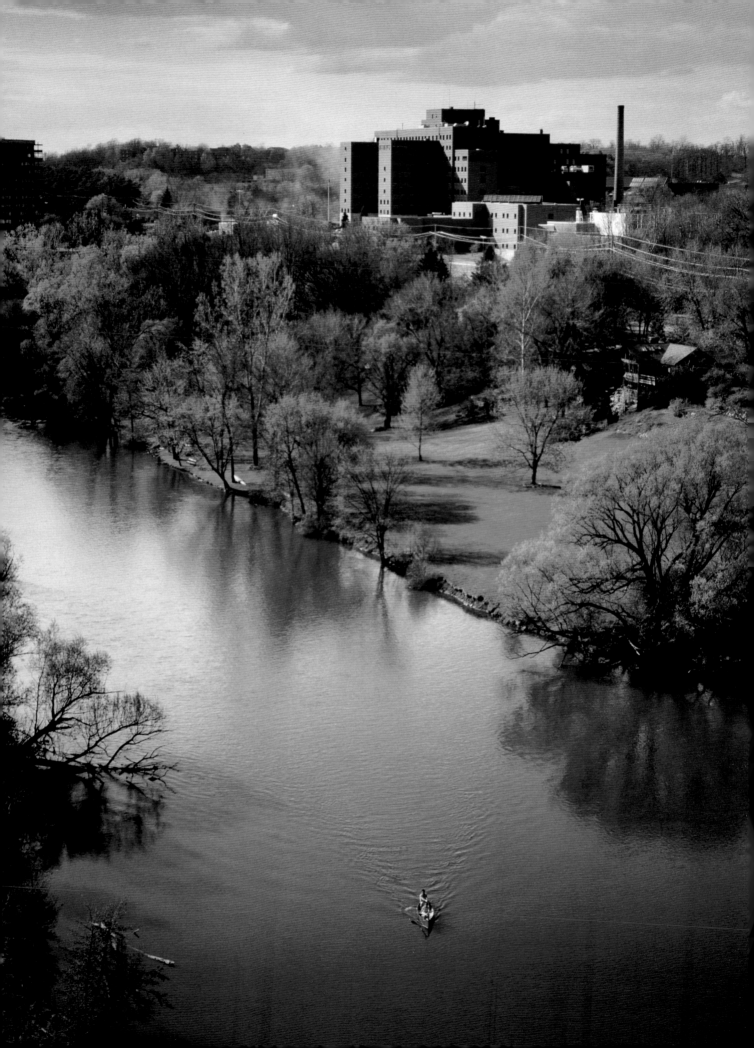

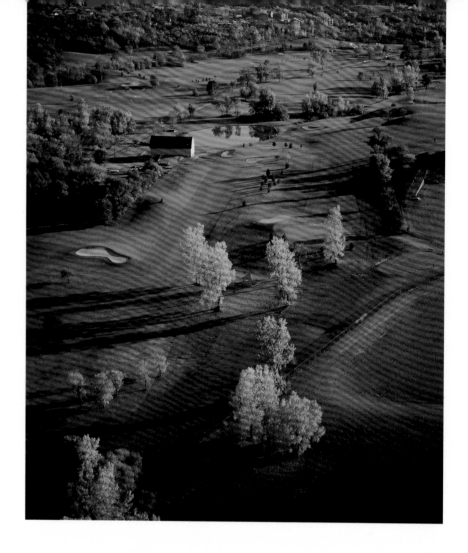

"The Huron flows from Delhi Mills to Barton Dam then to the old Municipal Beach and Argo Dam with its delightful mill race and pathways to Broadway Bridge and Riverside Park, the Island, the Fireplace, Beer Mountain, the sunken bridge, the Arboretum, the Fuller wildfowl area and finally to Geddes Pond and the beautiful bridge and Gallup Park. There is hardly a single foot of the riverbank which I do not associate with some delightful experience or beautiful view which will never be forgotten."

John R. Hathaway
Ann Arbor

Leisurely canoe trips along the Huron River may begin at one of three Ann Arbor liveries: Argo Park, Gallup Park or Delhi Metropark. Hudson Mills Metropark, Island Lake Recreation Area and Kensington Metropark offer overnight canoe campsites to those who canoe to and from the park. Among the attractions that line the Huron's banks is Nichols Arboretum *(opposite)*, a 123-acre preserve near the VA Medical Center *(also opposite)* and U-M Medical Center.

Located on Traver Road on the city's northeast side, Leslie Golf Course *(above)* is one of Ann Arbor's public 18-hole courses. It was designed by Arthur Hill and features beautiful woodland views including a long-standing pear orchard. Leslie Park, on the north side of the golf course, offers tennis and basketball courts, softball fields and a winter sledding area.

In addition to those already mentioned, Ann Arbor offers plentiful opportunities for year-round indoor and outdoor recreation, including bicycling, bowling, field hockey, fishing, horseback riding, ice skating, martial arts, racquetball, sailing, cross-country and downhill skiing, soccer, swimming and numerous fitness centers with a variety of equipment and classes to keep every family member in shape.

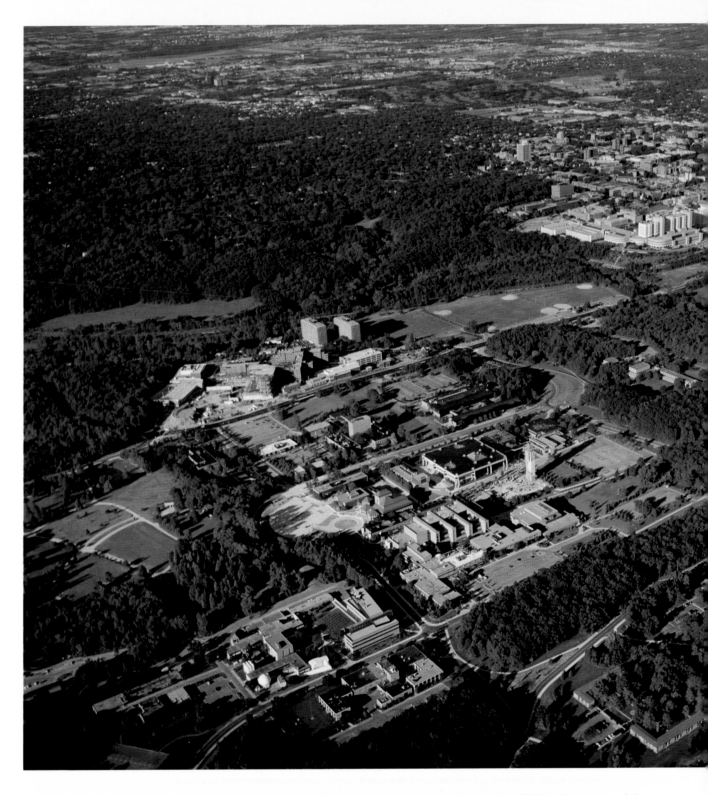

The University of Michigan traces its origins to the education act adopted on August 26, 1817 by Secretary of the Michigan Territory William Woodbridge, Judge Augustus B. Woodward and Judge John Griffin. Since its founding, Michigan has been one of the nation's top-ranked public universities and today is the leading research university in the United States. National rankings of the University's academic programs are the highest in its history, with nearly every one of its 18 academic schools and colleges considered to be among the top in its field. The University of Michigan's 2,872-acre Ann Arbor campus *(above)* contains 183 major buildings and 1,516 family housing units spread over four areas: **North Campus** *(foreground)*, **Medical Campus** and **Central Campus** *(middle)* and **Athletic Campus** *(near horizon)*.

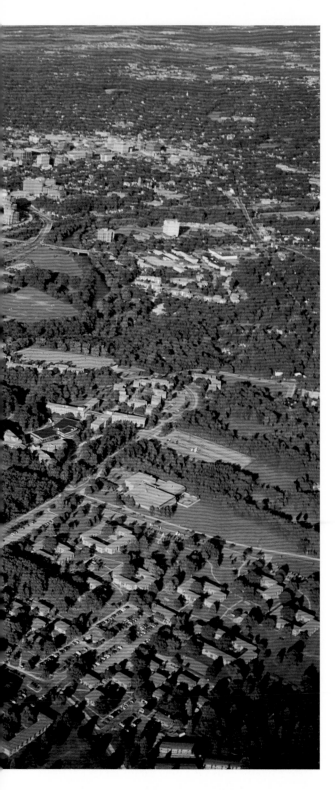

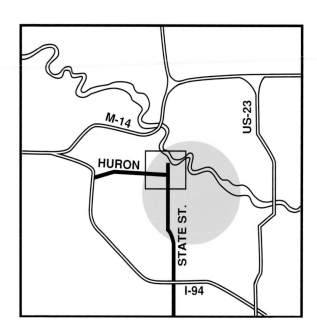

The University of Michigan

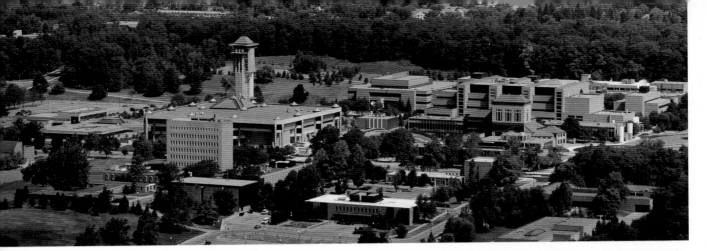

"Our ten-year-long move to North Campus is finally complete with the addition of the Media Union—a benchmark facility for the computing environment, the Robert H. Lurie Engineering Center—an outstanding facility for student services and College administration, and the 165-foot Ann and Robert H. Lurie Tower which contains the 15th largest carillon in the world. Taken together, these three major structures provide a capstone to an engineering campus of singular quality. The result is a physical plant that is the best in the world, without exception, which befits one of the nation's oldest, largest and most highly esteemed engineering schools."

Stephen W. Director, Ph.D.
Dean, University of Michigan College of Engineering

Founded in 1853-54, the U-M College of Engineering soon established itself as a leader with the nation's first engineering programs in Metallurgical (1854), Naval Architecture and Marine (1881), Electrical (1890), Chemical (1898), Aeronautical (1914), Nuclear (1953) and Computer Engineering (1965). Today, Michigan consistently ranks among the top engineering schools in the world, with most of its thirteen programs rated in the nation's top ten.

The subsonic Aerospace Wind Tunnel *(left)*, capable of generating wind speeds of 170 miles per hour, was designed and built for research in 1956 as a joint effort of the University and the Air Force. This 5' high by 7' wide continuous-operation low-turbulence wind tunnel was the University's sixth tunnel; the first was built by members of the Aero Club in 1911-12 for use in designing the first glider constructed and flown at U-M. The adjacent building houses four other tunnels, among the Aerospace Engineering Department's many uniquely designed research tunnels, some of which are capable of generating airstreams many times the speed of sound.

The Electrical Engineering and Computer Science (EECS) Building, Herbert H. Dow Building and George Granger Brown Laboratories *(opposite)* are among eighteen College of Engineering Buildings on the North Campus *(above and overleaf)* designed to include the best technology available for each of the College's eleven departments, ranking them among the best research and teaching facilities in the world. The dramatic 165-foot Ann and Robert H. Lurie Tower stands on a new quadrangle, adding an imposing architectural landmark to North Campus. The carillon tower and nearby copper-roofed Robert H. Lurie Engineering Center, the College's new "front door," were made possible by a $12 million gift from the Ann and Robert Lurie Family Foundation in honor of Robert Lurie, a 1960s Engineering graduate.

The magnificent 225,000 square-foot Media Union designed by Albert Kahn Associates *(above, adjacent to Lurie Tower)* represents a new concept for universities—the electronic library of the future housing the collections of the colleges of Engineering and Architecture and School of Art. With one of the most advanced and sophisticated networking environments anywhere, it offers unlimited access to other libraries through the Internet, and also includes the latest interactive technologies to further explore the physical and simulated world.

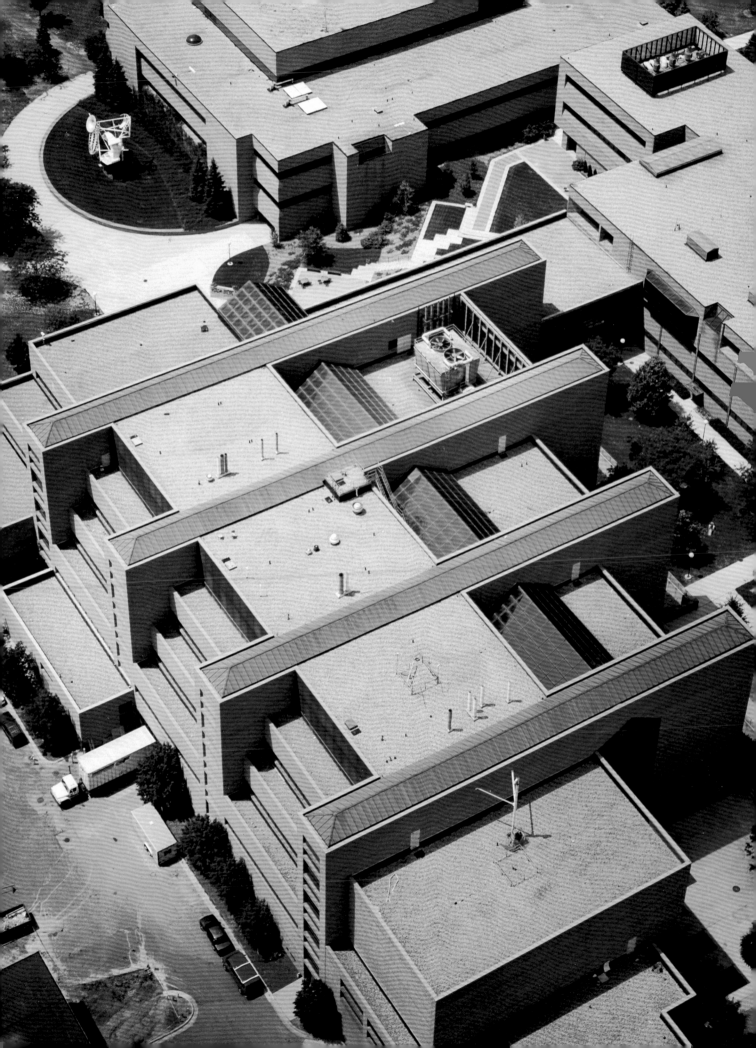

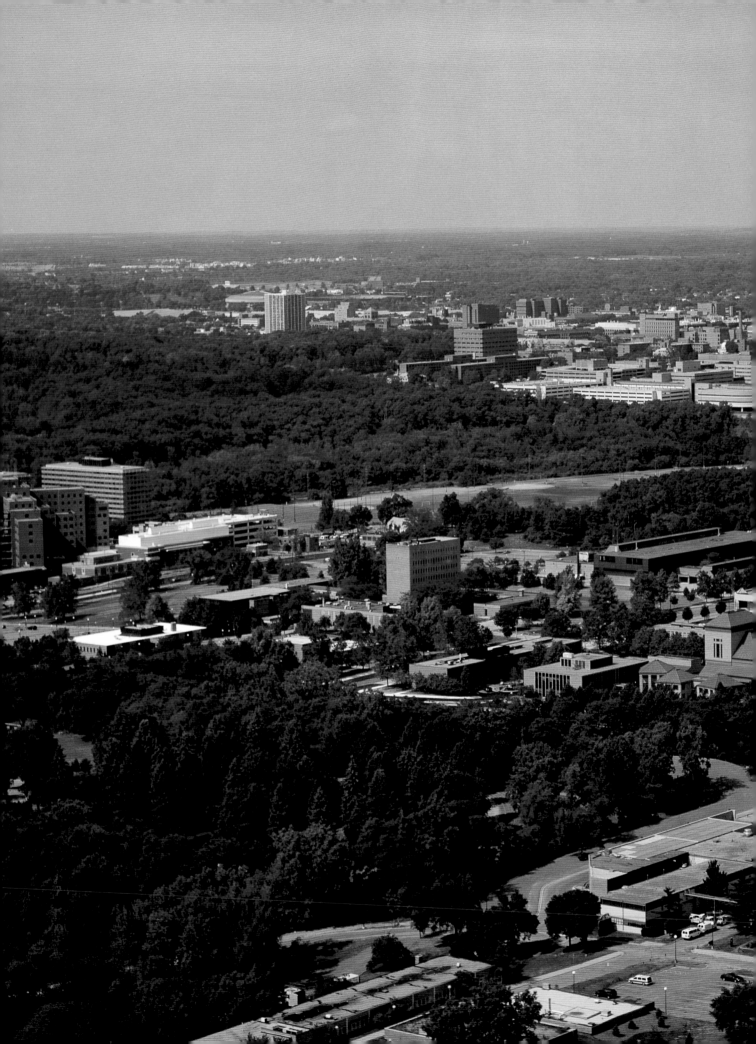

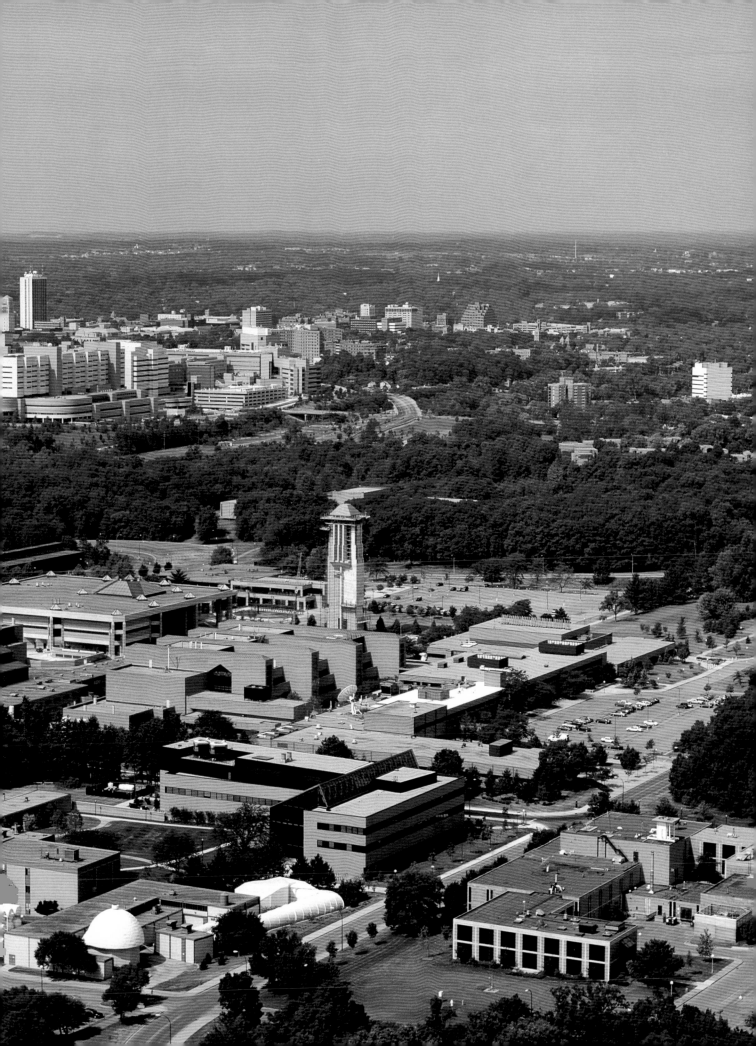

"Ann Arbor—a town with great community spirit, a wide range of diverse cultures, a love of sports, art, dance and music, a center for education, medicine and research—this town truly has it all!"

Kate Durham
VA Medical Center

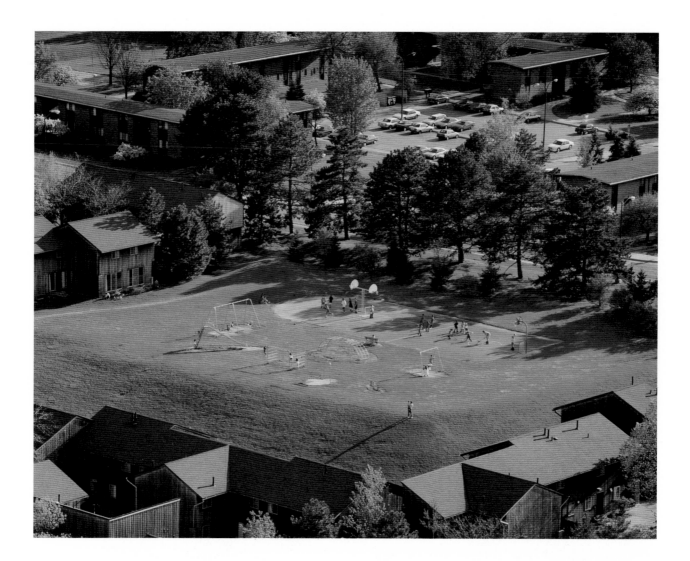

The five-part Northwood complex on North Campus *(above)* forms the major portion of the 1,516 University-owned and operated apartments and townhouses in the Family Housing system, which provides reasonably-priced quality housing for predominantly graduate and professional degree program students and their families, as well as for visiting scholars, new faculty and other staff members. The international community provides rich opportunities for residents to share, exchange and learn about one another's culture and national and ethnic traditions. Northwood also has playgound equipment and outdoor recreational facilities plus one of the most comprehensive children's programs of any family housing system in the U.S.

The Department of Veterans Affairs (VA) Medical Center in Ann Arbor *(opposite)* lies between the University's North Campus and Medical Campus. The VAMC is affiliated with the U-M Schools of Medicine, Dentistry and Nursing, and all its physicians hold joint teaching appointments at the University. With 178 operating beds and 60 nursing home care unit beds, the VA Medical Center provides primary, secondary and tertiary care to more than 26,000 veterans in lower Michigan and northwestern Ohio.

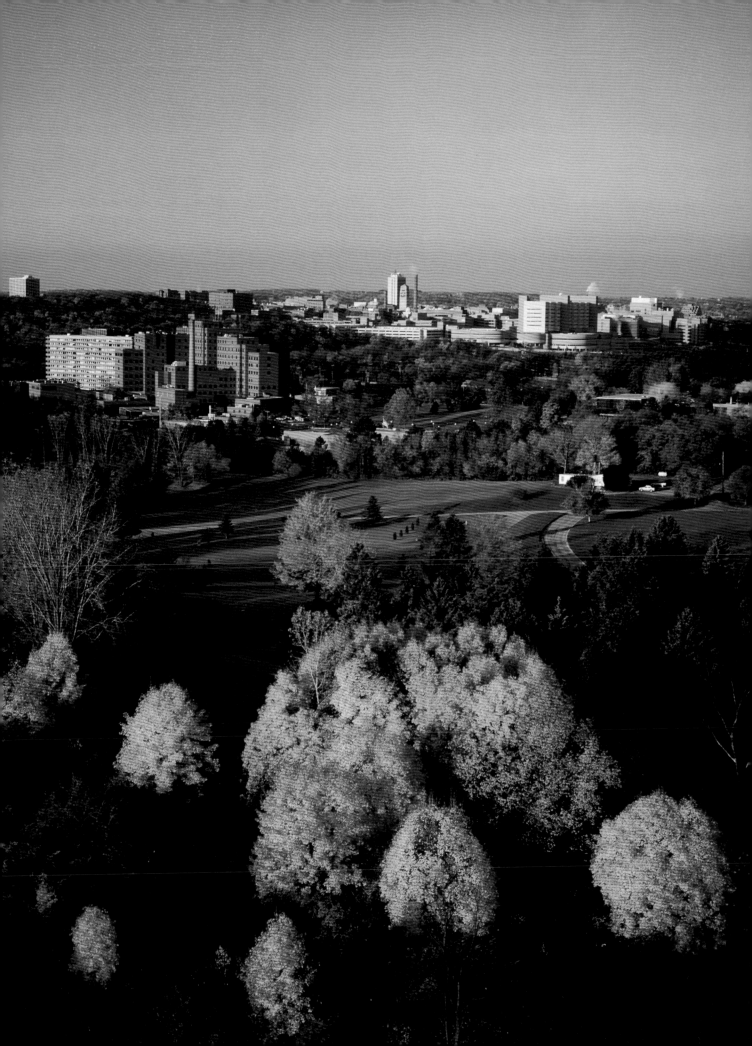

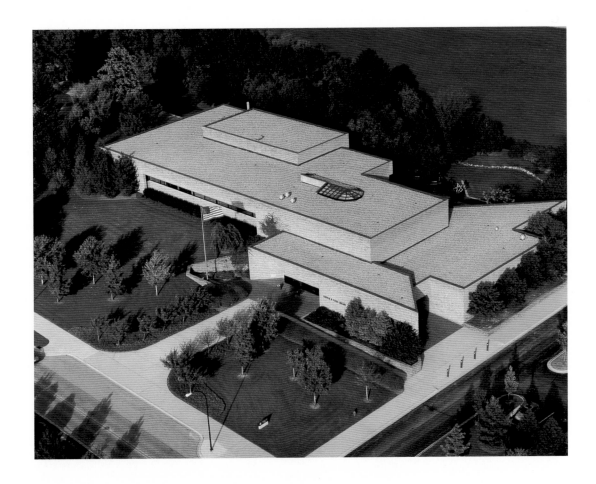

"Ann Arbor and the University of Michigan have been a great combination to help create an environment that is diverse, challenging and rewarding to live in. Our city is a true reflection of the gateway of our world. Our family has always been proud to call Ann Arbor home."

Mark Ouimet
President, Chairman and CEO, University Bank

Resident faculty of the U-M School of Music *(opposite)* include internationally active concert soloists, prize-winning composers, renowned scholars and performers with major symphony orchestras, operas, dance and theater companies. Consistently ranked near the top of every national poll of music schools and conservatories, the School counts among its noted alumni opera diva Jessye Norman, Chip Davis a.k.a. Louis Jr. of Mannheim Steamroller, Sesame Street's Bob McGrath and singer Bobby McFerrin ("Don't Worry, Be Happy"). Faculty and students present hundreds of recitals and performances annually in the School's auditorium located in the handsome building designed by Eero Saarinen.

In 1976 the National Archives gave the papers of Gerald R. Ford ('35), 38th President of the United States, to the University. Funded by private donations, the presidential library *(above)* was completed in 1979 and is located on the North Campus next to another special research library, the Bentley Historical Library, which contains the Michigan Historical Collections.

ANN ARBOR

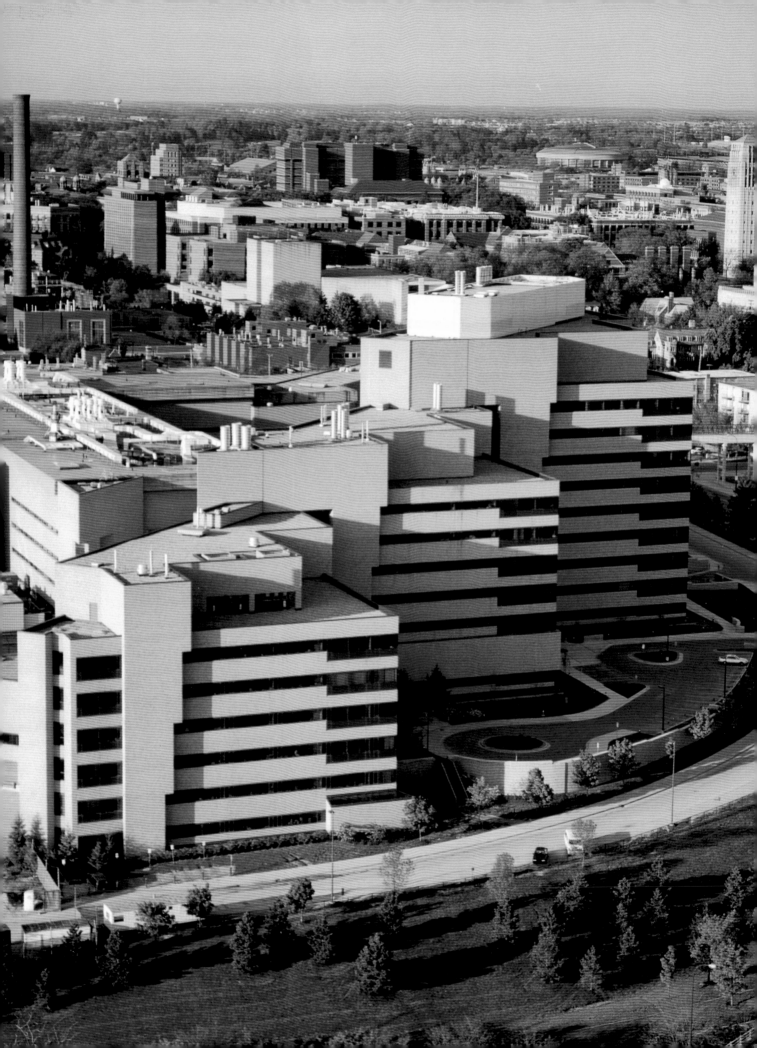

"'Care and Discovery' symbolizes for the School of Nursing the critical partnership between the clinical relevance of scientifically rigorous research and the continual improvement of the quality of health care. As a result, we appear in the top five of every recognized rating. About half of our graduates remain in the State of Michigan and the other half relocate across the country and around the world."

Ada Sue Hinshaw, Ph.D., R.N.
Dean and Professor, University of Michigan School of Nursing

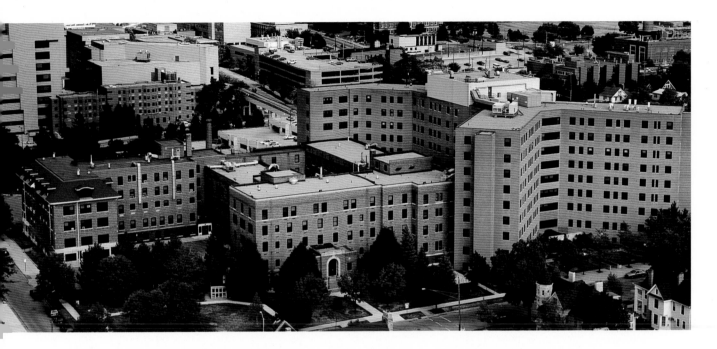

"As the University of Michigan Medical School approaches its 150th year, it continues a strong tradition and commitment to its three missions: education of future physicians and biomedical scholars, biomedical research and patient care. I have been a member of the Medical School community for more than forty years and have been privileged to watch and participate in its growth into the complex and diverse entity it is today. The School is committed to serving the needs of this community and of society as we move into the 21st century."

Giles G. Bole, M.D.
Dean Emeritus, University of Michigan Medical School

The University of Michigan Medical Center, comprising the Medical School (*opposite*) and Hospitals, ranks as the nation's largest. With more than 1.8 million square feet of research and education space, U-M is the country's largest Clinical Research Center and fourth in NIH funding of public institutions. Established in 1848, the Medical School has long excelled in teaching and research, graduating more than 18,000 physicians. U-M has been known historically for its pioneering efforts in taking research from the "bench to the bedside" and currently ranks ninth in the nation among research-oriented medical schools.

The U-M School of Nursing (*above*) opened in 1891 with six students. Today, with more than 9,000 alumni, the School ranks among the top five in the country, and its doctoral program is widely recognized as one of the best in the world. Ninety percent of the School's tenured faculty hold earned doctorates, and their research on various clinical nursing issues has received international recognition.

ANN ARBOR

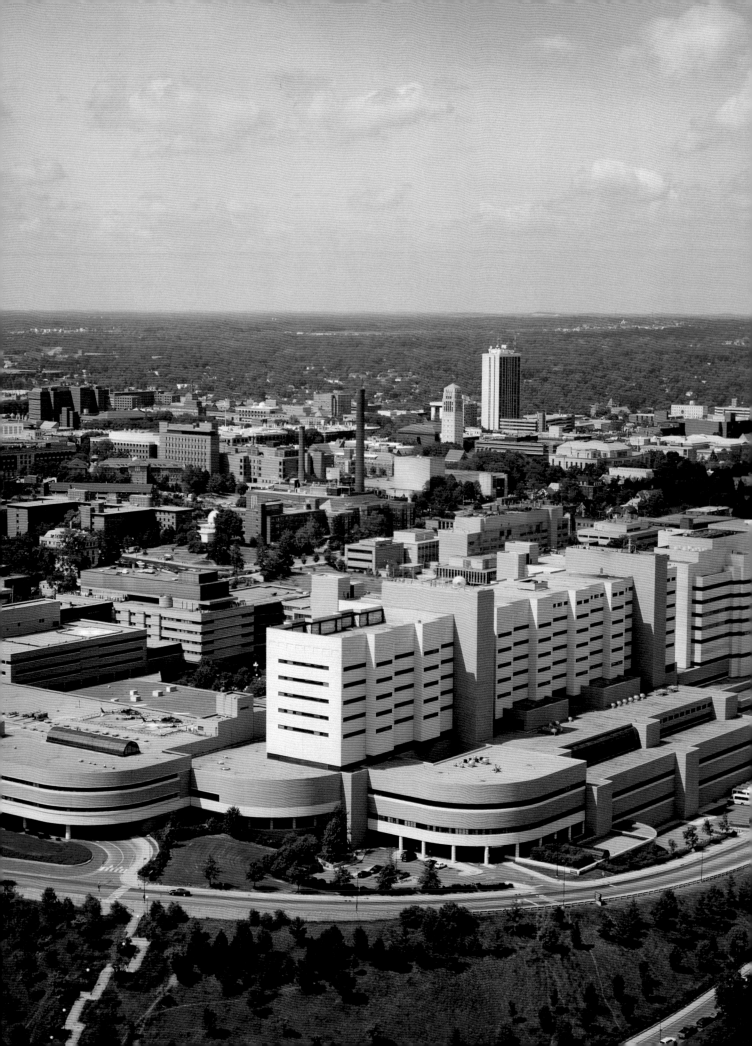

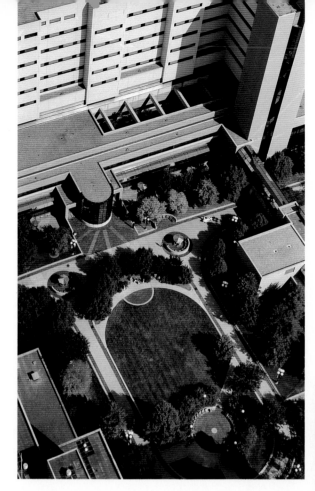

"The University of Michigan Medical Center's health care professionals and medical facilities rank among the finest in the world. Having this world-class teaching, research and patient care in our backyard is an immense enhancement to the quality of life of the residents in our community as well as people throughout the state of Michigan...it adds value to both the physical and economic health of our residents."

John D. Forsyth
Former President & CEO,
University of Michigan Health System

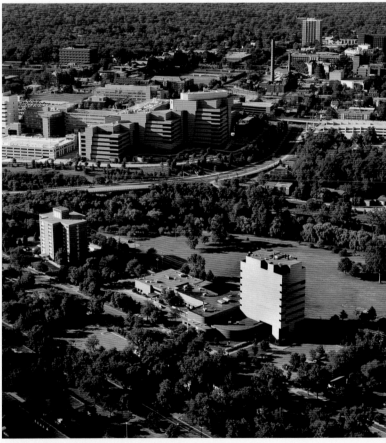

In 1869, Michigan's visionary leaders converted one of the original professor's houses into a teaching hospital, making it the nation's first university-owned hospital. Since then it has evolved into a world-class Medical Center located on 82 acres *(first overleaf)*, encompassing the Medical School plus seven hospitals with more than 800 beds. Consistently ranked among the top hospitals in America, the current University Hospital *(opposite and above)* opened in 1986 with 21st century design, one of only three hospitals in the world utilizing robotics in its daily operations. The adjacent Cancer Center and Geriatrics Center, scheduled to open in early 1997, is part of a decades-long building campaign that has made U-M Medical Center one of the most advanced health care facilities in the nation.

From its creation in 1872 to the present, the U-M Department of Ophthalmology has led the way in training outstanding physicians and performing cutting-edge research. In addition to caring for more than 50,000 patients each year, the W.K. Kellogg Eye Center's *(right)* renowned physicians and research scientists are finding the causes and best treatments for eye diseases and vision disorders. The building adjacent to the Eye Center *(right)*, a gift from Scott and Amy Pruden Turner, houses community services for older adults.

U-M Medical Center began Survival Flight *(second overleaf)*, the state's first air medical transport service, in May 1983. To date, their Bell 230 helicopters have carried more than 14,000 patients without accident. Part of a critical care transport system that also includes fixed-wing aircraft and ground vehicles, Survival Flight's average 1,200 patients annually are approximately one-third children, one-third trauma/accident victims and the balance are a variety of medical/surgical patients taken to U-M Medical Center and other hospitals.

ANN ARBOR

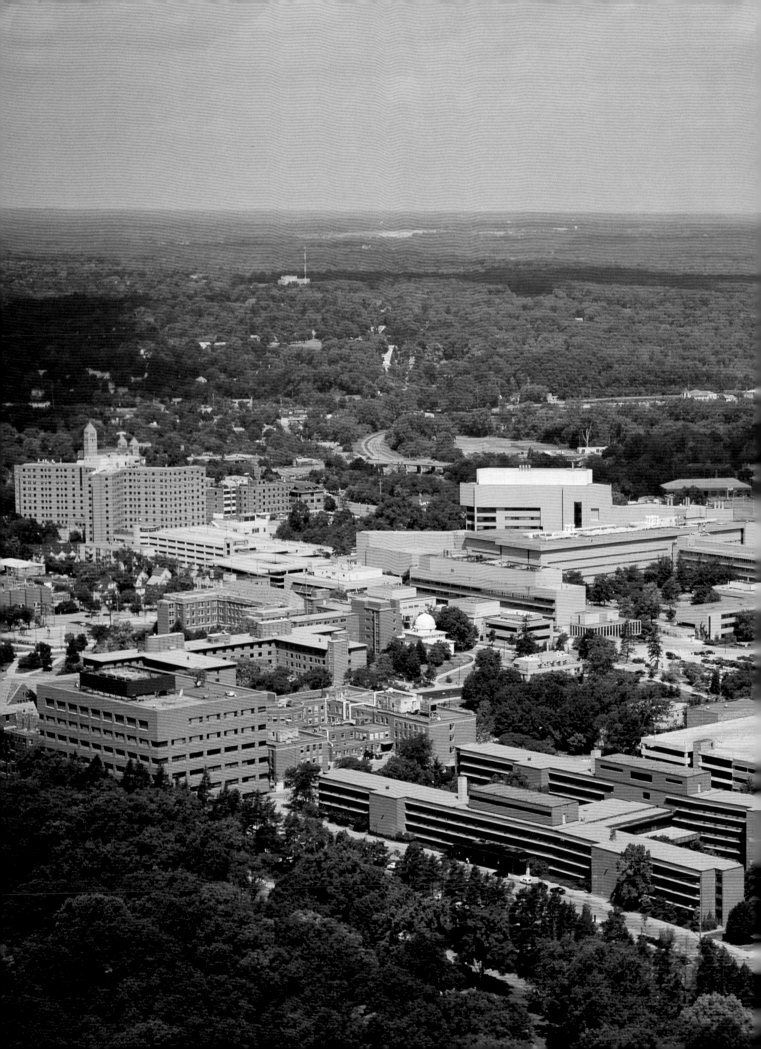

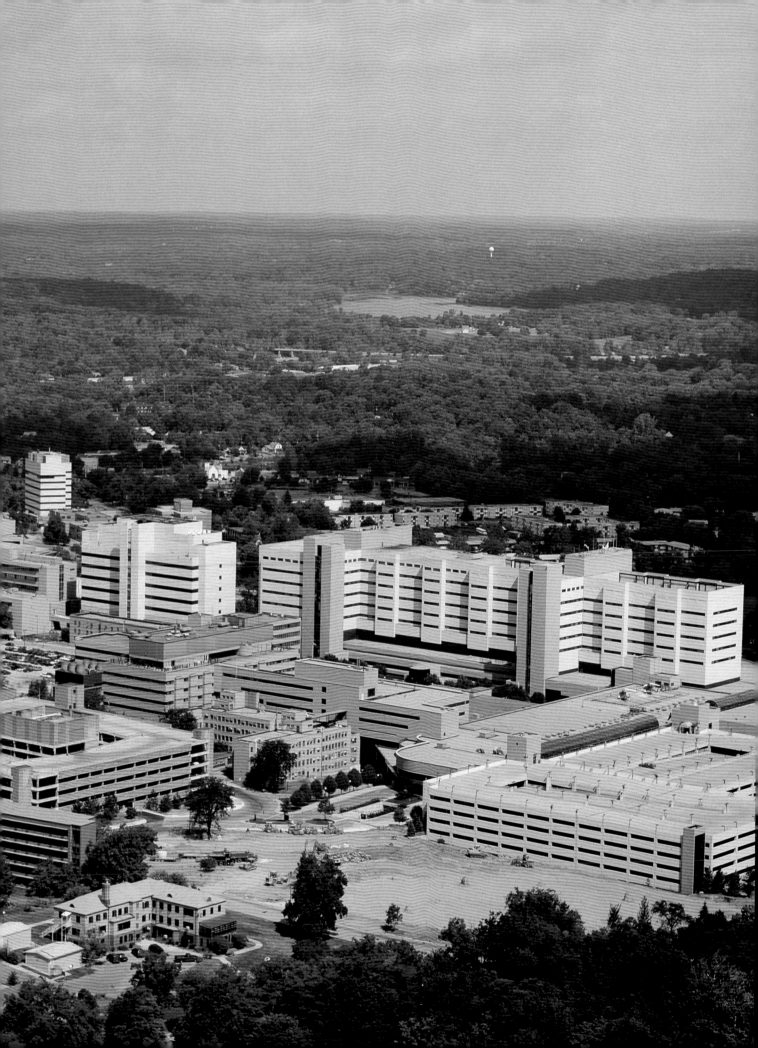

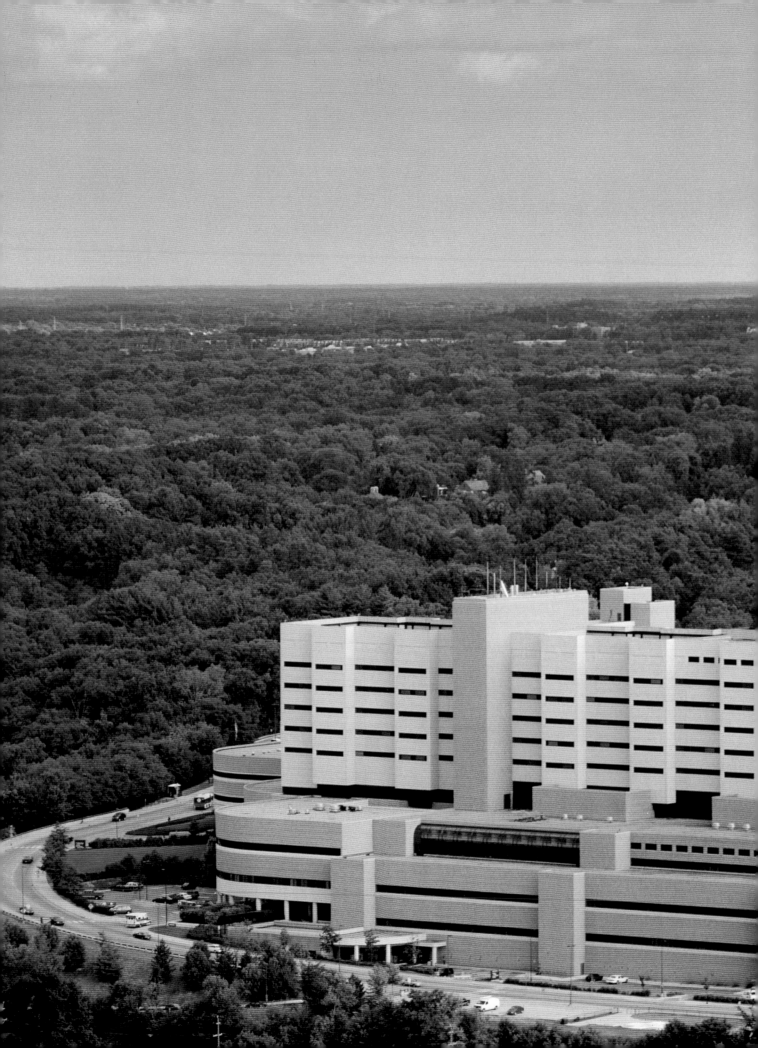

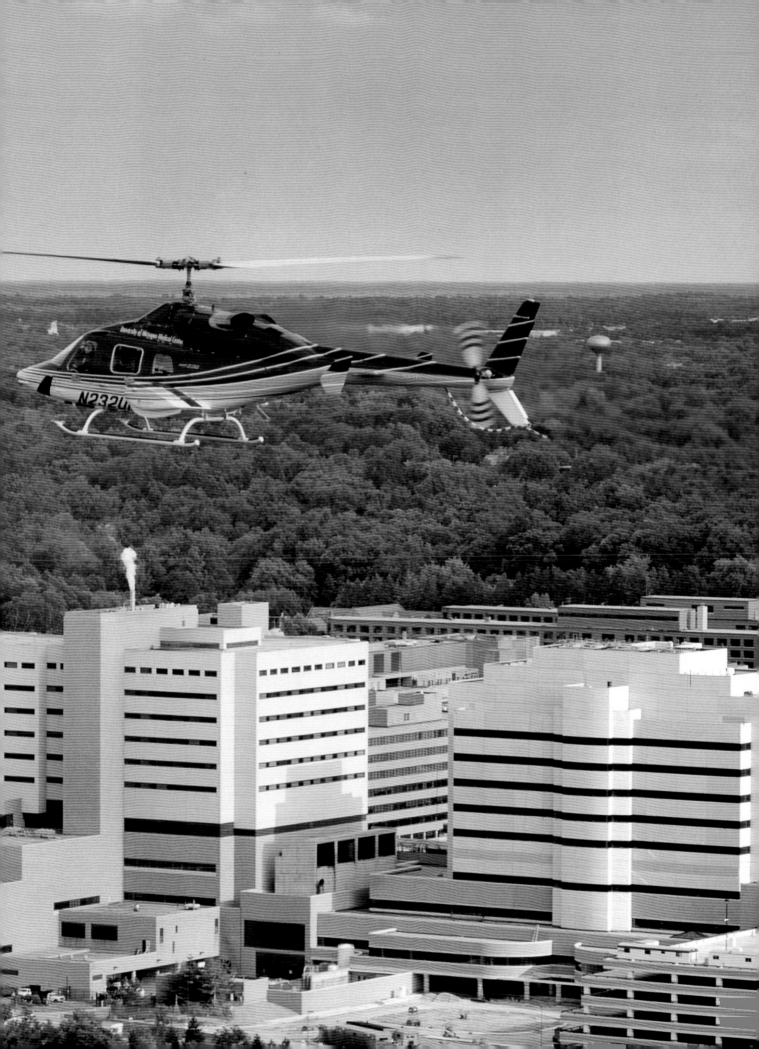

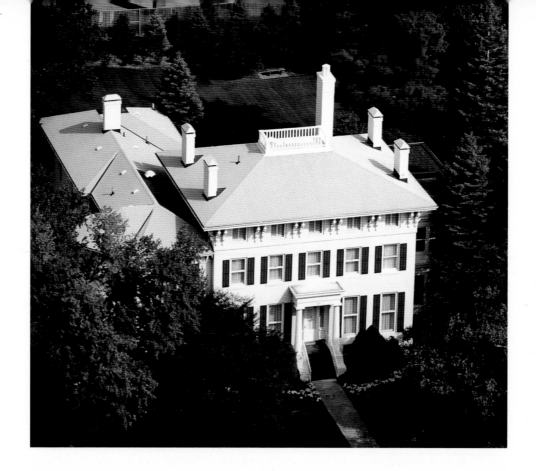

"When I first came to Ann Arbor in the early 1960s as a graduate student in physics, I soon discovered sparks of energy and excitement emanating from the University of Michigan campus and Ann Arbor. The city and campus provided then, as they do now, a welcoming but stimulating cultural and natural environment for an eclectic group of scholars who converge here to learn and to push the frontiers of knowledge.

It was a wonderful homecoming in 1987 when, after teaching and doing research for some twenty years in Indiana and in New York, my wife, Jeannie, and I returned to Ann Arbor. The community and campus had grown markedly during our absence, but we soon rediscovered the energy, excitement and natural beauty of the City of Trees, from the Tappan oak and century-old elms that shade the Diag to the hundreds of gardens scattered like so many wildflowers thoughout Ann Arbor."

Homer A. Neal, Ph.D.
Interim President, The University of Michigan

The stately white house on South University *(above)*, one of the four original professors' houses completed in 1840, is the oldest building on campus and serves as home to the University president. The original structure has been enlarged and altered over the years; for example, President Angell stipulated that a water closet be installed when he took office in 1871, and the house was remodeled with a sleeping porch and porte cochere added in 1919 for President Burton.

A month before he died, Albert Kahn was asked which one of all his famed buildings he would like most to be remembered for having designed. "The William L. Clements Library," *(opposite)* he replied. Opened in 1923, this architectural treasure was a gift of Regent William L. Clements built to hold his Americana library, which he also gave to the University. During the years since then, the library's many acquisitions of materials relating to America's history have earned it a national and international reputation.

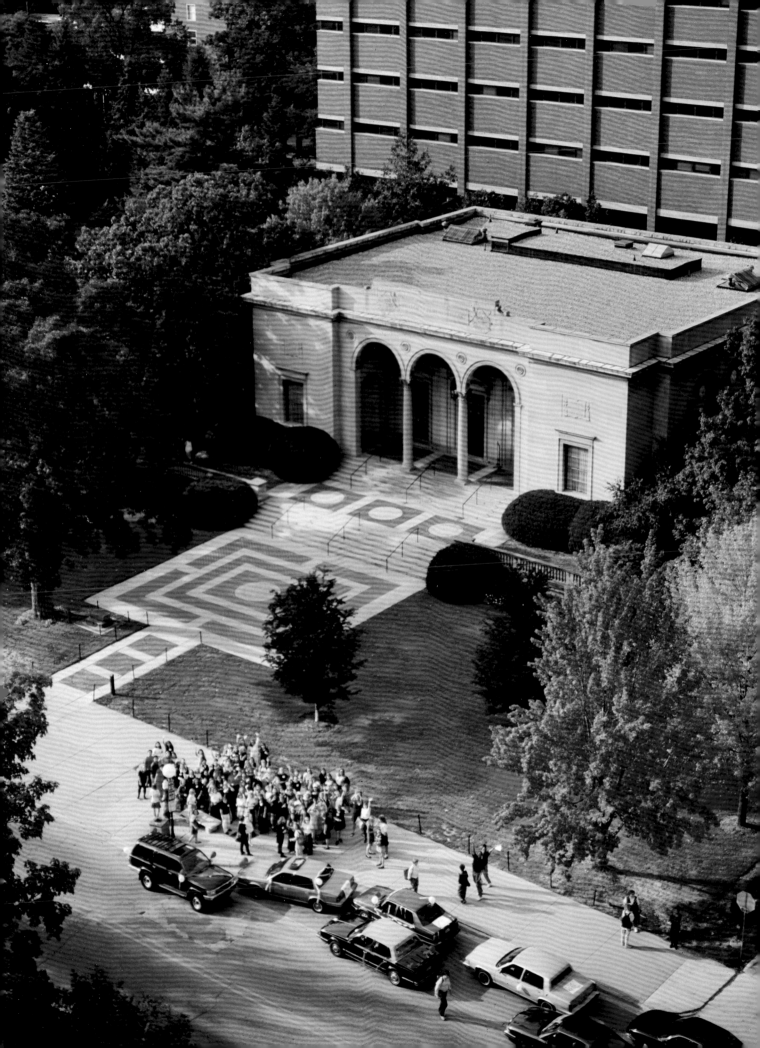

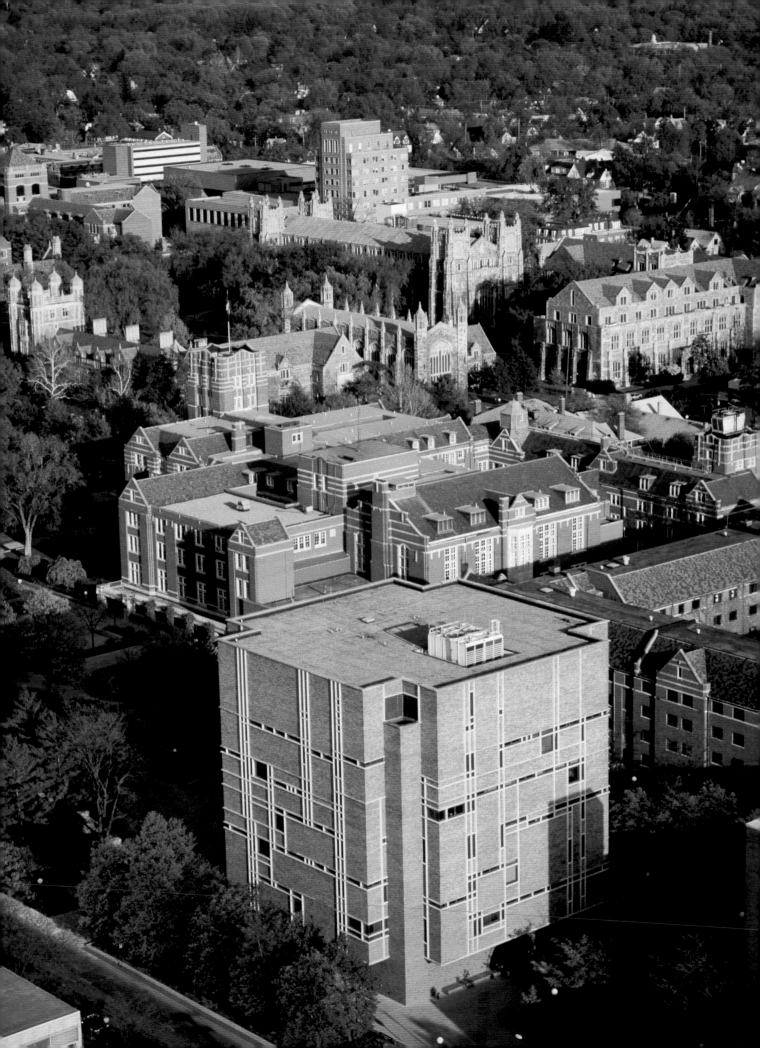

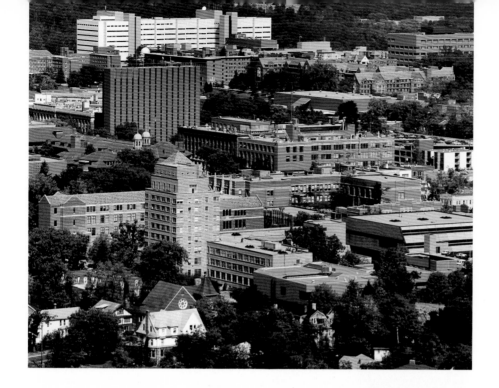

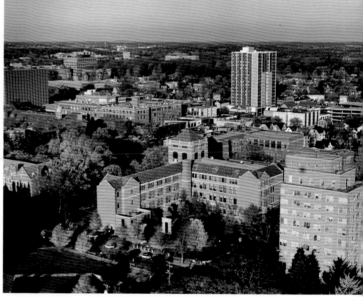

"Ann Arbor and the University of Michigan offer the most vibrant environment imaginable. If you can't have a good day here, you're just not trying very hard!

What I love are the people: those from around the world who are bright and motivated, people with ideas and expertise in every area of human endeavor, intellectuals, artists, athletes, professionals and business people. The University and the city provide a wonderful environment to support, develop and showcase the abilities of all these amazing people."

B. Joseph White
Dean, University of Michigan Business School

Opened in 1968, the Fleming Administration Building *(opposite)* is named for former President Robben Fleming, whose negotiating skills and belief that the President should preserve peaceful dissent and intellectual freedom kept the educational process at the University of Michigan operating with only minor interruptions during the turbulent '60s and '70s.

The U-M Business School *(above, top)* was founded in 1923 with a faculty of 15 and a student enrollment of 26. Today, the School is considered one of the world's top business schools, offering top-tier BBA, MBA, Master's of Accounting and PhD programs, as well as an Executive Education program that has been declared the best in the world by *Business Week* magazine.

Lorch Hall *(above, bottom)* is home to the U-M Department of Economics and School of Public Policy. Boldly introduced by Judge Woodward in 1817 as one of the original thirteen professorships, the Economics Department today is nationally and internationally known for its quarterly and annual forecasts for the U.S. economy, widely used by business, academic and government economists. The Department also maintains the national headquarters of the Committee on Japanese Economic Studies, which receives extensive funding from foundations and corporations in both Japan and the United States.

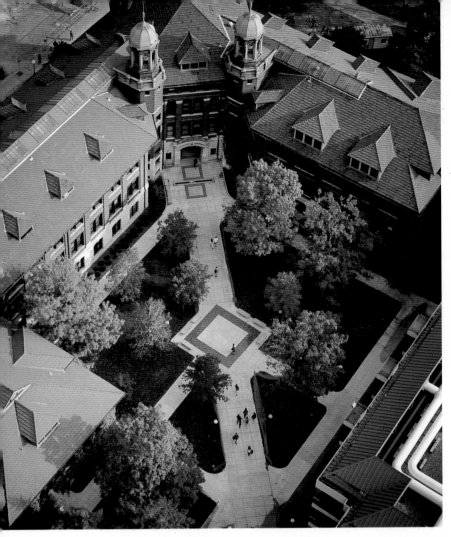

"It was in 1903 that a young architect, Albert Kahn, was called upon to design his first collegiate structure—the West Engineering Building at the University of Michigan. He continued on to design twenty-five other major buildings for the U of M during his lifetime. We at Albert Kahn Associates are honored to carry on our founder's work for the University today."

Gordon V. R. Holness
President and CEO,
Albert Kahn Associates, Inc.

The Diag *(opposite and above)* has been the heart of the U-M central campus for more than 135 years, but a recent building campaign has changed its look dramatically. The new addition to the Randall Physics Lab at its eastern end is larger than the original structure. The handsome Shapiro Library, newly expanded and renovated by Albert Kahn Associates, has a new architectural image that will make its previous unflattering acronym "UGLI" (Undergraduate Library) quickly fade into the past. Now connected by a second-floor bridge to Shapiro Library is the older Harlan Hatcher Graduate Library, whose 1970 eight-story South wing addition was the first high rise on the Diag.

The West Engineering Building archway over the southeast end of the Diag *(above and right)* is a familiar campus landmark. When built in 1903, the West Engineering Building contained the only naval testing tank outside the Washington Naval Yard. The building is now home to Women's Studies, the Center for AfroAmerican and African Studies and the School of Information and Library Studies.

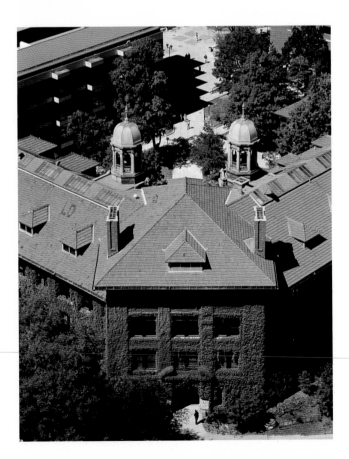

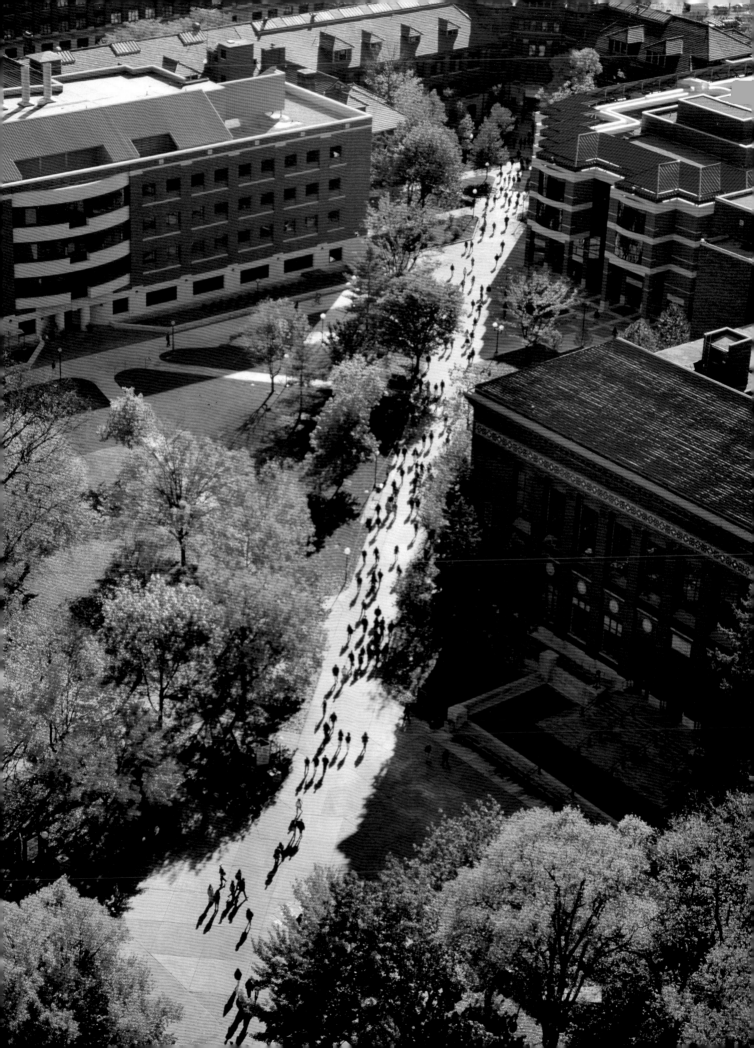

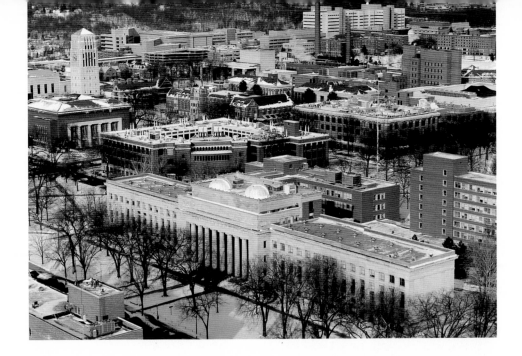

"Knowledge breeds confidence, which breeds enthusiasm, which breeds competitiveness, which breeds success. As co-founder of the African American Endowment Fund and sponsor of a scholarship fund for academically ambitious students, I firmly believe in full service support of important community initiatives that benefit all of the people who live here."

Jim Bradley
President, Jim Bradley Pontiac, Cadillac, GMC Truck, Inc.

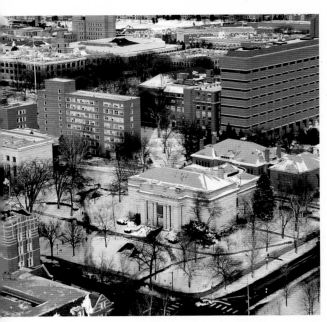

When the Michigan Union *(opposite)* was first conceived in 1903 as a special center to bring male students together for a variety of activities in a completely democratic setting, no other campus in the country had such a building. After a lengthy fundraising campaign and building delays due to World War I, the Union finally opened in 1920. Beginning in 1936, a succession of seven dormitories for men were added, forming the West Quadrangle. A new wing housing an International Center for the University's growing foreign student population was built in 1938. Perhaps the Union's most historical moment occurred in October 1960 when Presidential-candidate John F. Kennedy announced his concept for a Peace Corps in a speech on its steps.

Reportedly inspired by the Lincoln Memorial in Washington, Albert Kahn designed the Literary College building *(above)* in 1922 as one of the classic centerpieces to the University campus. The stately building was later named Angell Hall in honor of President James B. Angell (1871-1909). Following complete destruction of the old Haven Hall by arsonist fire in 1950, two new large buildings named Mason and Haven Halls were constructed at the back of Angell Hall. Today the Angell-Haven computing site is one of the largest installations of its kind in the country, and a current building campaign has brought needed renovations to Angell Hall and added a connector between Angell and Haven halls.

The University's Museum of Art *(above, left)* serves simultaneously as a scholarly and teaching resource and as a vibrant and involved community cultural center. The U-M began collecting art in 1855 and established the Museum in 1946. Today the Museum houses a permanent collection of close to 14,000 objects with representative holdings from both the Western and Asian traditions, second only to the Detroit Institute of Arts in importance among art collections in Michigan. Special exhibitions from its permanent collection, major loan shows and educational programs for adults and children are also offered by the Art Museum.

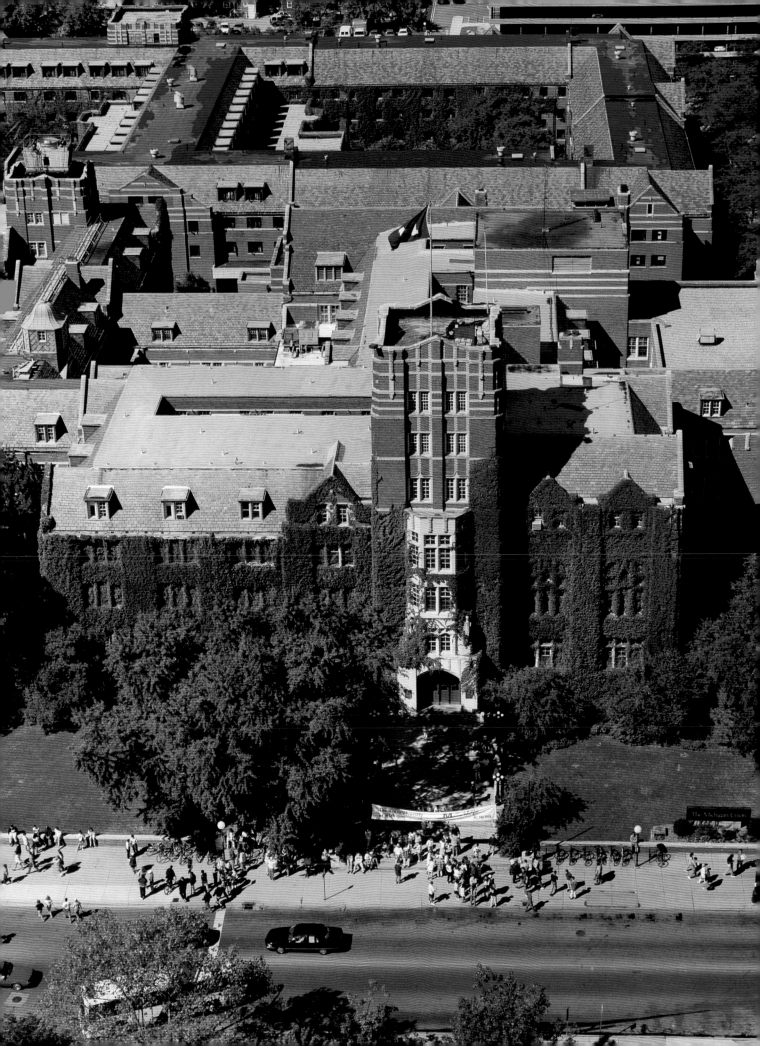

Founded in 1859, one of the nation's oldest and finest Law Schools is housed in a 10-acre Quadrangle *(opposite and right)* of magnificent Gothic-style buildings begun in 1923 with a bequest from William W. Cook (Class of 1882). From its inception, U-M Law School has drawn students (more than 1,000 in 1996) from throughout the United States and the world, many of whom have later become community, national and international leaders. Several of the nation's leading legal treatises are the work of Michigan faculty.

The Law Library's world-renowned collection of more than 750,000 volumes and the School's preeminent reputation as a center for the study of international and comparative law draw large numbers of distinguished foreign visitors, judges and professors from other law schools for research; their presence further enriches the students' education. Opened in 1981, the award-winning Allan and Alene Smith addition to the Law Library *(below)* was masterfully constructed below ground to provide daylit study carrels, reader stations and special facilities for both computers and microforms.

"We aim to strengthen Michigan's tradition as an exemplar of excellence in legal education and to draw closer together all those people who participate in that tradition."

Jeffrey S. Lehman
Dean, University of Michigan Law School

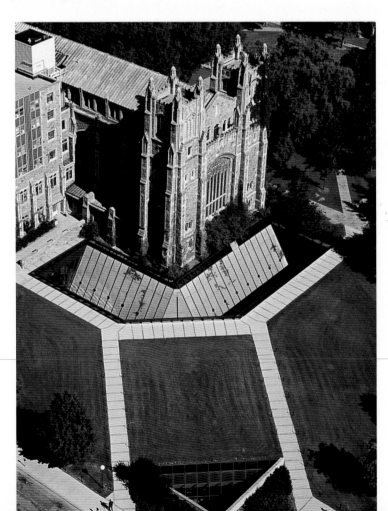

Ann Arbor

80

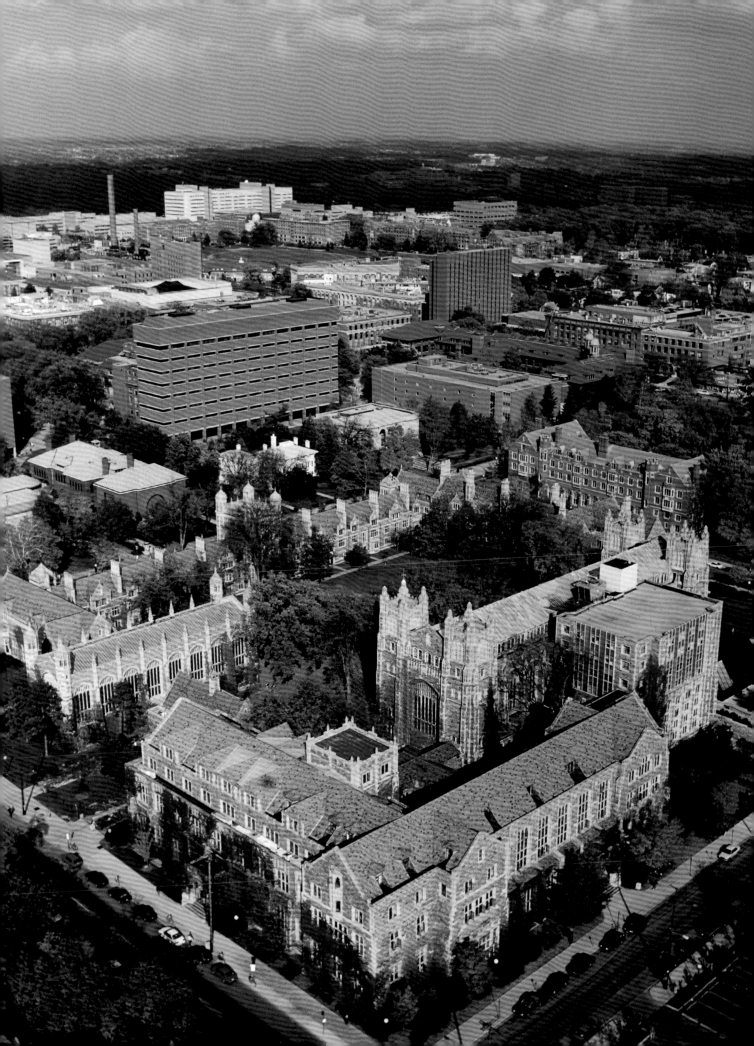

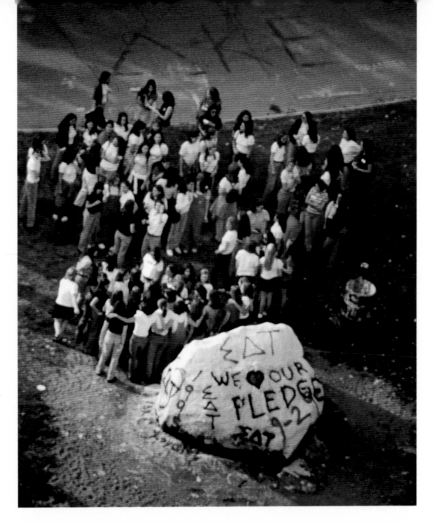

"The rebuilding of the Beta house was not simply physical reconstruction, it was revitalization of the spirit of brotherhood and camaraderie! Young and old worked together to accomplish what pessimists believed was impossible. The most important lesson I learned while at the University of Michigan, Ann Arbor was taught to me by Bill Johnson: One is only limited by his/her fear of failure. He did not tell me this, *he showed me*."

Paul Taylor
Chicago, IL (1987 President of Lambda Chapter, Beta Theta Pi Fraternity)

The Lambda Chapter of the Beta Theta Pi national fraternity has been a part of the University of Michigan landscape since 1845. Since that time, the State Street house *(opposite)* has required maintenance and renovation work, but never to the magnitude of its 1987 reconstruction. Demolition and renovation of the house began in May 1987 and was completed by mid-fall of that year. This project was spearheaded by the dynamic and persistent Bill Johnson ('57) along with the support of several hundred cash pledges from Beta alumni, most notably Stan Kresge ('22).

Pledges from Sigma Delta Tau sorority gather around "The Rock" *(above)* on Hill Street at Washtenaw, the site of secret nighttime painting expeditions by generations of U-M students. Sororities have been a fixture on the Ann Arbor campus since 1879 when Kappa Alpha Theta began a chapter here.

The Michigan League *(overleaf)*, the women's equivalent of the Union, opened in May 1929 following a fundraising campaign by women students and alumnae that lasted almost a decade. The League includes an elegant theater made possible by a gift from Gordon Mendelssohn in memory of his mother Lydia. Nationally and internationally acclaimed performers have appeared on the stages of Lydia Mendelssohn Theatre and the nearby Power Center for the Performing Arts *(overleaf)*. Opened in 1971, the 55,000 square-foot Power Center was a gift to the University from Eugene Power, founder of University Microfilms. These two exceptional facilities are among the many venues that provide Ann Arbor with a breadth of cultural activities normally found only in the country's largest cities.

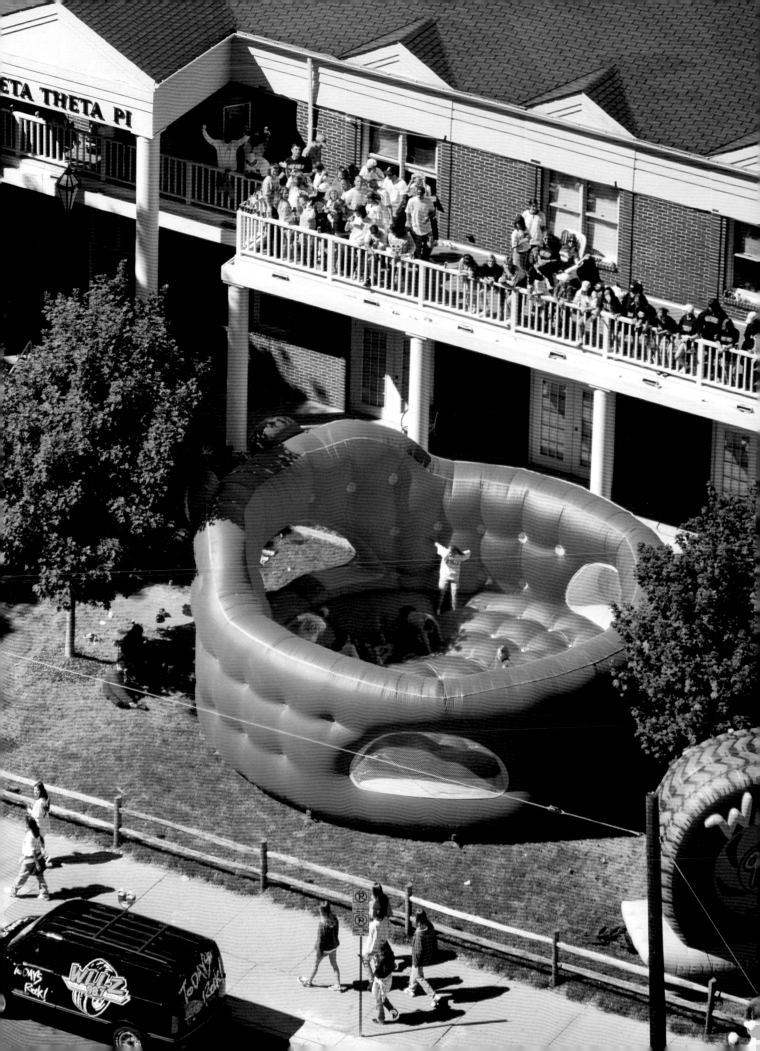

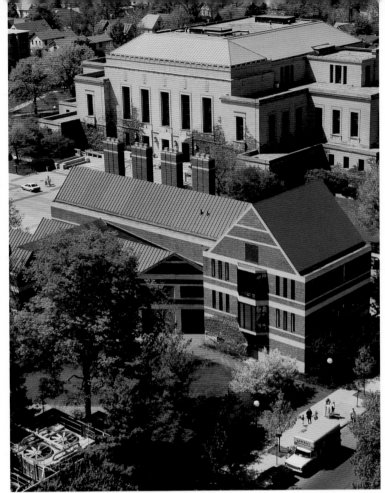

"Ann Arbor has all the benefits you would find in a larger city—cultural programs, educational opportunities and athletic events—but delivered in a warm and inviting setting not found in other cities. It's a wonderful community."

George H. Cress
President,
Michigan District, KeyBank

May Festival attendees (1993) gather on Ingalls Mall *(opposite)* during intermission. Beginning in 1894 and continuing for 100 years, the May Festival was a beloved annual series of classical music performances by some of the world's finest soloists and acclaimed symphony orchestras. Ingalls Mall is a broad landscaped expanse that stretches from the Rackam Building to Hatcher Graduate Library. The fountain by Carl Milles was a gift from Charles Baird in memory of Professor Thomas M. Cooley.

The Horace H. Rackham School of Graduate Studies *(left and above, background)* resulted from a $6,500,000 gift in 1935 from the Horace H. and Mary Rackham Fund, designated for a graduate studies building and an endowment to support scholarly investigations. Home of U-M graduate and graduate/professional education and the central administrative body for most graduate programs, the School currently enrolls more than 7,000 men and women from all parts of the world in more than 120 master's degree and doctoral level programs.

Designed by Hugh Newell Jacobson and financed entirely by private contributions, the Alumni Center *(above, foreground)* opened in 1982 on the newly created Ingalls Mall. The building contains meeting space and administrative offices of the Alumni Association which represents more than 400,000 U-M alumni living in virtually every country in the world. Among U-M's many well-known graduates are Dr. William J. Mayo, co-founder of the Mayo Clinic, playwright Arthur Miller, actors James Earl Jones and Ann B. Davis, director Lawrence Kasdan, ABC news anchor Carole Simpson, *60 Minutes'* Mike Wallace and the entire crew of Apollo 15 who established Michigan's only intergalactic club on the moon.

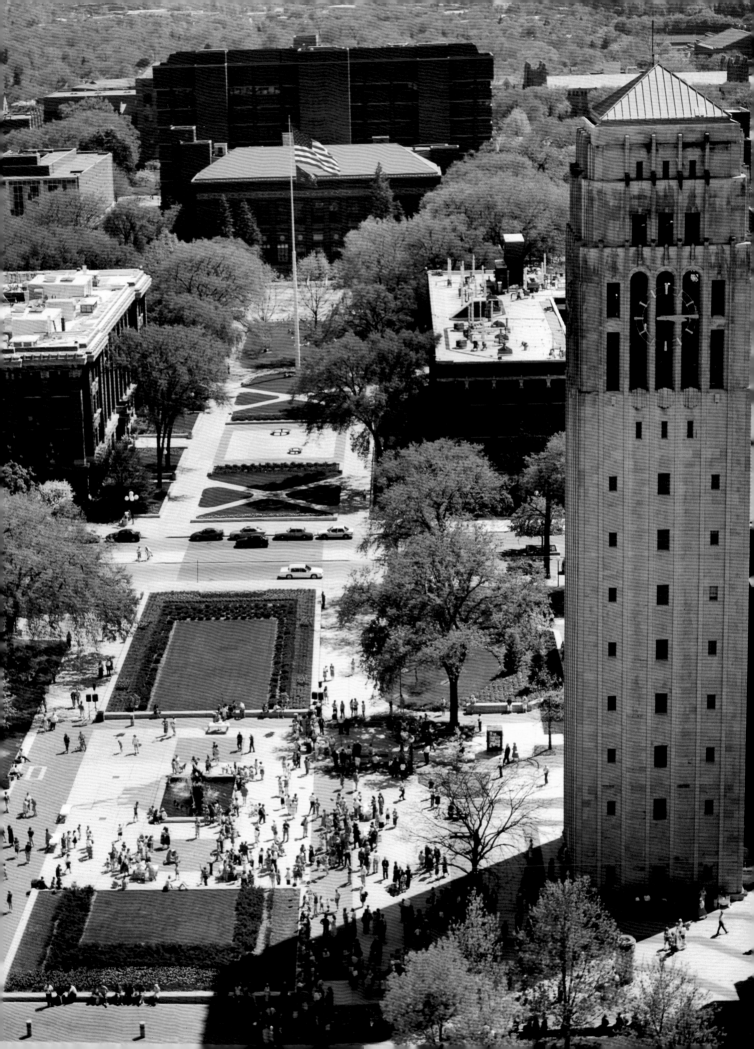

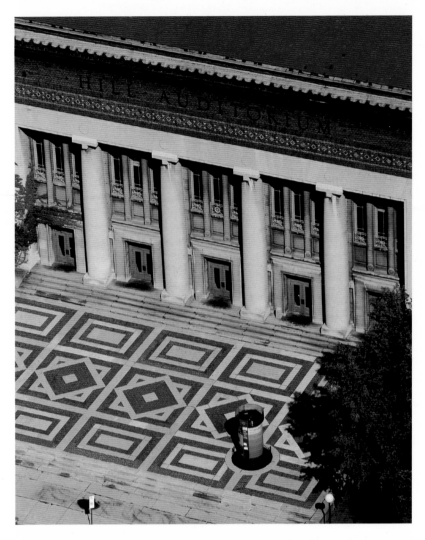

"The fabulous acoustics in Hill Auditorium make it a memorable venue for music performers from across the country and around the world, whether classical, rock & roll, country or folk. With the audience's proximity to the stage, Hill is an ideal setting for all participants."

Linda Siglin
Event Coordinator, U-M Office of Major Events

The 212-foot Burton Memorial Tower *(opposite)* is one of the highlights of the University of Michigan campus skyline and can be seen for miles. Named for Marion Leroy Burton, a former president of the University, the tower provides an enduring symbol of Ann Arbor. When former athletic director Charles M. Baird offered to give the University a set of carillon bells and a great clock, Burton Tower was designed by architect Albert Kahn in 1936 to house the carillon, third largest in the world in tonal range. The 40-foot high bell chamber, which affords the largest possible openings for the sound of the carillon, contains 53 bronze bells with the largest weighing 12 tons.

Hill Auditorium *(opposite and above)* resulted from a bequest to the University in 1910 by Regent Arthur Hill. The approximately 4,100-seat auditorium, an architectural and acoustical triumph designed by Albert Kahn, also became home to the Frieze Memorial Organ when the building was dedicated in 1913. Internationally acclaimed performers and renowned symphonies have performed on its stage, presented by the century-old University Musical Society and the U-M Office of Major Events. Famous lecturers and a variety of University activities and theatrical productions have also educated and entertained generations of students and non-students in this treasured Ann Arbor facility.

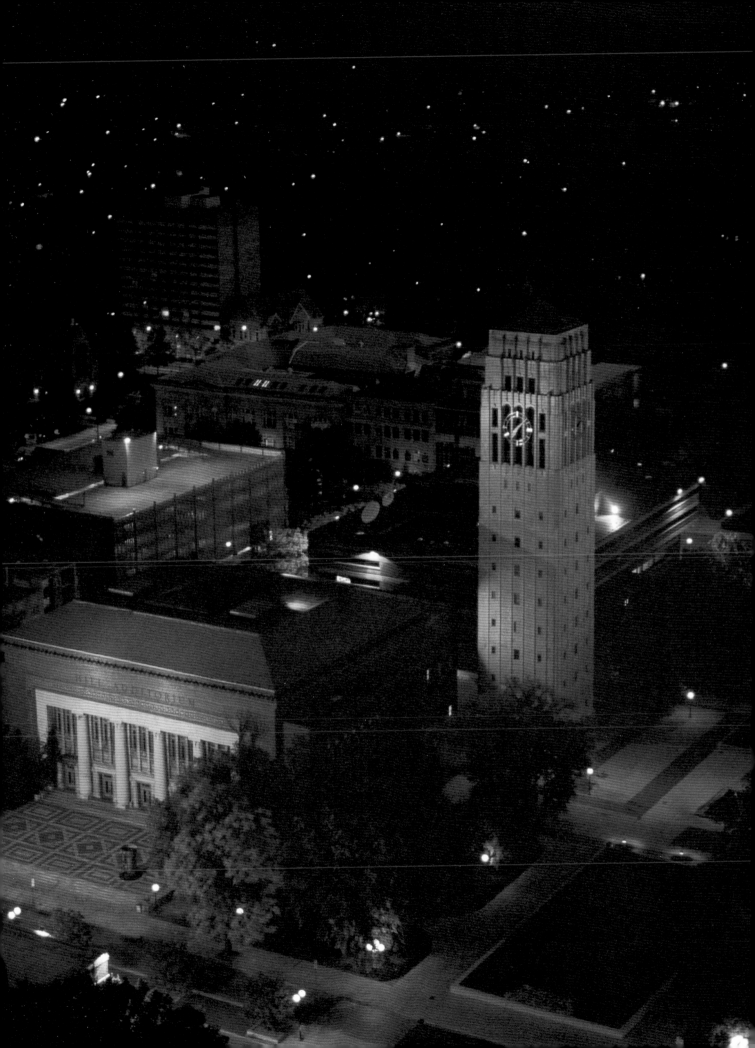

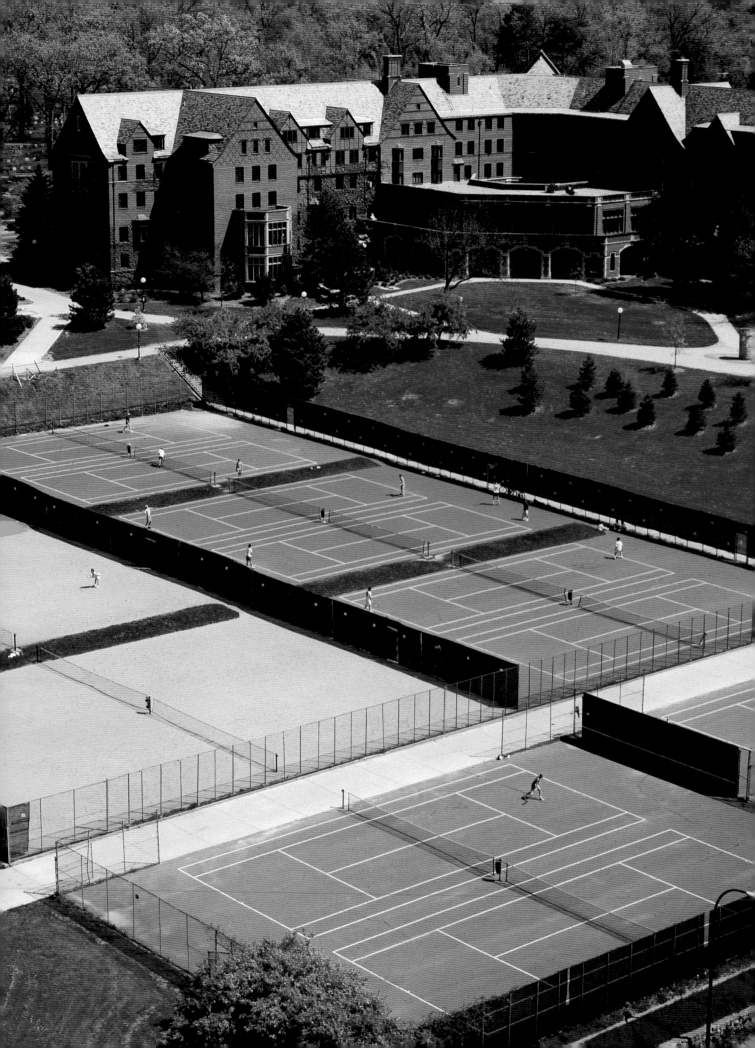

"Ann Arbor to me is a force field. It's powerfully attractive to a widely diverse population and energizes those that visit, study or stay who are receptive and eager."

Frank Lovejoy
President,
Lovejoy-Tiffany & Associates, Inc.

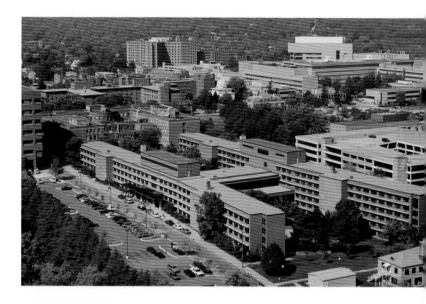

The Central Campus Recreation Building (CCRB), Margaret Bell Pool and nearby tennis courts *(opposite)* are conveniently accessible not only to adjacent dormitories *(also opposite)* but to Central campus buildings via the overpass that connects with the Diag. CCRB's basketball, racquetball and volleyball courts, along with weight training and a variety of other year-round fitness activities and classes, are available to U-M faculty, staff, students and sponsored members of the public.

Madelon Stockwell Hall *(below)*, named for the University's first coed, was opened next to Mosher-Jordan Hall in 1940 to house 400 women. Rising female enrollment in the mid-'50s prompted the building of Mary Markley Hall *(above)*, a giant new dormitory complex for women near the Medical Center. In addition to the library facilities in each residence hall, students today have dormitory access to the University's incredible 6.4-million-volume library system through 17 residence hall computing sites or via Ethernet hookup in many dorm rooms.

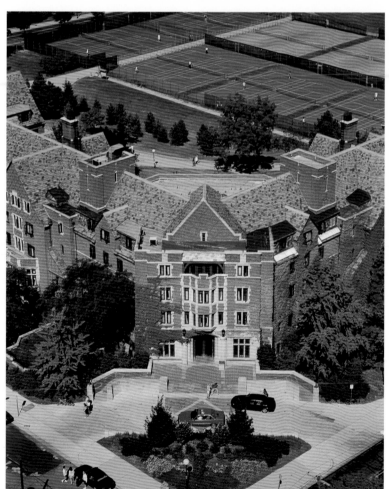

With an official capacity of 102,501, Michigan Stadium *(overleaf)* is the second largest college-owned structure of its kind designed solely for football (Tennessee upgraded to 102,544 in 1996). From its first game on October 1, 1927, to date, more than 31 million jubilant fans have cheered the Wolverines. Michigan has set numerous NCAA attendance marks (a record 106,867 at the 1993 Ohio State game) and has led the nation since 1975 in attendance of crowds in excess of 100,000 for consecutive home games.

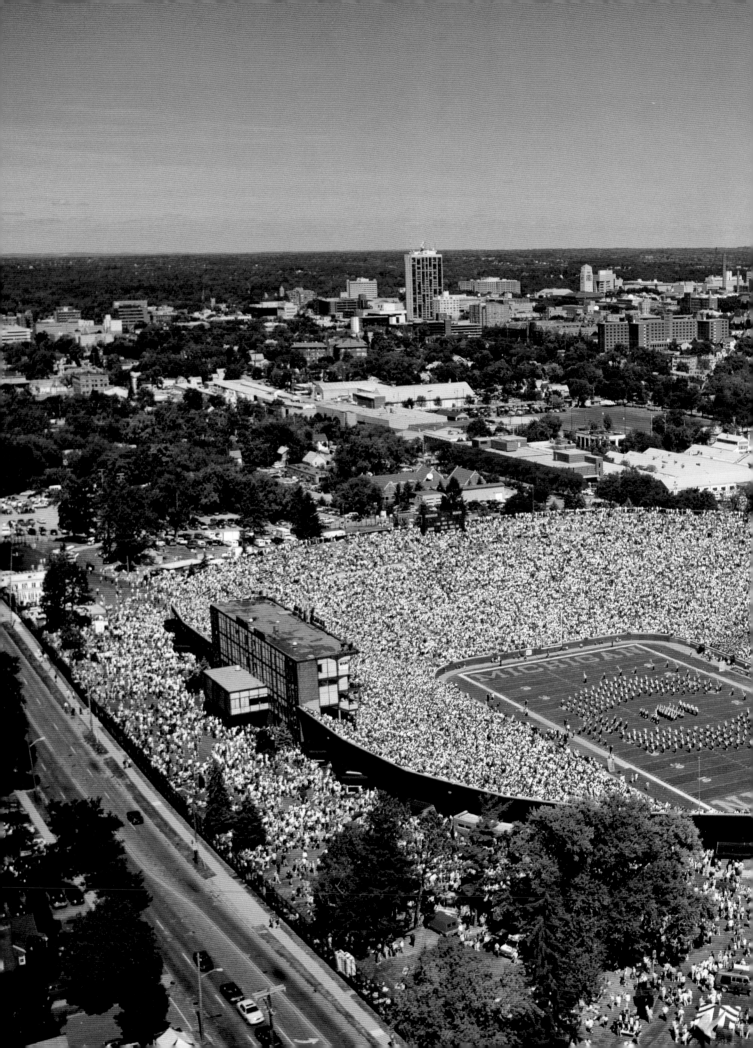

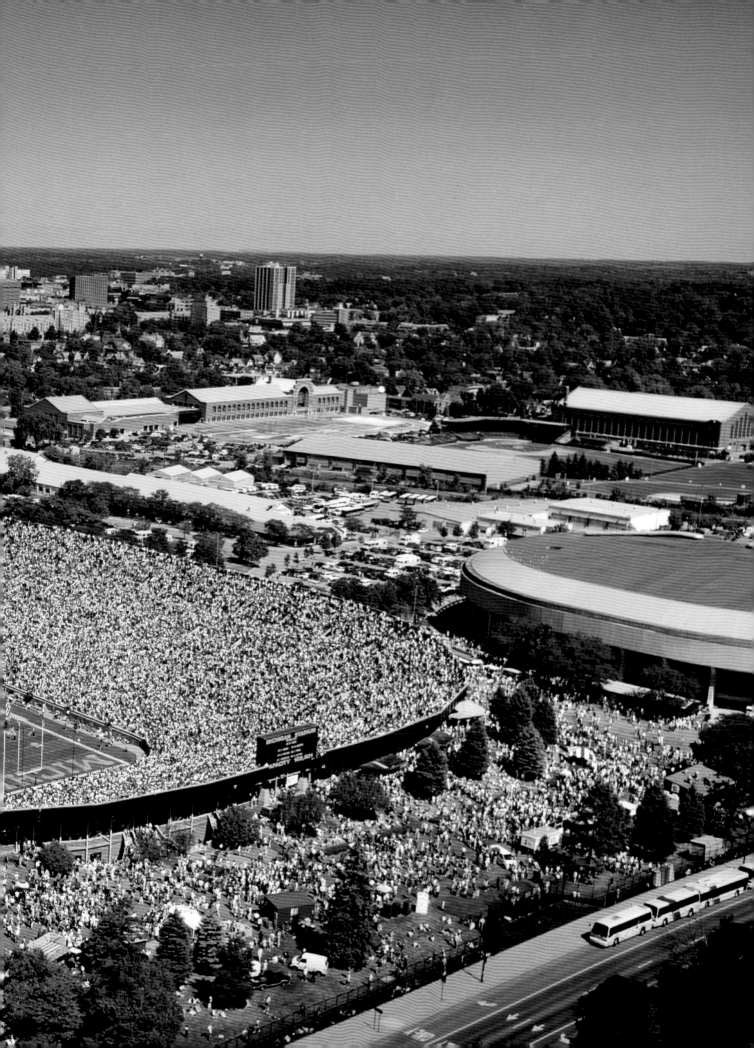

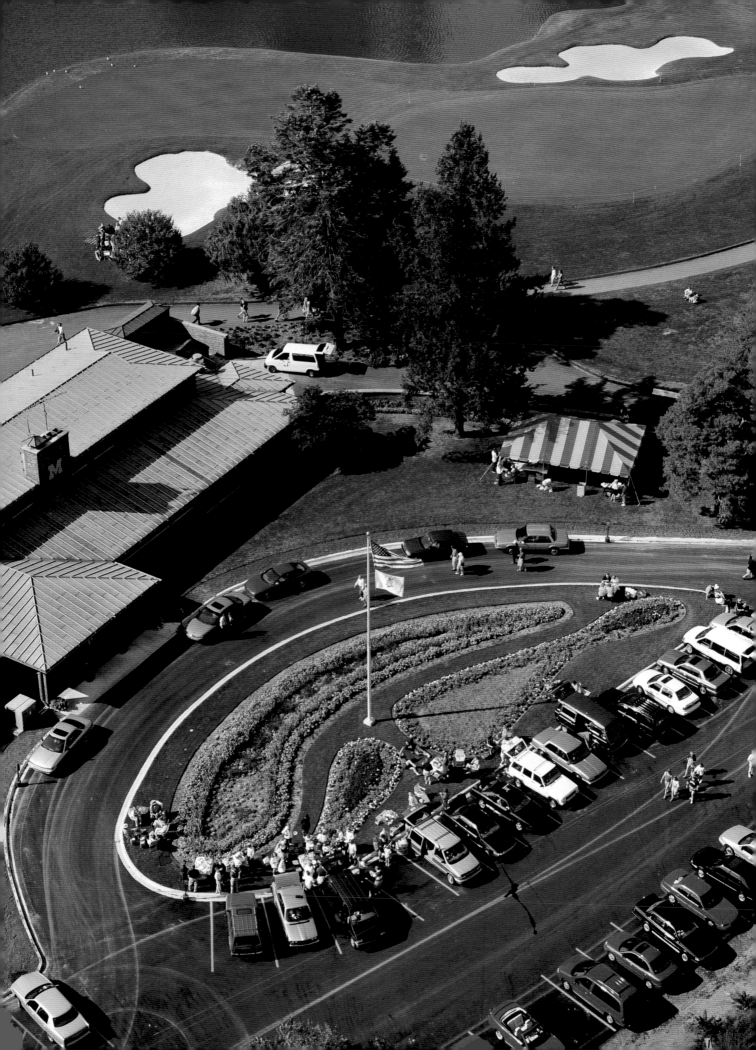

"The rich football tradition at the University of Michigan began in 1879, and in the ensuing years many of the great names in the history of college football have helped build what is arguably the finest football tradition in the country. The showcase for this great tradition is the crown jewel, Michigan Stadium...the colors are Maize and Blue...the symbol is the winged-helmet...the incomparable sound is "The Victors"...the expectation is always victory and the standard is forever excellence. All of us who coach and play at Michigan are proud to be a part of the legacy— "Win for Michigan." Our challenge and our responsibility is to continue to play and coach the game as it was meant to be played: A TEAM GAME! HAIL TO THE VICTORS...GO BLUE!"

Lloyd H. Carr
Head Football Coach, University of Michigan

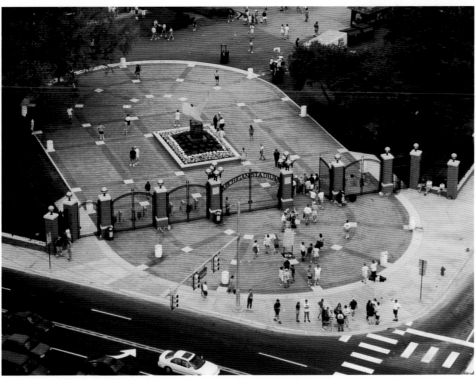

Tailgate parties (*opposite and above*) **on the U-M Golf Course and in parking areas within several blocks of the stadium celebrate Michigan's great tradition and fabulous heritage of Maize and Blue football. U-M stands alone as the winningest program in college football with 756 all-time Division I victories. To date in the Big Ten Conference, the Wolverines have captured the most titles (37), the most wins (385), set a record 19-game undefeated streak in Conference play (1990-1992) and have had more Rose Bowl victories (7) and appearances (16) than any other Big Ten team. U-M has also produced 102 first team All-Americans and won ten national championships over the past 117 years. Champions Plaza (*above*) celebrates these U-M victors and gave loyal fans an opportunity to place lasting remembrances in the stadium by engraving their names and messages on entrance paving bricks.**

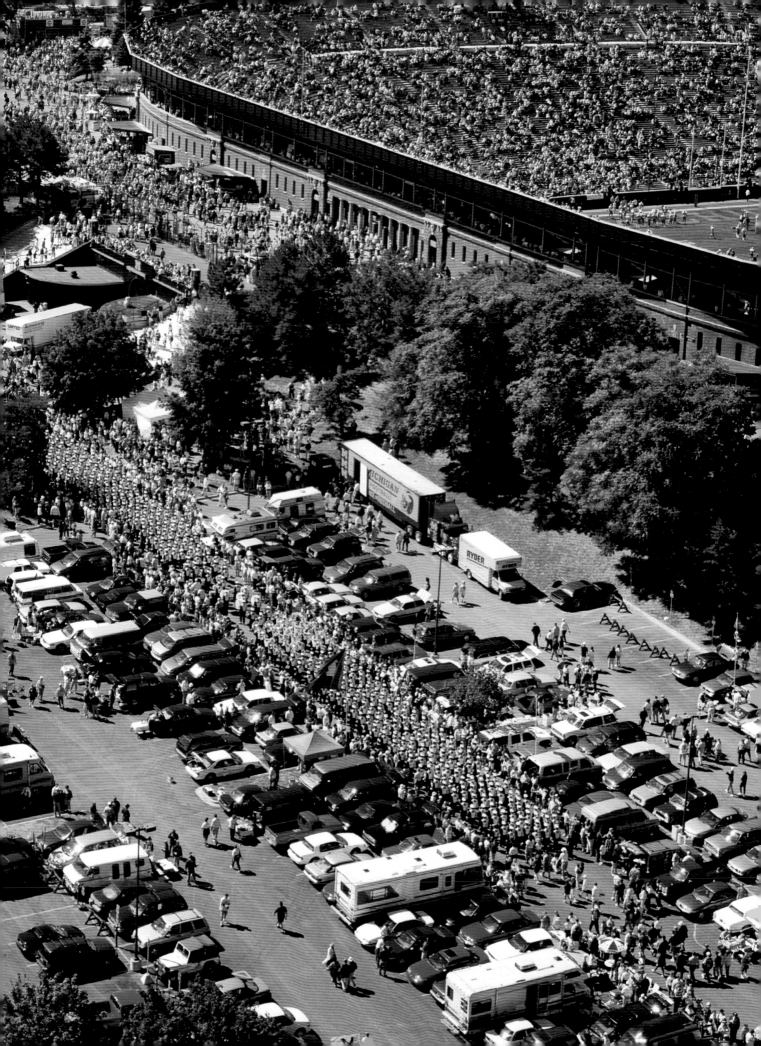

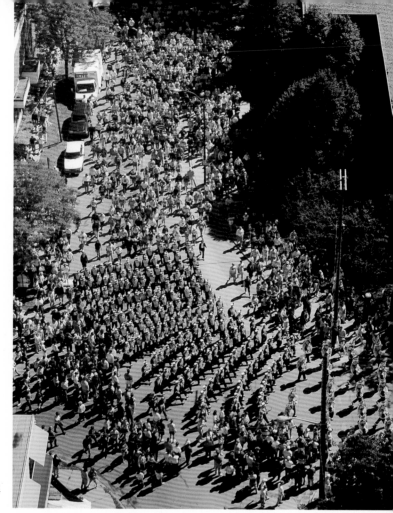

"Ann Arbor is such a wonderful place. The University of Michigan has thrived here, both academically and athletically, in an atmosphere of diversity and culture unparalleled in cities of comparable size. We are very lucky to call this unique town our home."

Joe Roberson
Athletic Director,
University of Michigan

Originating with a grass-roots student effort, the Michigan Band's first rehearsal occurred in November 1896, and its first public performance took place the following February at the request of University President James B. Angell. Today, the Michigan Marching Band *(opposite, right and below)* is still among the most democratic student groups on campus, selecting its own drum major, twirlers and "performing block" of 235-250, based on individual musical performance and marching ability, from its total membership of nearly 400.

One of the most active and respected bands in America, the Michigan Band was selected in 1983 as the first recipient of the annual Louis Sudler National Intercollegiate Marching Band Trophy by a ballot sent to sportswriters, TV commentators and 700 college marching band directors. Other Marching Band "firsts" include: first appearance on a Michigan football field (1898); first Big Ten band to perform in the Rose Bowl (1948); first to appear in both Yankee Stadium and the Rose Bowl in the same season (1950), earning it the nickname "Transcontinental Marching Band"; and first college band to perform for an NFL Super Bowl game (1973).

The Victors, written in November 1898 by U-M music student Louis Elbel in celebration of a last-minute 12-11 Wolverine victory over rival Chicago, was first performed by John Philip Sousa's Band in May 1899, and hailed by the March King as the greatest college march ever written. For nearly a century, Michigan's Marching Band has stirred millions of fans with this famous fight song.

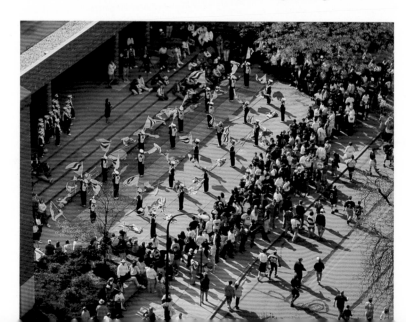

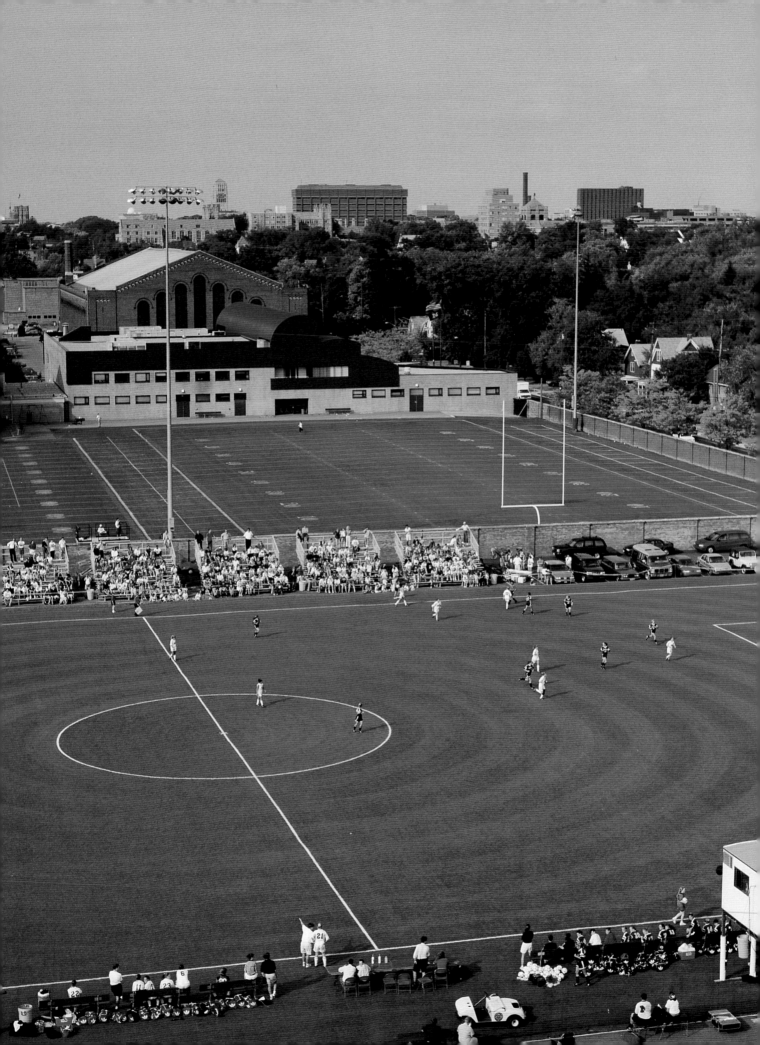

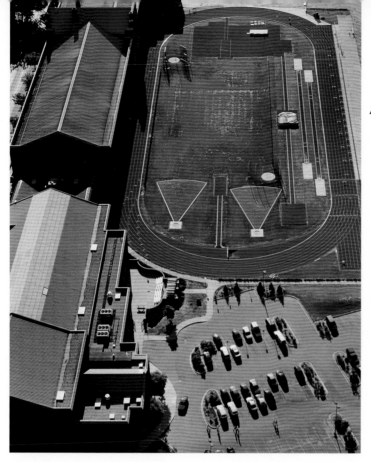

"How many other places can you drive down the street on an autumn Friday afternoon and see one thousand people watching a women's soccer game, right next door to a major college football team practicing for a big game the next day? Ann Arbor and the University of Michigan provide so many opportunities. This is part of what makes the Michigan experience so special."

Peggy Bradley-Doppes
Senior Associate Athletic Director,
University of Michigan

Adjoining the Phyllis Ocker field hockey facility and football practice field, U-M's new (1995) natural grass soccer field *(opposite and right)* seats more than 1,500 fans. In 1994, Women's Soccer became Michigan's newest varsity sport and the team advanced to the Big Ten Conference semifinals in its very first year. Under Coach Debbie Belkin, a member of the 1991 U.S. Women's World Championship team, eleven women's soccer athletes have already received Academic All-Big Ten Conference recognition. U-M also recently became the first major public university in the nation to achieve full gender equity in athletics, and aspires to be a leader among American universities in promoting the success of women and making them full and equal partners in all facets of University life.

In its 103-year history (1893-present), the U-M Men's Track and Field team has won 26 indoor and 30 outdoor Big Ten Conference titles, more than any other member institution, and Michigan athletes have posted Big Ten Championships 462 times in 54 different indoor and outdoor track and field events. A former Big Ten shot put champion at Michigan himself (1966), Coach Jack Harvey is recognized as one of the top coaches in the country, producing 45 All-Americans who have won recognition 69 times. The new outdoor track *(above)* including shot put pits, long jump, high jump and discus throwing areas provides the team with complete, modern outdoor facilities.

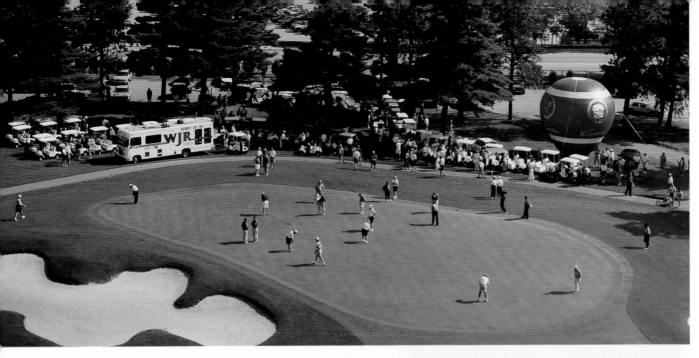

"We hold our golf outing here in Ann Arbor at the University course because, in my mind, there is no better place to be on a sunny summer afternoon. I can count on many of our former athletes and coaches coming back because Ann Arbor holds such a special place in their hearts. This campus etches itself in your memory whether you spent years here or days."

Bo Schembechler
Chairman,
Millie Schembechler Memorial Golf Classic

Designed by famed golf architect Alister MacKenzie, the U of M Golf Course *(opposite and above)* was immediately praised as one of the finest in America when it opened in 1931. A 1992-94 renovation project orchestrated by alumnus Arthur Hills, one of today's foremost golf course architects, has restored the course to Dr. MacKenzie's classic design. Although the first U-M varsity golf team was organized in 1901, its first conference meet wasn't until 1922 against Ohio State. Two of the Wolverine's finest golfers were John Fischer and Chuck Kocsis who each won both the Big Ten individual championships and NCAA titles, a rare achievement in any sport. To date, the Michigan golf team has won 12 Big Ten titles and produced a third NCAA Champion, Dave Barclay.

Since its inception in 1993, the Millie Schembechler Adrenal Cancer Research Fund at the U of M Hospital has received more than $1 million dollars as a result of the tournament *(above)* held each year in her memory at the U-M Golf Course. Coaches and athletes from college and professional teams around the country, along with sportscasters and other celebrities, have joined former Wolverine football coach Bo Schembechler in his effort to support research to develop effective treatment and a better understanding of the disease that took his wife's life. WJR radio's beloved J.P. McCarthy made what proved to be his second-to-last public broadcast *(above)* at this event on July 9, 1995.

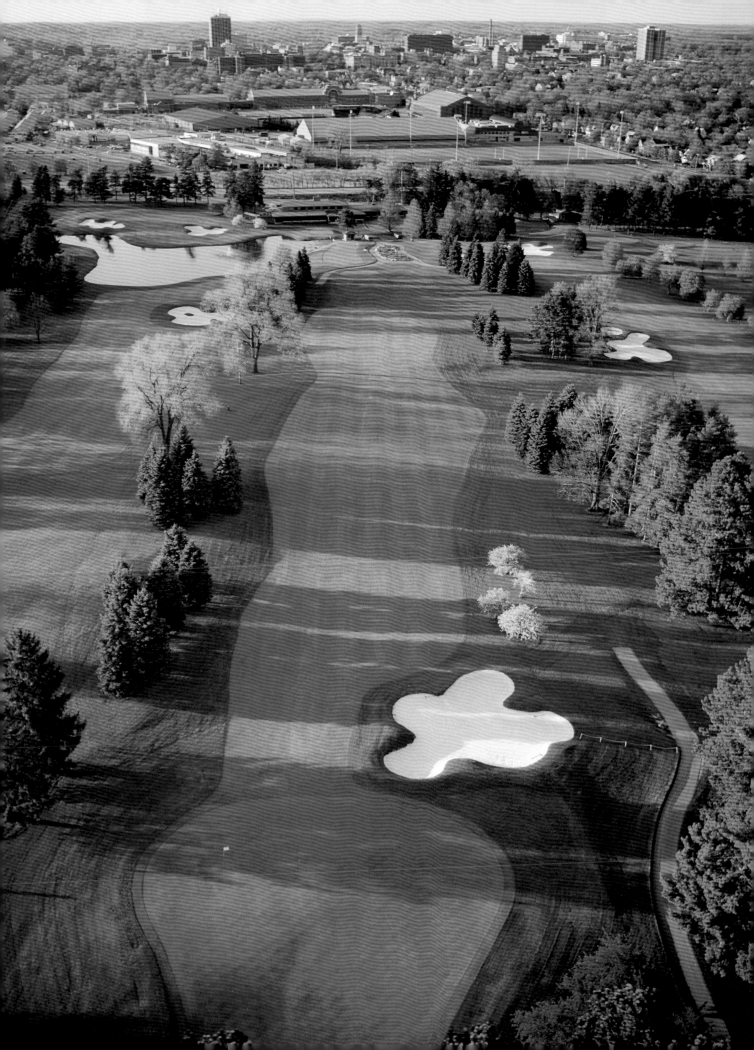

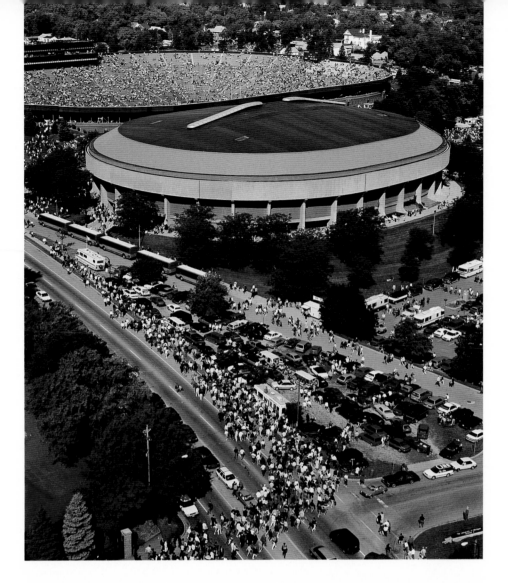

"Fisher Stadium holds so many great memories from Ray Fisher to Don Lund, from Moby Benedict to the great teams of the eighties with Larkin and Sabo and Abbott. For me it was the place where I daily learned the fundamentals of the game under Coach Benedict. The view from the field to the University in the background is a constant reminder of my total Michigan experience."

Geoff Zahn
Head Baseball Coach, University of Michigan

Baseball is Michigan's oldest varsity sport, dating back to 1866. The U-M team won its first Big Ten title in 1899, and since then has won the most Big Ten baseball championships (30) and the National Championship at the College World Series in 1953 and 1962. More than 150 Michigan players have signed pro baseball contracts, nearly 50 of whom have played in the Major Leagues. Former Major League Wolverines who have returned to Michigan as head coaches include Don Lund, Bill Freehan and Geoff Zahn. Baseball at the U of M has been played on the current site of Ray Fisher Stadium *(opposite)* since 1923. The stadium, which now seats 4,000, was dedicated in 1967 to Fisher, head coach of the Wolverines from 1921-58.

Named for former Athletic Director and football coach Fritz Crisler, U of M's basketball arena *(above)* was designed by U-M grad Dan Dworsky. Michigan's basketball program began in 1910, but the sport's popularity and game attendance soared after player Cazzie Russell arrived and the team won three consecutive Big 10 Championships between 1964-66. To date, the Wolverines have won twelve Big 10 titles and one NCAA championship. Under current Coach Steve Fisher, U-M's program has ranked among the top in the country, with eight players going on to the NBA, including "Fab Five" members Chris Weber, Jalen Rose and Juwan Howard.

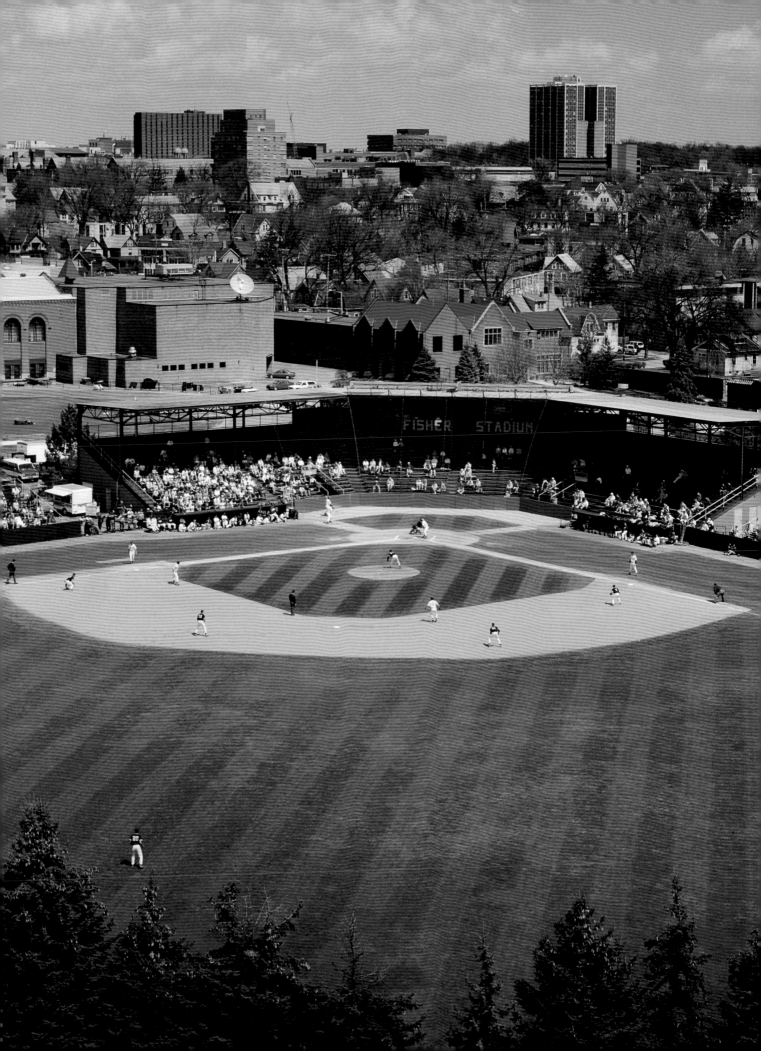

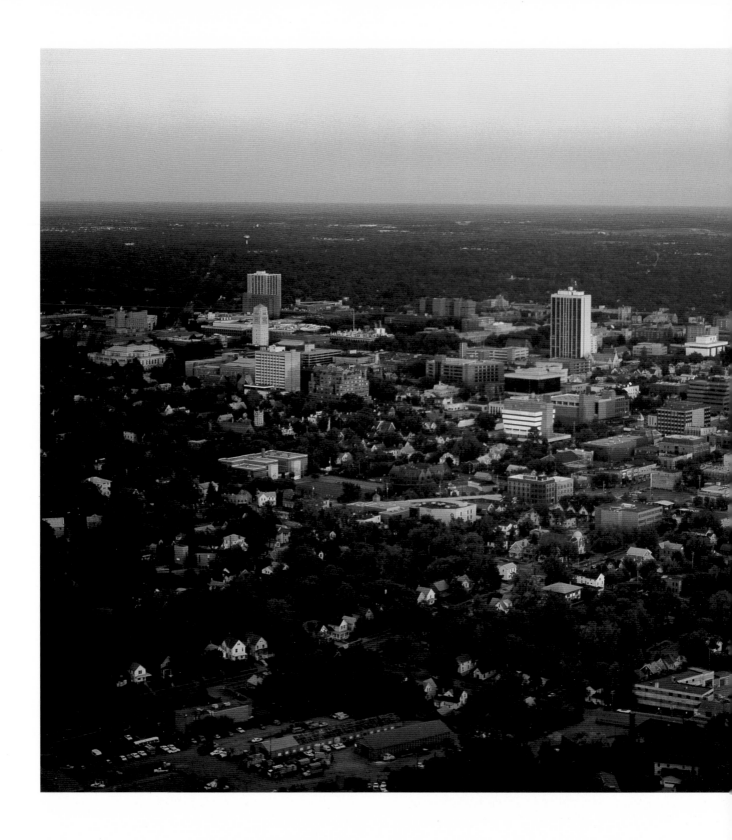

Named among *Money* magazine's top cities in which to live, Ann Arbor combines small town charm with big city amenities and a highly diverse population. The University of Michigan and major companies headquartered in the area draw people here from across the country and around the globe to study, work or visit. Whether you are sitting in a restaurant or coffee shop, attending a concert, shopping or strolling down a busy street, you are likely to meet someone whose race, culture, language, religion or point of view is very different from your own. That is one of Ann Arbor's richest treasures.

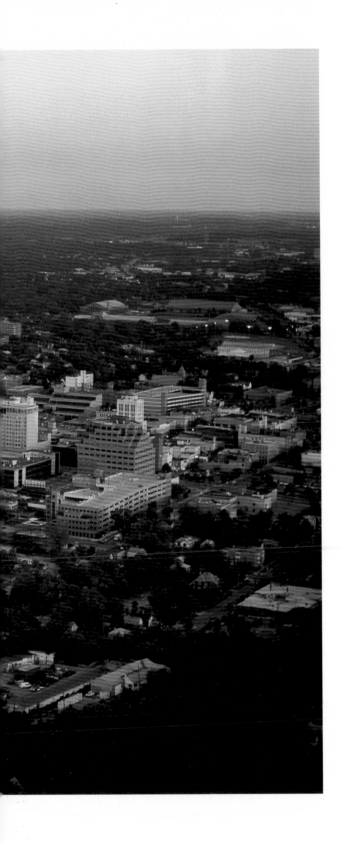

Downtown

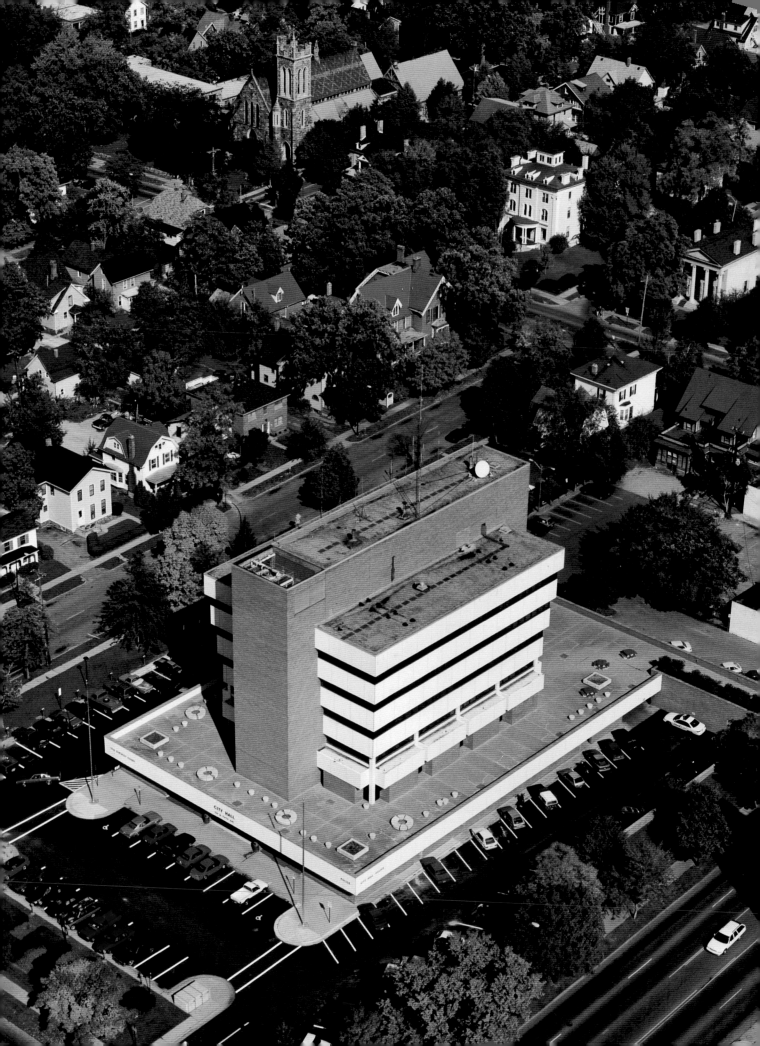

"Big and small! That is how I describe Ann Arbor! We are big in that we seem to offer all the advantages of big cities—museums, live theater, quality restaurants, expansive parks, extensive shopping opportunities, a diverse population, many institutions of higher learning including the world-class University of Michigan, comprehensive health care—all contributing to a very cosmopolitan atmosphere. But we are a small town with all its advantages—schools in our neighborhoods, shopping just around the corner, many people can walk or bike to work, and even during rush hour we can drive across town in twenty minutes. Most of all, we know each other and try to respect our differences in order to strengthen our city. It is indeed an honor to be part of this exciting, vibrant, and caring community."

Ingrid Sheldon
Mayor of Ann Arbor

Ann Arbor's modern City Hall *(opposite)* is a distinct contrast to the surrounding historic homes built a century or more ago and now authentically restored to their original grandeur. For example, the 1835 Wilson-Wahr House on N. Division was inspired by classic Greek temples and is cited often in books on architectural history. The 1858 pale yellow mansion on its north side was built for Dr. Ebenezer Wells, and the exuberant Queen Anne-style house to the south was built in 1894 by George and Emma Wahr.

The Federal Building on Liberty Street *(left)* houses a Post Office branch as well as other U.S. Government offices, including the Social Security Administration, U.S. District Court and various Defense Department field offices.

Designed by Ann Arbor architects Hobbs & Black in 1986, One North Main *(above)* quickly became a skyline landmark. Major retail tenants share the striking ten-story building with elegant condominiums whose residents enjoy panoramic views from their rooftop patios.

(Overleaf) As Ann Arbor wakes up, more than 181,000 people make their way to work in and around the city — nearly 28,000 of them at the University of Michigan. Looking east along Huron, for example, the mix of major employers, small businesses and self-employed professionals is perhaps why Ann Arbor retains more of its University graduates than any other college town in the country.

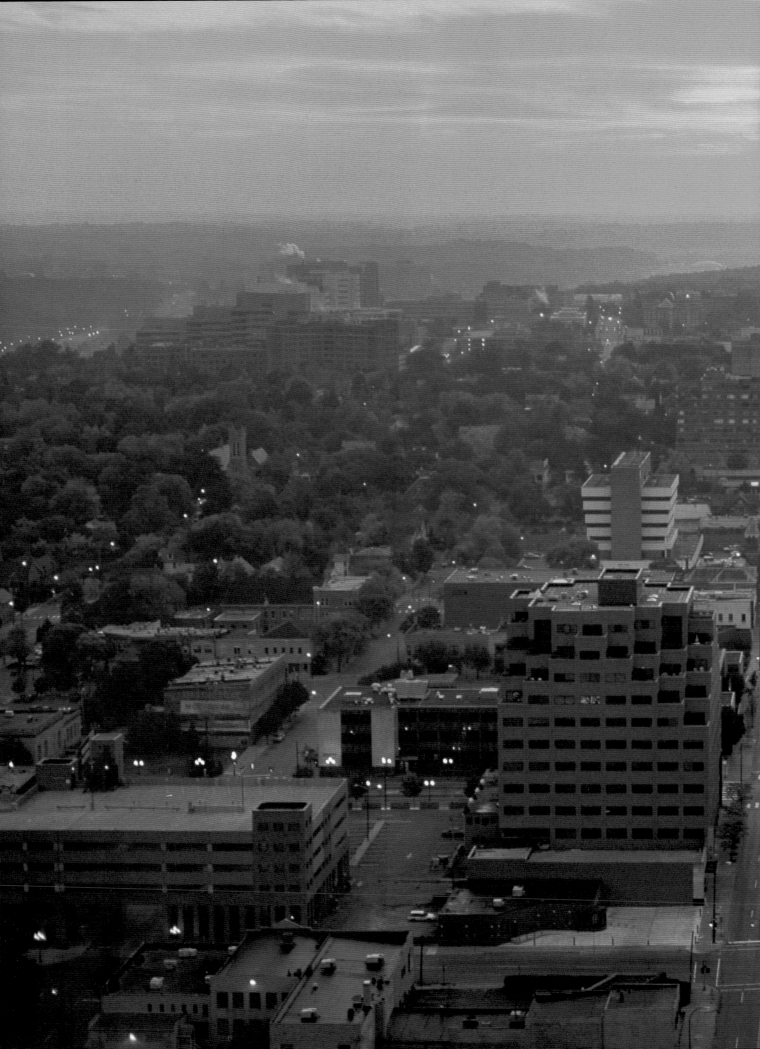

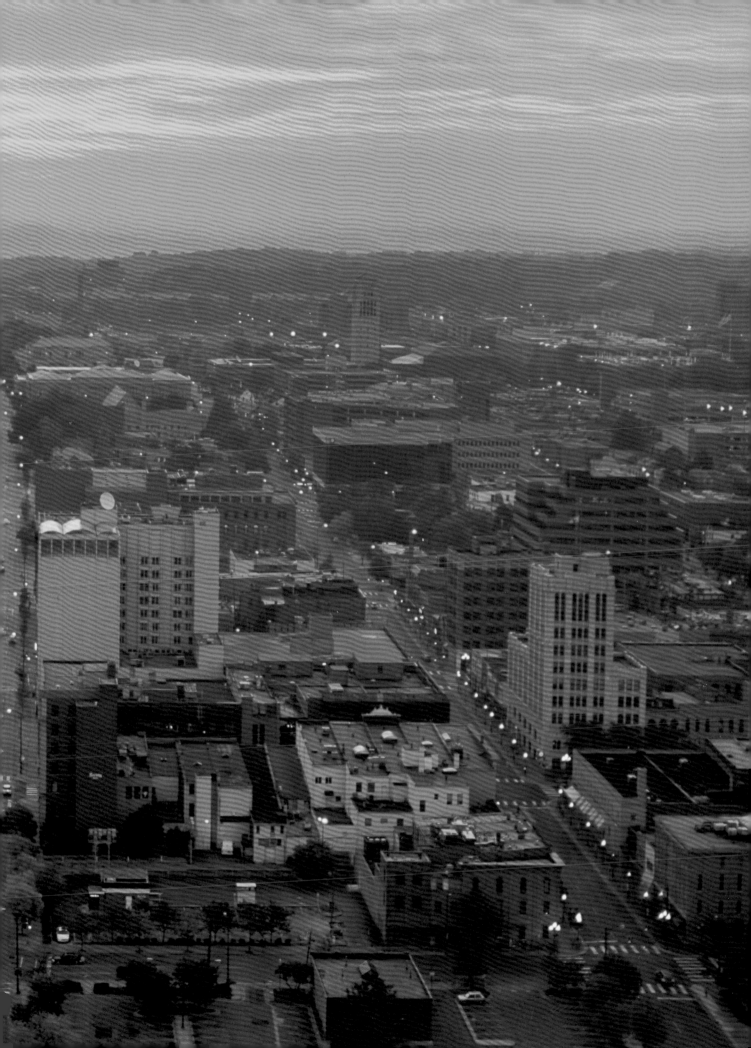

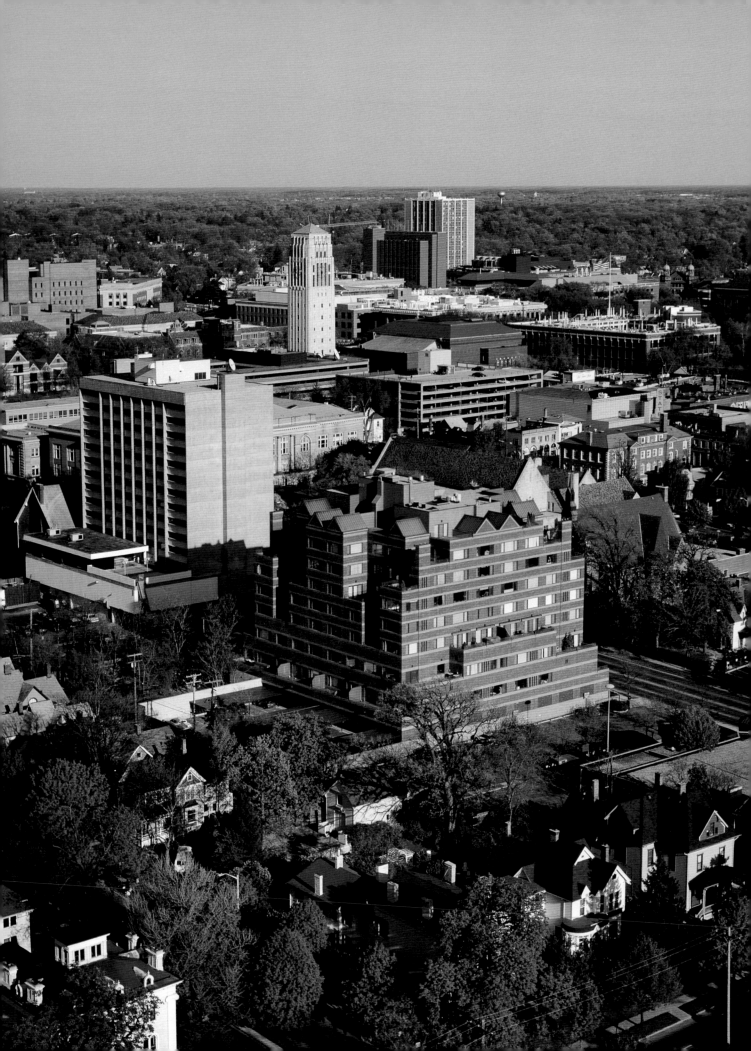

"From the ground we see the segments—businesses, hotels, restaurants, government, theater, sports events, Universities, volunteers, galleries—all with whom we interact on a day-to-day basis. But through this elevated perspective we see the weaving that represents the fabric of our metro area, the energy of the city and the charm of the small towns and countryside. This weaving represents the excellent quality of life that makes our area one of the best communities in the U.S. in which to live and work."

Richard Dorner
President & CEO, Ann Arbor Commerce Bank
and
Deanna Dorner
Community Volunteer

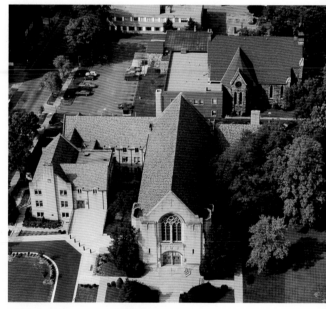

Located on Huron just west of State Street, Sloan Plaza *(opposite)* was designed by Hobbs + Black and completed in 1986. The joint venture between Donald Chisholm and O'Neal Construction, Inc., combines 34 luxury residential condominiums with 28,000 square feet of commercial office space.

At the intersection of State and Huron *(above)* are two historic church buildings creatively redesigned to house 20th century commercial space. Harris Hall, a two-story brick building designed by Gordon W. Lloyd in 1886 as a student center and parish hall for St. Andrew's Episcopal Parish, now houses Harris Marketing Group. The architectural firm of Hobbs + Black Associates totally rebuilt the interior and now occupies the 1882 Richardsonian Romanesque First Unitarian Universalist Church and adjacent parsonage. Nearby is the Campus Inn, a recently renovated 202-room hotel with extensive conference and meeting facilities that also houses the casual but elegant A-Squared Grill.

Across Huron Street are the First Methodist and First Baptist Churches *(above right)* whose history dates to Ann Arbor's earliest settlers. Following its first sermon in an 1825 frontier log cabin, the First Methodist Church built two earlier churches (1837 and 1867) before dedicating in 1940 its present Gothic style T-shaped church faced with Indiana limestone. Born in 1828 in Pastor Moses Clark's small farm house, the First Baptist Church went on to reside in two buildings (1835 and 1849) before ground was broken in 1880 for the stately Gothic stone church it occupies today.

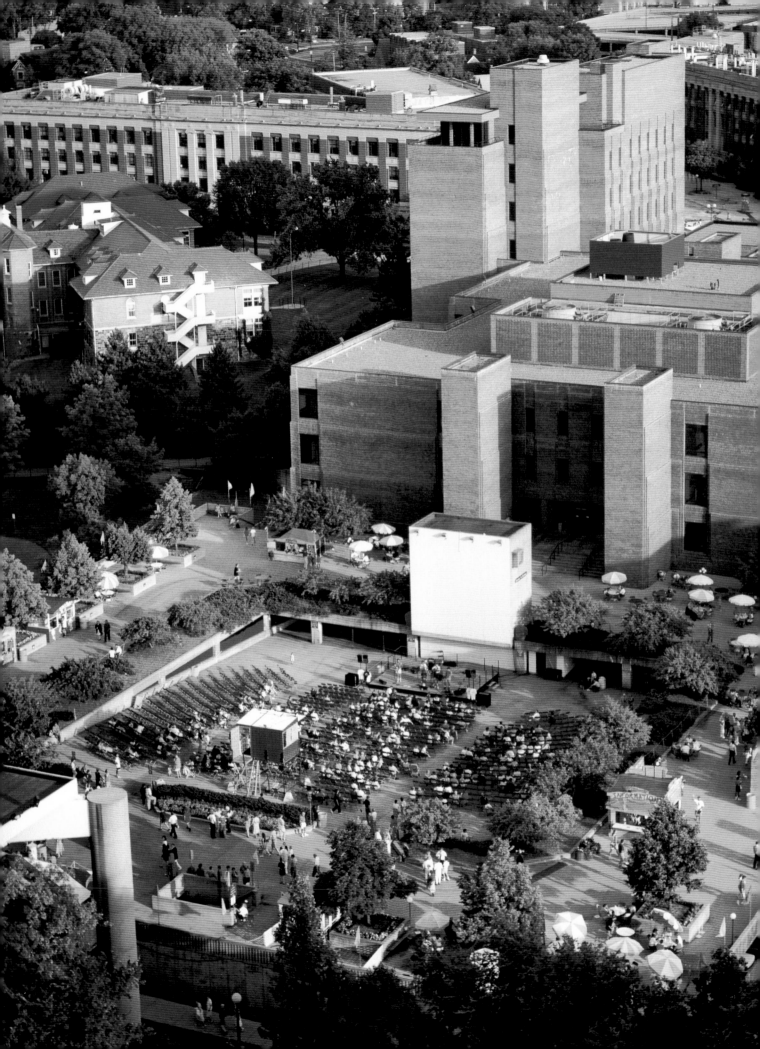

"The diversity and style that Ann Arbor offers is unique in the Midwest. The world's foremost musicians have long enjoyed performing on our stages, and artists flock here by the hundreds to take part in our Art Fairs. After an evening at one of our fine theatrical presentations, you can sample cuisines from across the globe. Multicultural and alive with excitement, Ann Arbor has something for every visitor to enjoy."

Mary Kerr
President, Ann Arbor Convention & Visitors Bureau

Located on the top level of the Power Center parking structure, the innovative "Top of the Park" (TOP) *(opposite)* is half of the Summer Festival, an Ann Arbor tradition since 1984. For three glorious weeks in the summer, TOP offers a series of free open-air concerts by Michigan artists and free movies on a giant outdoor screen, plus booths selling beverages and cuisine from some of the area's most popular

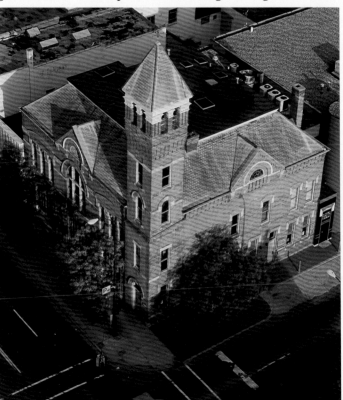

restaurants. Next door at the Power Center for the Performing Arts, the Festival's exciting Mainstage Series presents prominent performing artists from around the world in a broad mix of music, dance, comedy and theater.

The Michigan Theater *(above)*, originally built as a vaudeville and silent film palace in 1928, was extensively renovated in 1986 to its original grandeur, complete with gilded domes and Barton Theater Organ. A community-owned treasure, the 1,655 seat facility plays host to national and international theater, dance and concert events as well as foreign, art and classic films.

Housed in a former brick firehouse built in 1882, the fascinating Ann Arbor Hands-On Museum *(left)* features four floors filled with interactive exhibits for children and adults. Since it opened in 1982, more than 1.25 million children and adults have playfully learned a variety of scientific truths there.

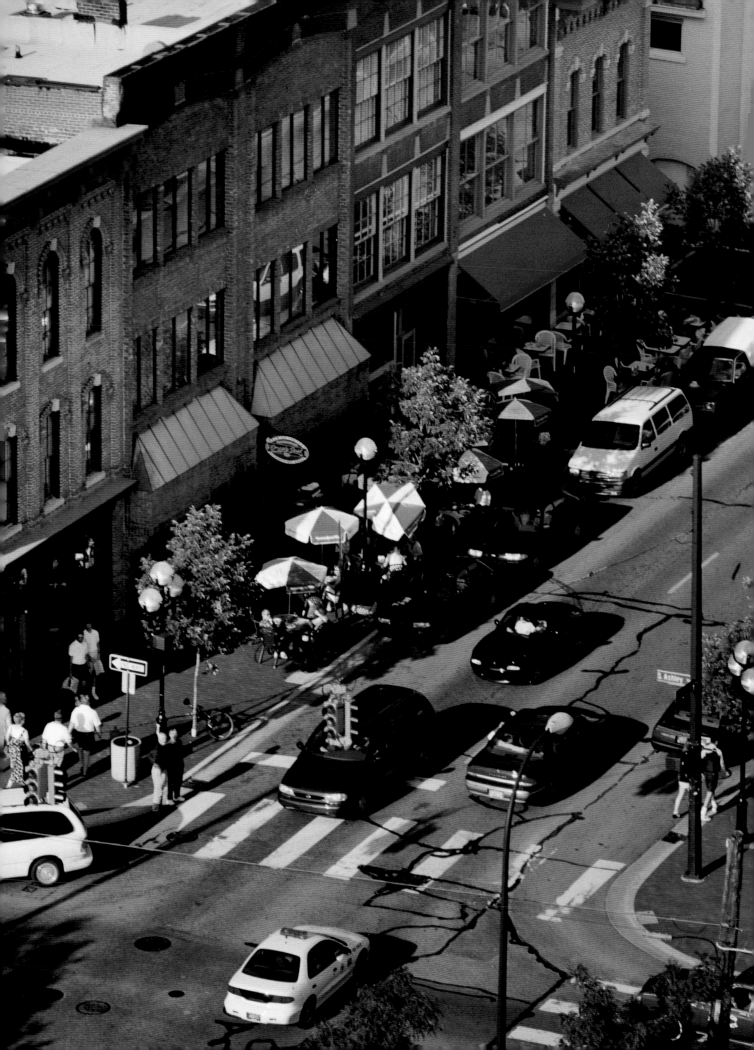

"Ann Arbor—great football, friendly people and more restaurants per capita than anywhere!"

Matt Humbel
Veterans Affairs Medical Center

"The beauty and grace of the Ann Arbor area is without equal. The variety of entertainment and activities enhance the allure of our area. I travel around our country and have yet to find anywhere else I would prefer to spend my time. The PMC membership is pleased to be a part of Ann Arbor's development."

Sandra L. Miller
President,
Plumbing & Mechanical
Contractors Association
of Washtenaw County, Inc.

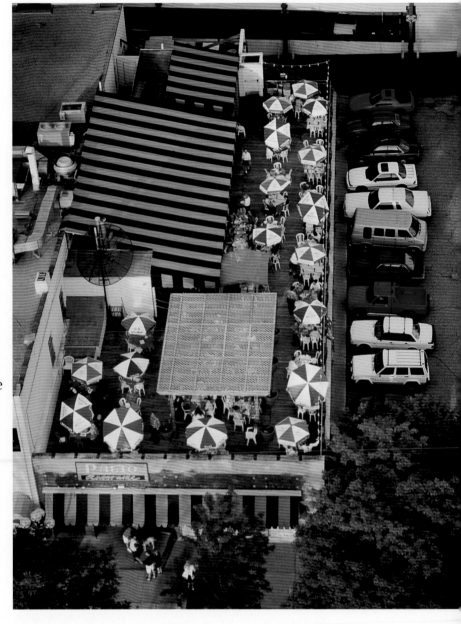

At Grizzly Peak Brewing Company *(opposite)*, patrons select from an imaginative, beer-inspired menu and tasty sampler of its home brews in the carefully preserved, yet updated, former Old German restaurant. If brewpub fare is not your choice, you can stop next door at Cafe Zola, a laid-back coffee house and creperie, or at Del Rio for a black bean burrito. In just this section of West Washington Street, there are a half-dozen eateries offering cuisine from nouvelle American to classic French.

Whether you're looking for an intimate dinner for two by candlelight, or the ambience of rooftop dining at sunset, the Main Street area can satisfy you. For example, Palio's charming rooftop Dizko del Sole *(above)* features a grazing menu of satisfying provincial Italian cuisine presented at your table on tray after tray of delectable courses. From crystal and linen to casual sidewalk cafes, an amazing variety of Ann Arbor establishments feature an array of ethnic, Continental and American dishes that will tantalize even the most discriminating palate. No wonder Ann Arborites spend more than $450 million a year on food and drink!

"When I first met Dale, he was dangling precariously from the open door of a helicopter recording our progress as we constructed the Power Center for the Performing Arts. Since 1961, O'Neal Construction has been busy shaping Ann Arbor's streetscape and infrastructure with projects like Kerrytown, the Huron River dams, Michigan Theater and Sloan Plaza. We are proud and honored to be a part of this unique and dynamic city."

Joe E. O'Neal
Chairman, O'Neal Construction, Inc.

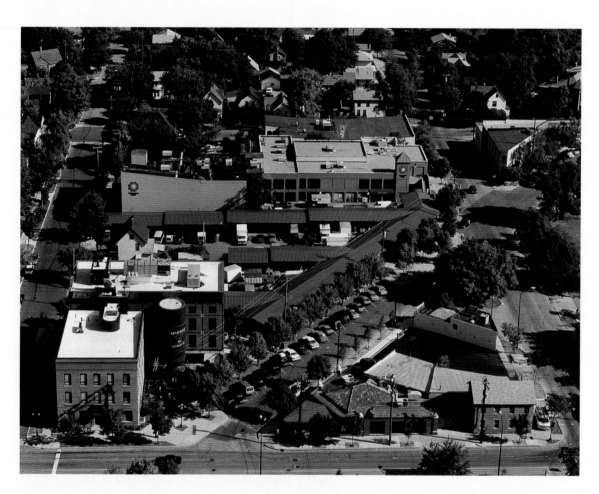

Restored by O'Neal Construction in the late '60s, Kerrytown *(opposite and above)* was one of the first specialty shopping areas utilizing structures otherwise destined for decay. Its 27 shops and restaurants, housed in a trio of century-old buildings just a few blocks from downtown, present an eclectic array of services, cosmopolitan foods and boutiques emphasizing local merchandise and personal service.

Local growers and producers bring fresh fruits and produce, herbs, plants, preserves, baked goods and crafts year-round to the Ann Arbor Farmer's Market *(opposite and above)*. The friendly, open-air setting turns shopping into a delightful social event. The adjacent Market Place building, originally the 1856 home of Moses Rogers' farm implement and grain business, was totally renovated and expanded in 1990 by MAV Development. The contemporary space now houses the *Ann Arbor Observer*, Sweet Lorraine's Cafe, retail shops and offices.

(Overleaf) Zingerman's, considered by many to be one of the best delicatessens in the world, occupies three buildings across from Kerrytown. Since opening in 1982 in the historic former Desderide's Grocery Store, this major Ann Arbor tourist attraction has grown into a multi-million-dollar food and catering emporium offering an extensive selection of sandwiches, hearth-baked breads, gourmet foods and delicacies from around the world, along with fantastic desserts guaranteed to tempt the most resolute dieter.

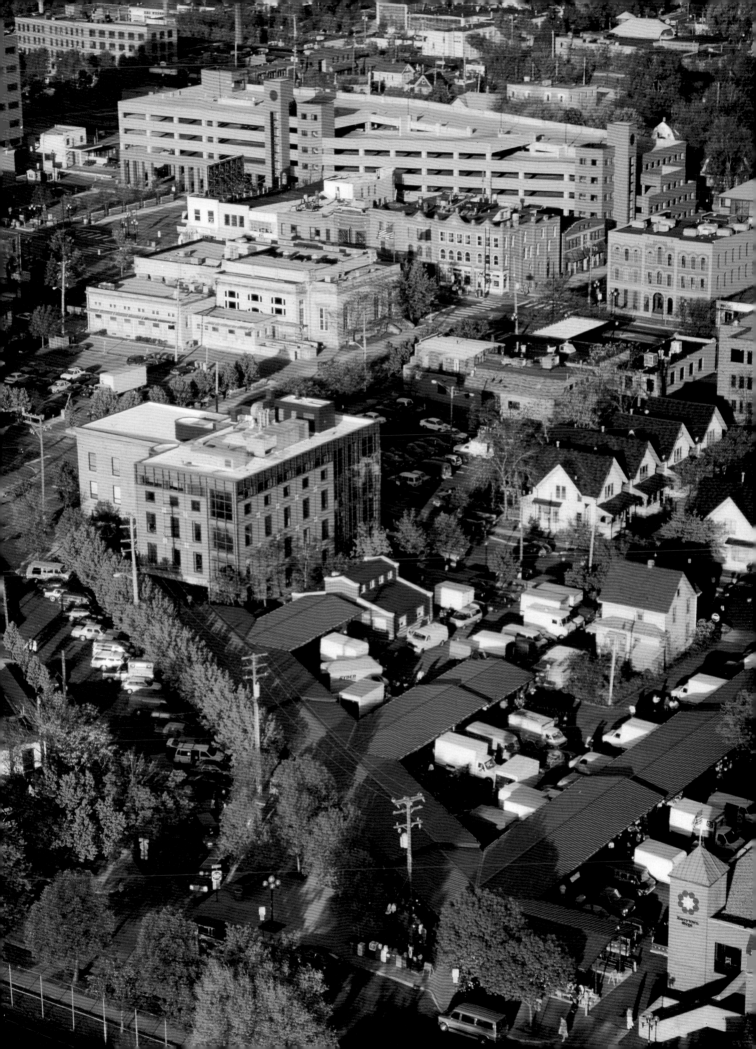

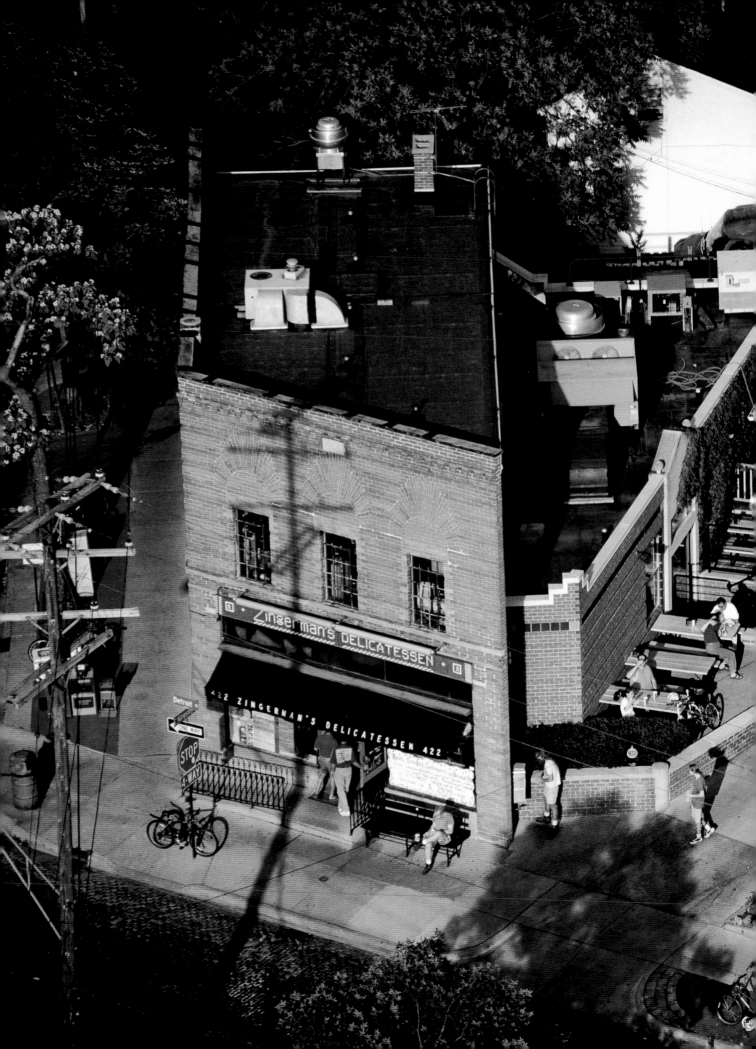

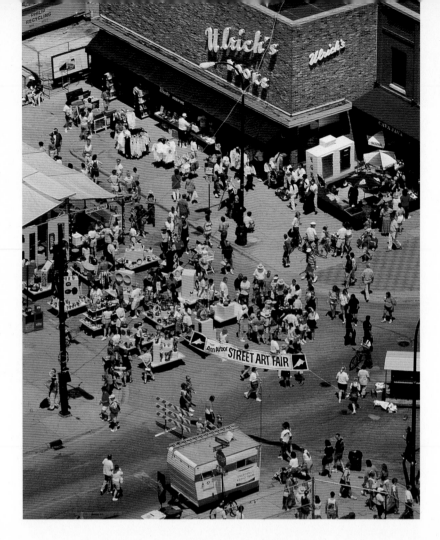

"Ann Arbor is a unique city because of the University. In the years before World War II the population was, as I recall, around 25,000, and it felt like a small town. At that time, the University played an even larger role in the community than it does today. During the depression, the University offered free or inexpensive forms of entertainment to the people of Ann Arbor which weren't available in other cities. I mostly took advantage of the sporting events the University hosted, but concerts, plays and art exhibits were also plentiful. Today, Ann Arbor is an important community in the country for many reasons in addition to the University: its health care facilities, its high-tech industries, and it is also a national center for book printing and binding."

Herbert H. Upton, Jr.
President, Malloy Lithographing, Inc.

What began in 1960 as two blocks of booths and 100 artists now covers South University *(opposite)*, East University *(above)* and Church Streets each year during the third week in July. Today, the juried Ann Arbor Street Art Fair, a leader of the nationwide art fair movement, is the smallest and most selective of the three simultaneous fairs, with nearly 200 artists representing 36 states exhibiting from a pool of thousands of applicants.

From coffee houses to music dealers, fast food to flowers, South "U" is home to dozens of businesses catering to the student population. An eccentric blend of old and new, this area features everything from fine wine to pinball, bagels to school books, pizza to pastries. Ann Arbor is a book collector's paradise, boasting the highest per capita book buying rate in the country. It is home to Ulrich's *(above)* and many other bookstores, birthplace of Border's Books, and has the highest number of antiquarian books and booksellers per capita for any U.S. city.

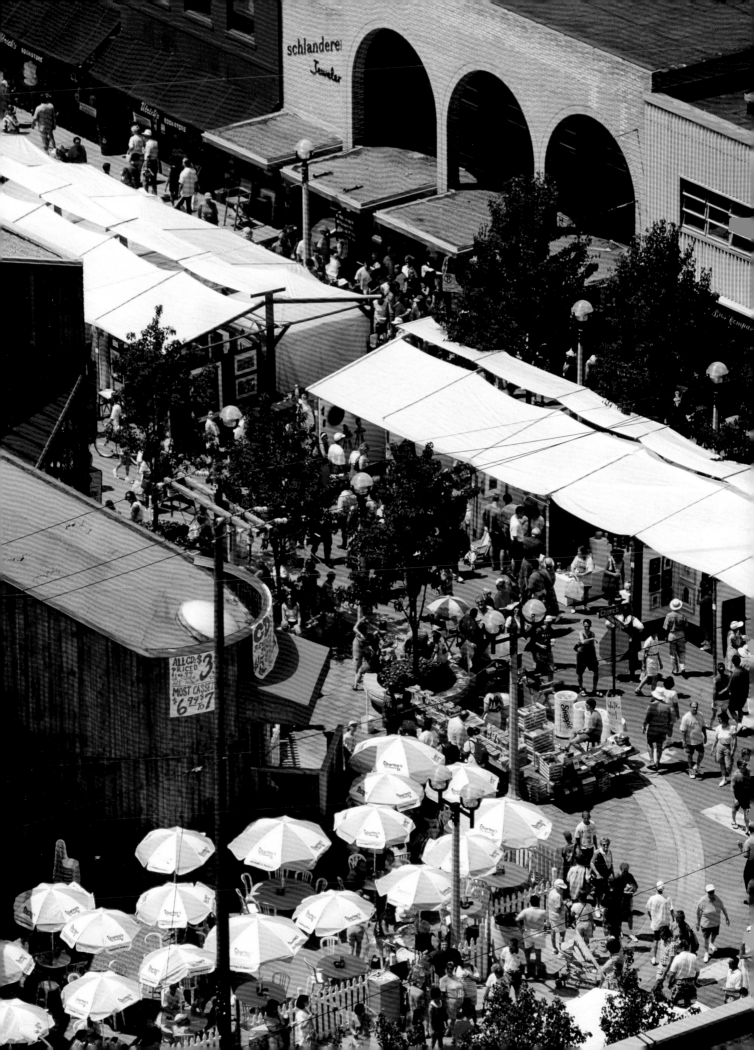

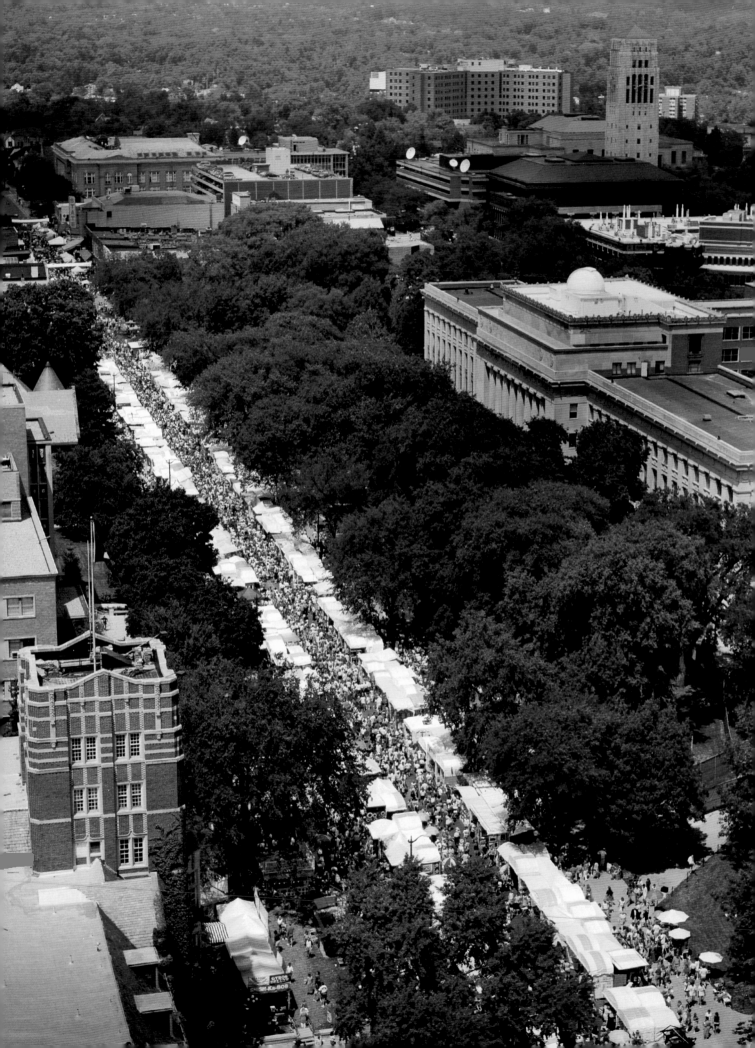

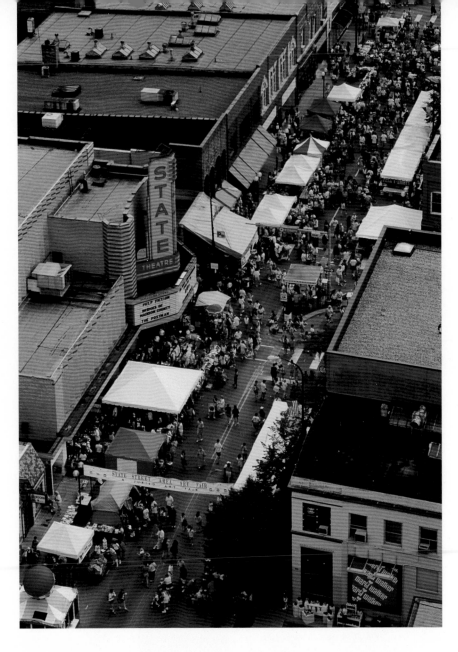

"Ann Arbor is a remarkable community filled with astonishment and beauty. Capturing images of it is hugely worthwhile. The University of Michigan contributes greatly to the Ann Arbor community, both in the vigor and variety of its members and the glories of its architecture."

Philip H. Power
Regent, University of Michigan

Each July, more than 500,000 art lovers converge on Ann Arbor for the three simultaneous art fairs, one of the largest such events in the country. In 1996, the 29th annual State Street Art Fair *(opposite and above)* welcomed nearly 300 prominent artists representing a variety of media. In addition to enjoying the fine arts and crafts, participants are entertained around the Diag by multiple street performers, and on two nearby amplified stages by diverse groups from jugglers to ethnic dancers and musicians. This fair's location, in the heart of the State Street business district, also allows attendees to partake of delicacies from the many restaurants and coffee houses nearby or to shop 'til they drop at area stores.

The Art Deco State Theater *(above)* has been an Ann Arbor landmark since it opened in 1942. Designed by C. Howard Crane, architect of the ornate Fox Theater in Detroit, the State also houses trendy Urban Outfitters on its first floor.

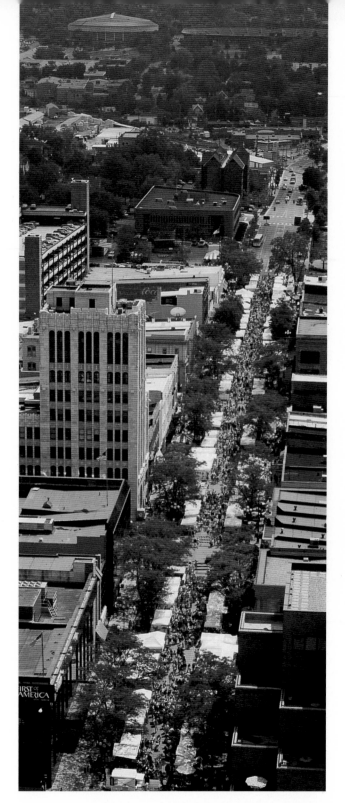

"Ann Arbor is, in many ways, Michigan's undesignated capital. It represents so much of what modern Michigan strives for: preservation of the past, creation of the future—and it has a wonderful present. From its vibrant cultural life centered on the University (but not exclusively) to its wonderful Main Street restaurants and shops, Ann Arbor has a lifestyle almost anyone can appreciate. Its older communities and its vigorous recent housing represent some of the Midwest's finest creative planning."

Edward Surovell
President, Edward Surovell Co./Realtors

Main Street, between William and Huron *(left and opposite)*, is the heart of Ann Arbor's vibrant downtown. Heralded as a model of urban redevelopment, its cosmopolitan blend of shopping, dining, entertainment and personal services are housed in new construction intermingled with restored and revitalized historic buildings. The 350 S. Main building is downtown's newest mixed-use development, combining retail space on the first level with expansive offices above. Just down the street, the former Kline's Department Store is being reconfigured to house Chianti, award-winning chef Jimmy Schmidt's newest venture, along with The Ark, Ann Arbor's beloved folk music venue. The array of Main Street eateries such as Gratzi, Real Seafood Company, Palio, Mongolian Barbecue and others, along with several new specialty boutiques, provide many choices for exciting downtown excursions.

The Ann Arbor Summer Art Fair *(above)*, youngest and largest of the three art fairs, is sponsored by the Michigan Guild of Artists and Artisans. The work of nearly 600 nationally-known and emerging artists specializing in contemporary American art and fine crafts is accompanied by performing and edible arts throughout the four-day event.

(Overleaf) In the area near South University and Geddes, Washtenaw Avenue passes several U-M central campus buildings including East Engineering, Dennison and C. C. Little before converging with North University where Ruthven Museums, the Dental School, Chemistry Building and Natural Science Museum are located.

ANN ARBOR

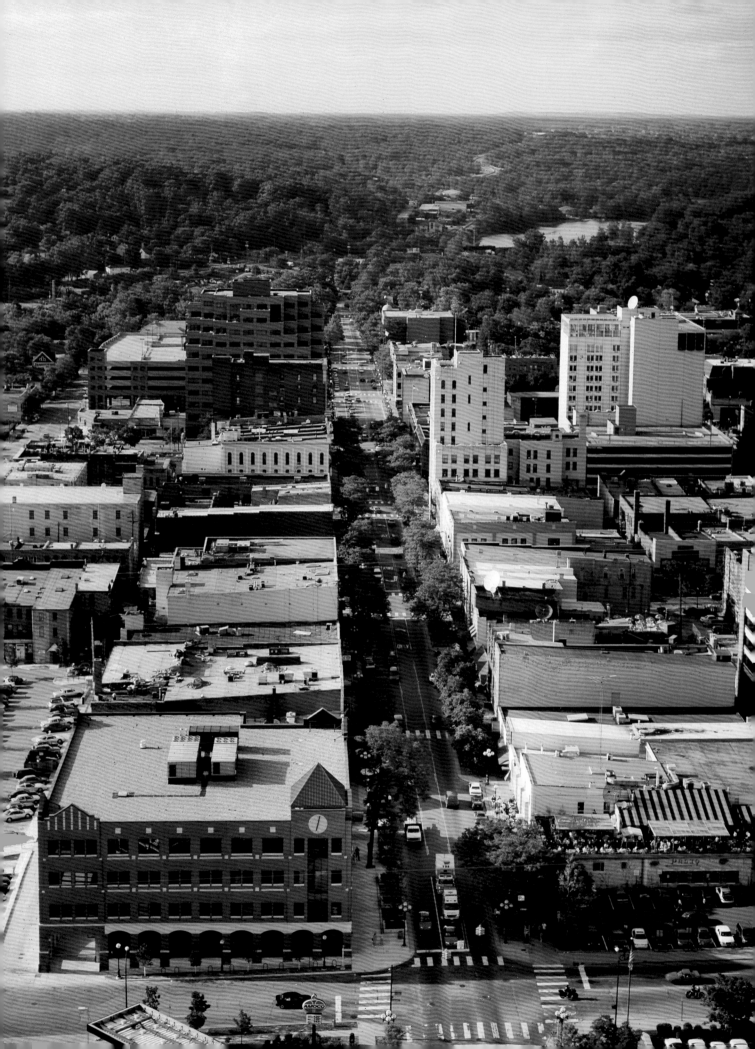

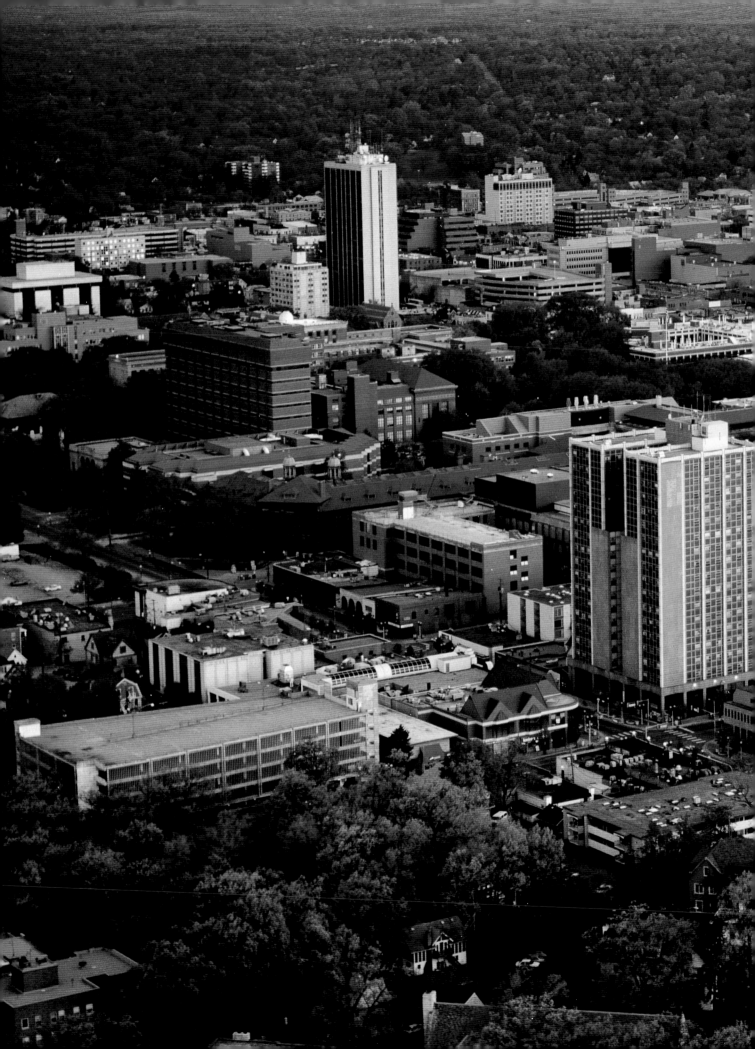

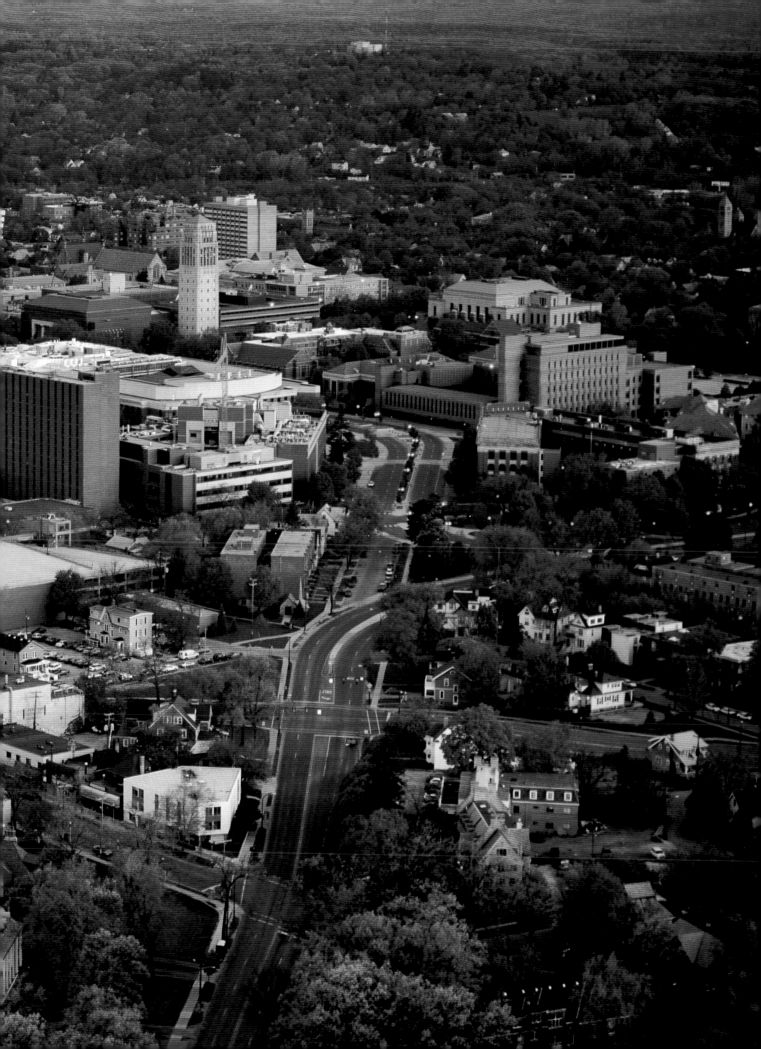

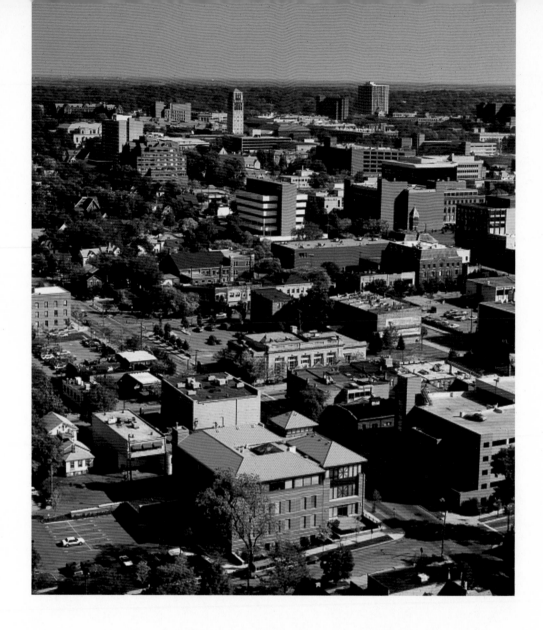

"Without question, downtown is the heart and soul of the community from a business standpoint. Its vitality and evolving businesses and attractions give Ann Arbor distinctive character and appeal. Downtown benefits the entire community and without it there is no Ann Arbor."

Woody Holman
President, Ann Arbor Area Chamber of Commerce

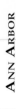

A unique blend of old and new, many of Ann Arbor's historic red brick structures have been preserved and renovated to accommodate everything from legal offices to art galleries, restaurants, fitness centers and music stores. In the area near Liberty and First Streets *(opposite)*, one treasure, Hertler Brothers, was established as a feed store in the early 1900s and still sells garden supplies in the same location. Others like Schlenker's Hardware, Ann Arbor's oldest retail business that opened in 1886, recently closed, making way for new stores and new traditions.

Another mix of old and new, the area near Ashley & Miller *(above)* includes a variety of architectural styles, from Italianate and Romanesque to contemporary. Just as diverse is the mix of government buildings and businesses—from century-old Dobson McOmber insurance and landscape architects Johnson, Johnson and Roy to the landmark Heidelberg Restaurant.

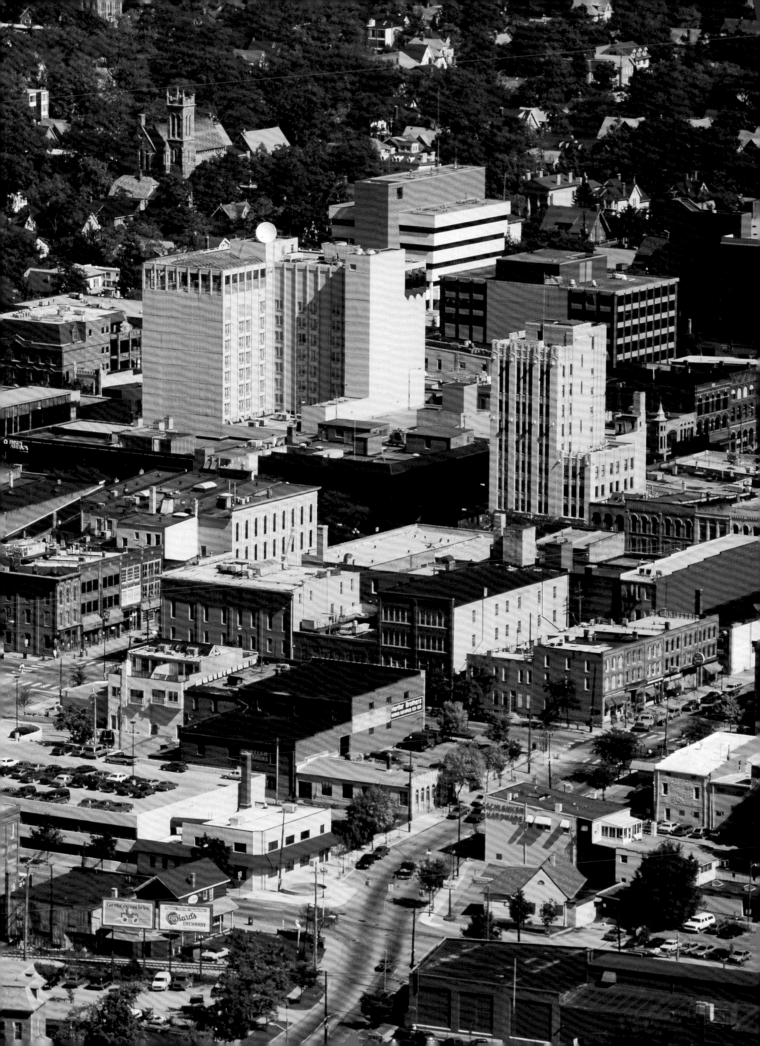

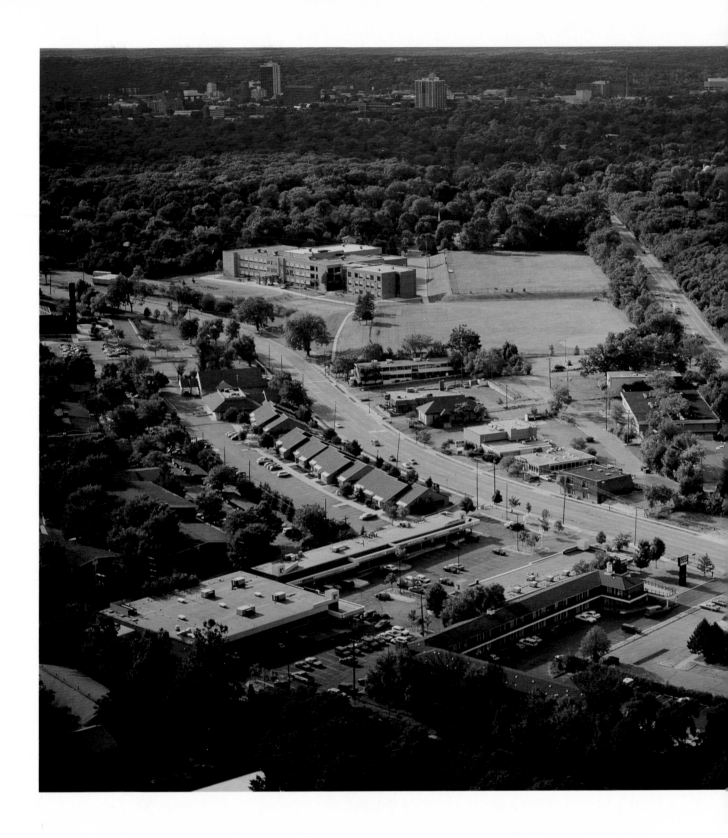

Washtenaw Avenue and East Stadium converge in the center of southeast Ann Arbor. Private homes and small businesses share this area of the city with U-M fraternities, sororities and residence halls. Residents are served by neighborhood shopping centers such as LampPost Plaza, one of Ann Arbor's first, built in 1964; churches of many denominations such as Assembly of God-Evangel Temple; and schools including Tappan Middle School, located on 20 acres at Brockman and E. Stadium.

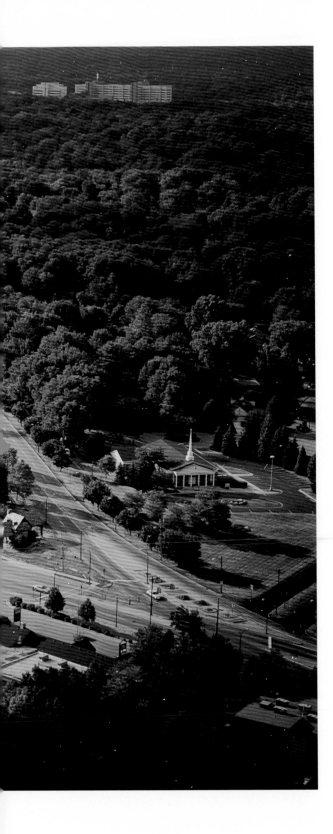

Southeast

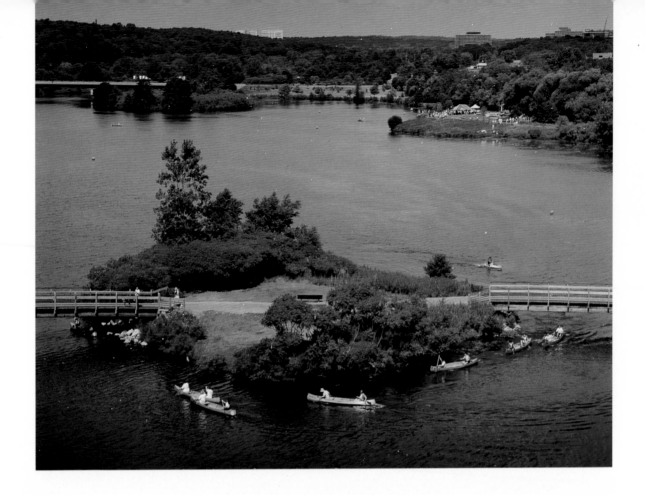

"I first came to Ann Arbor on a hot July day in 1967 and immediately rented a canoe at the Livery on Argo Pond. You could take the canoe right between Main Campus and North Campus and down to what later became Gallup Park. There are now 13 parks along the river from Barton Pond to Gallup Pond, almost totally connected by paths for strollers, bikers and Rollerbladers. While most people regard it for its campus and downtown, Ann Arbor is really a "river city."

Peter Allen
Partner, Allen & Kwan Commercial

A spectacular sunrise over Gallup Park *(previous pages)* signals another picture-perfect day in Ann Arbor's most popular park and nature area. After a 1972 flood damaged the dam at Dixboro Road, Gallup Park *(opposite and above)* was developed at Fuller Road just west of Huron Parkway. Its 83 acres span Geddes Pond and the Huron River, creating a wildlife refuge and offering a wide range of outdoor activities for people of all ages, from canoe and paddleboat rentals to fishing, jogging and biking. The park's extensive nature trail system, picnic and playground areas make Gallup a delightful getaway just minutes from downtown.

Companies large and small participate in the annual Corporate Challenge Canoe Race *(above)* held each July at Gallup Park during Huron River Day. Sponsored by *The Ann Arbor News*, the event raises funds for Parks and Recreation Department-sponsored scholarships that make recreation possible for low income children. More than 300 local families benefit each year, with their children participating in activities such as ice skating instruction, neighborhood competitive swimming meets and a variety of programs made available to them through the Ann Arbor Public Schools.

(Overleaf) For decades the annual Ann Arbor Blues and Jazz Festival has signaled the end of summer with an all-star lineup of national and local talent. The serenity of Gallup Park, the stately grandeur of the Michigan Theater and the dark, smoky ambience of The Bird of Paradise jazz club offer an unusual combination of venues for the three-day music fest.

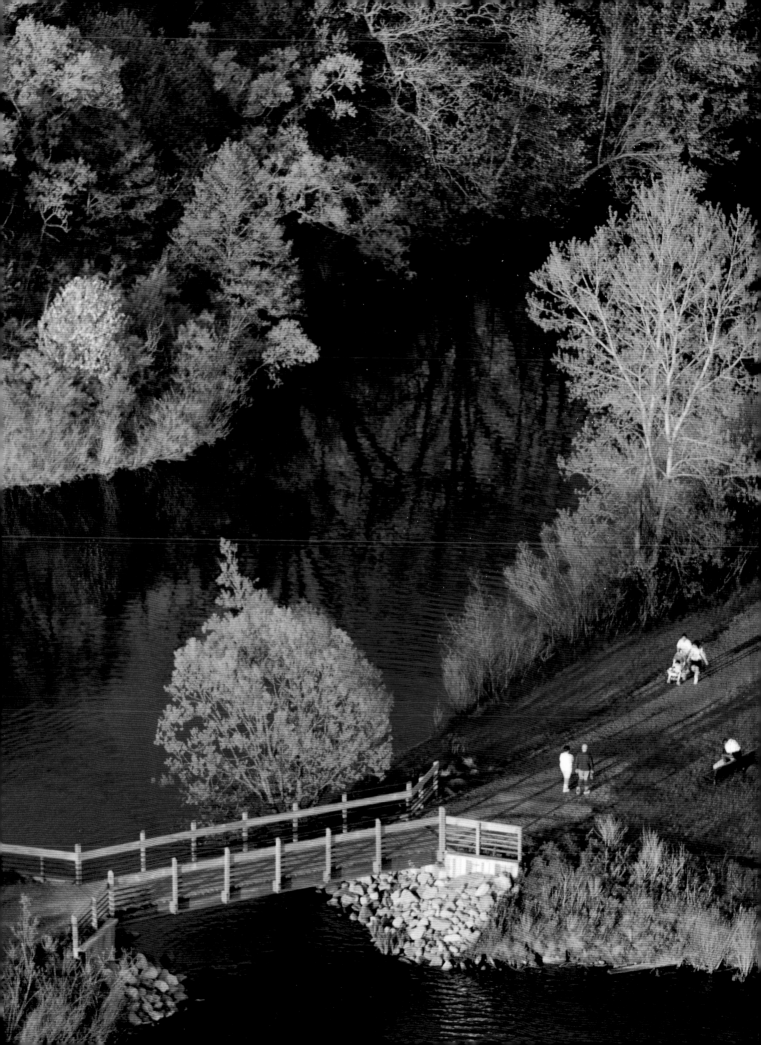

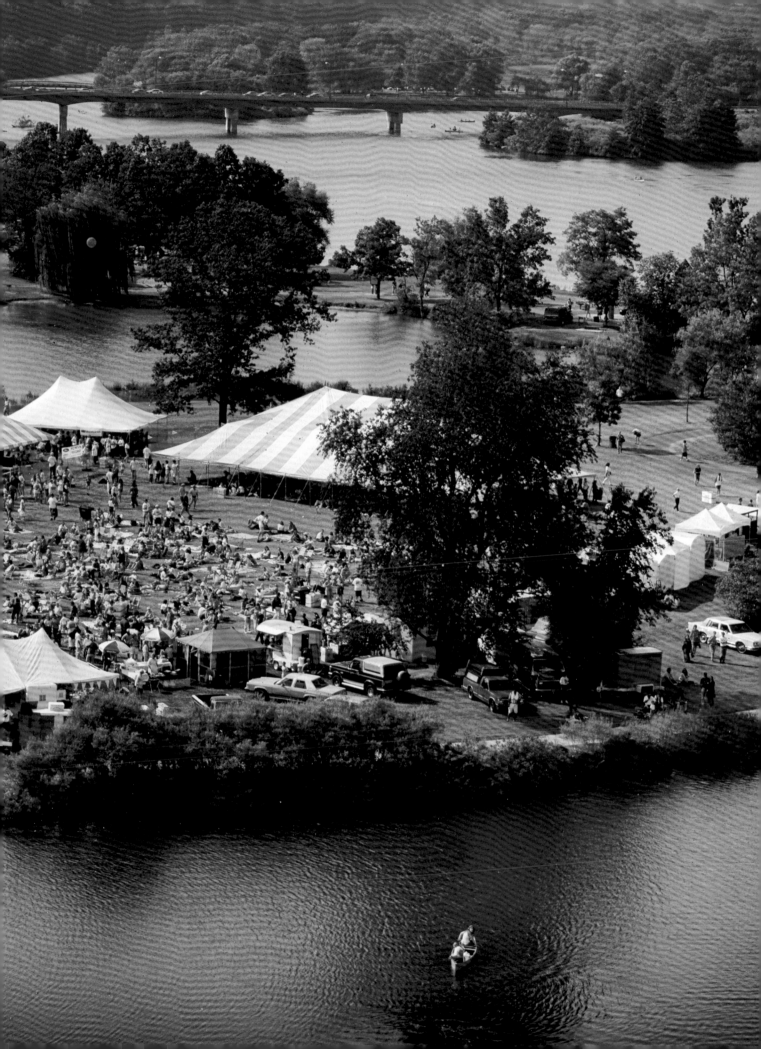

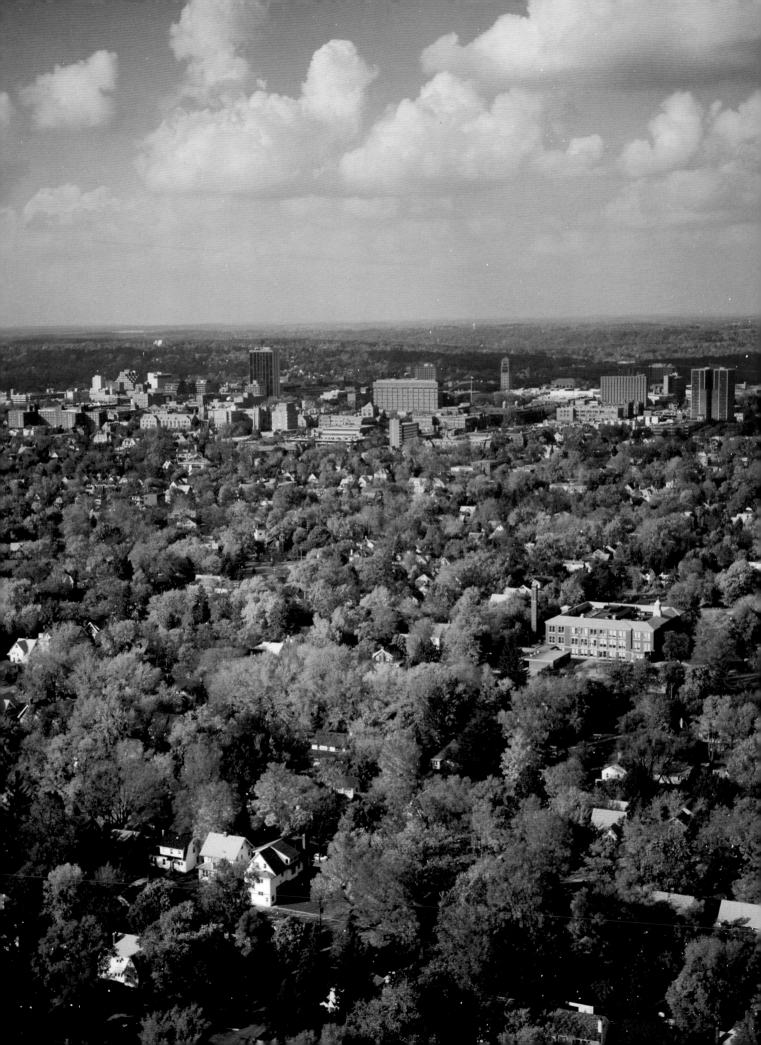

"Ann Arbor is a remarkable city, economically strong, diverse and constantly changing. Shaped by a world-renowned University, with all of its academic, cultural and social opportunities, it's also a quiet family town, with beautiful neighborhoods, wonderful restaurants and outstanding parks along the Huron River. Ann Arbor is a journalist's dream—a colorful, vibrant community with no end of interesting stories to tell."

Patricia Garcia
Publisher, Ann Arbor Observer

Many of Ann Arbor's most cherished homes are located in the tree-lined Burns Park area *(opposite)*. Families with young children choose the quiet, peaceful neighborhood of older colonial and traditional homes because it offers one of Ann Arbor's finest schools, Burns Park Elementary, with an impressive student to staff ratio of 16:1. Fifteen-acre Burns Park is among the city's oldest parks. Originally part of the Washtenaw County Fairgrounds, it was developed in the early 1900s and included an oval of trees where horses raced.

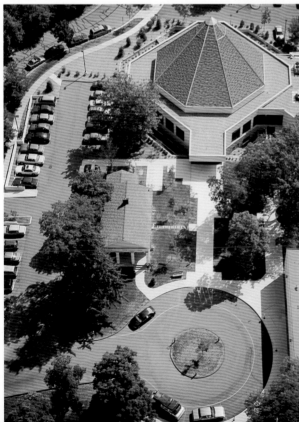

St. Francis of Assisi Catholic parish was founded in 1950, celebrating its first Masses in Pittsfield School before moving into a small church the next year. The continued growth of the parish culminated in 1969 with the dedication of a larger contemporary structure featuring an uplifting carillon *(above)*. St. Francis of Assisi also offers a "waiting list only" parochial education alternative—a K through 8 curriculum touted as one of Ann Arbor's best educational programs.

Temple Beth Emeth and St. Clare Episcopal Church each hold their own religious services under a single roof *(left)* through an innovative governing body called Genesis of Ann Arbor. Built in 1955 by St. Clare Episcopal Church, the facility has served both congregations since 1970 and became jointly owned by them in May of 1975. Temple Beth Emeth holds Jewish Temple services each Friday and Saturday, and St. Clare Episcopal Church conducts its liturgy on Sundays.

"Ann Arbor has a personality all its own that appeals to one's senses. As a place that encompasses the benefits of a small town, a big city, urban and rural life, once you've arrived it's very hard to leave. Ann Arbor is a real gem!"

Terry Foster
Community Leader, Ann Arbor

"I was born in Ann Arbor and have lived here all my life. I've watched it grow from a sleepy little college town to the prosperous urban area it is today. Despite the intense growth of recent years, Ann Arbor keeps its uniqueness and natural beauty. This city is the greatest!"

Richard E. Raab
Entrepreneur,
Ann Arbor

Tranquil...fragrant...lush describe the peaceful beauty of Nichols Arboretum *(opposite and above)*, an elegantly designed forest preserve in the heart of town near the U-M Medical Center. Owned and maintained by the University's School of Natural Resources and Environment, the "Arb" began with a gift in 1906 of 30 acres from Dr. and Mrs. Walter H. Nichols. Today, more than 600 different native and exotic species of trees and plants, including collections of peonies *(above)*, lilacs, rhododendrons and the 10-acre Dow Prairie, create a scenic botanical garden that winds through more than 120 acres. The Arboretum is the perfect spot for a quiet stroll, a refreshing run, a picnic or lazy afternoon.

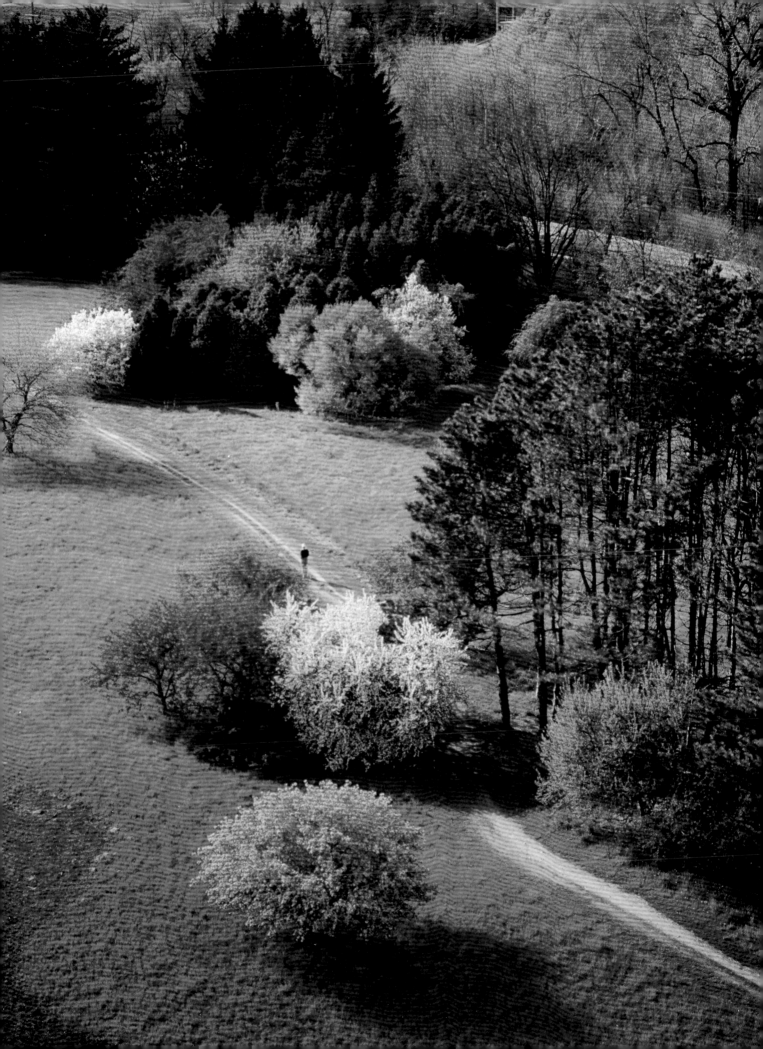

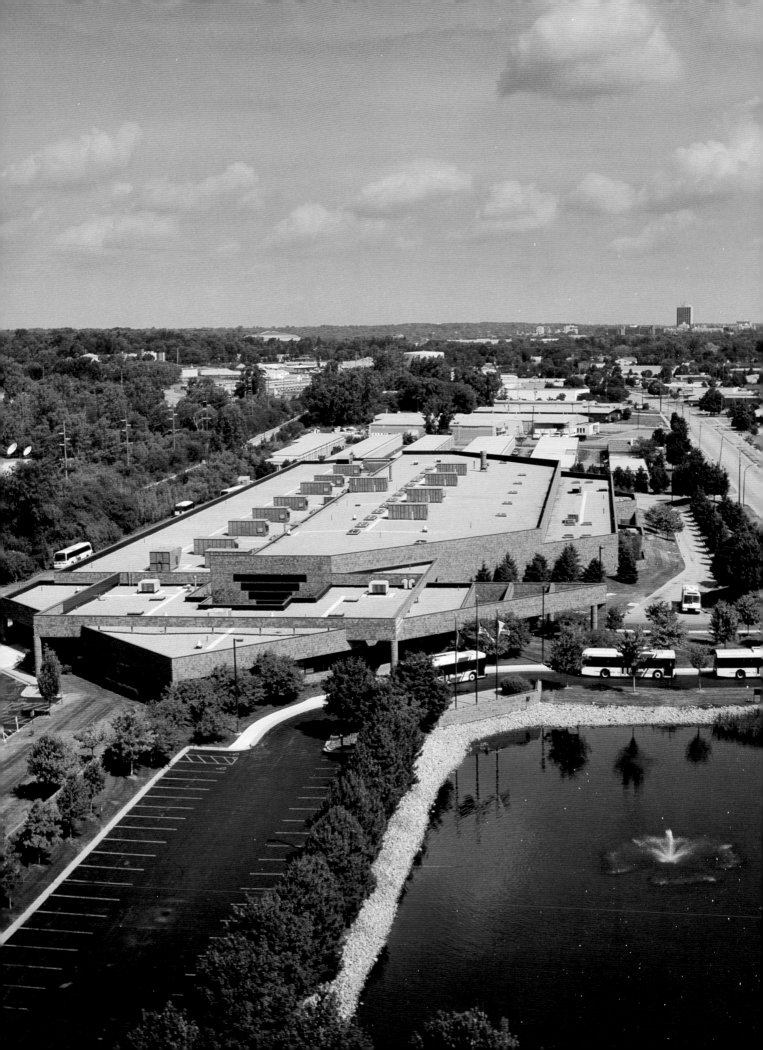

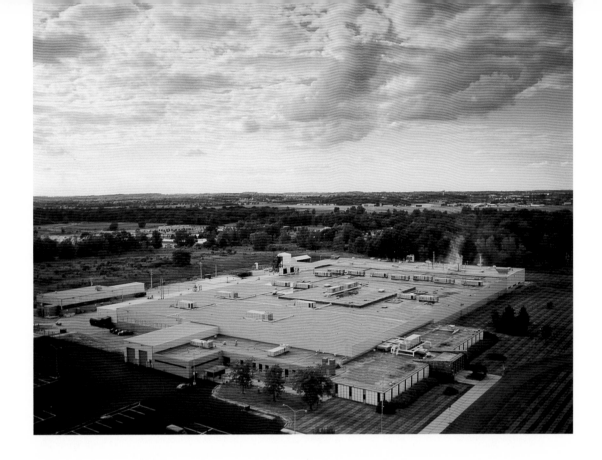

"Ann Arbor is a unique community with diversity, great parks, varying educational opportunities, trees, culture, fine dining, shopping, good business and, above all, caring people. It is a distinct pleasure to head up our public transit system and serve this wonderful community."

Gregory E. Cook
Executive Director, Ann Arbor Transportation Authority

"Sights, sounds and smells of Ann Arbor are unlike any other place. Where else can art, medical research, manufacturing and business all converge so beautifully in a single city? A city that has never acted its age, new ideas, new businesses and new people breathe fresh life into Ann Arbor every day."

Larry McPherson
President & C.O.O., NSK Corporation

Ann Arbor's public transit fleet carries more than four million passengers on "The Ride" each year. Housed in a striking 137,000 square-foot facility *(opposite)*, the AATA serves Ann Arbor, Ypsilanti, Pittsfield and Superior Townships and the villages of Dexter and Chelsea. Recipient of the American Public Transportation Association Award for Best Midsize Transit System, "The Ride" also meets the transportation needs of senior citizens and the disabled as well as sponsoring special Art Fair and Football Saturday shuttles.

NSK Corporation *(above)*, a manufacturer of anti-friction bearings and related precision products, has been a part of Ann Arbor since 1913. Serving customers from twelve locations throughout the United States, its corporate headquarters, a technical center and a manufacturing facility are all located in the city.

ANN ARBOR

"Ann Arbor: an eclectic collection of great people, great food, books galore, the best coffee in America, wonderful music, shady streets and entertainment politics."

Don Van Curler
President, Van Curler Associates, Architects + Planners

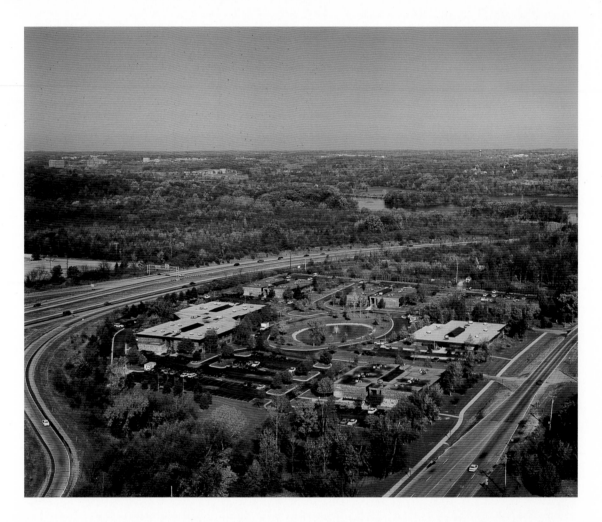

"One of Ann Arbor's greatest strengths is the diversity of its citizens. You're as likely to meet someone from halfway around the world as from a neighboring state. That diversity makes our community an interesting place to live."

Dave Wierman
Publisher, The Ann Arbor News

Blooming forsythia inundate the tree-lined Huron Parkway in spring. Come summer and fall, the Huron Hills area is filled with golfers, only to be replaced by cross-country skiers in winter. The Parkway makes its lazy way south through Ann Arbor's eastern sector beginning north of Plymouth Road, crossing the Huron River at Gallup Park *(opposite)*, and terminating at Platt Road.

On 7.3 parklike acres between US-23 and Hogback Road, the seven contemporary buildings—each with its own atrium—of Hogback Officenter *(above)* enjoy the sylvan atmosphere of the nearby Huron River. Built in 1980 by Flying Dutchman Construction, the Officenter is home to *Car & Driver* magazine and the Subaru of America Emissions Office, both of which have been tenants since the development opened, plus housing a combination of 54 additional community service organizations, healthcare and other professionals.

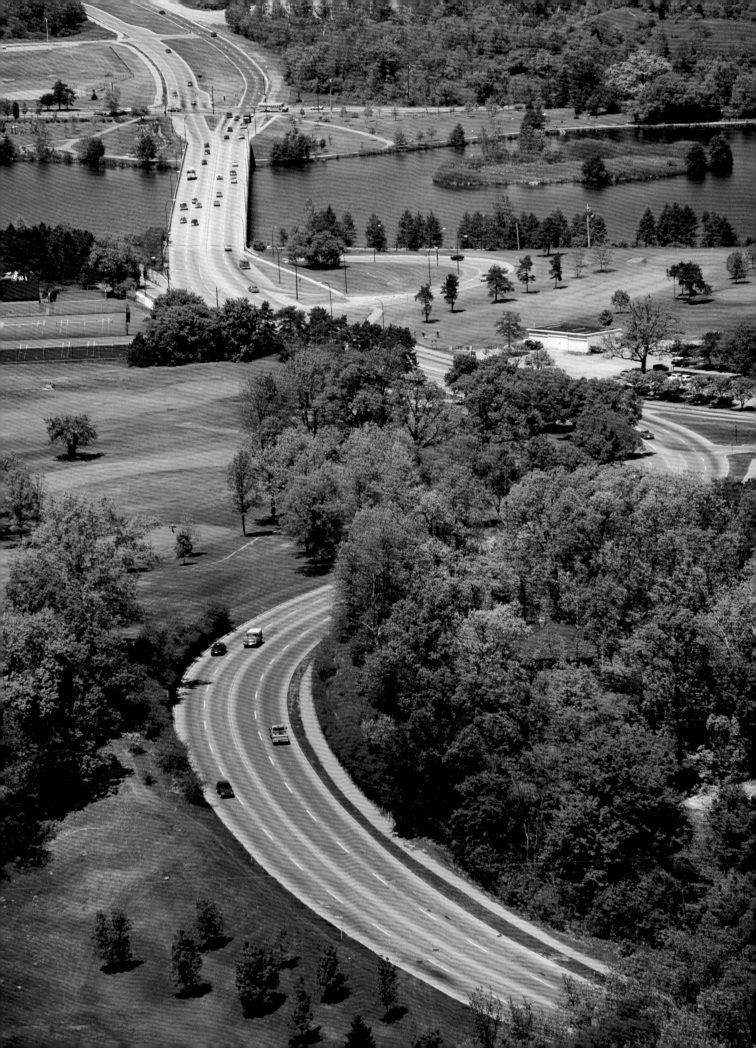

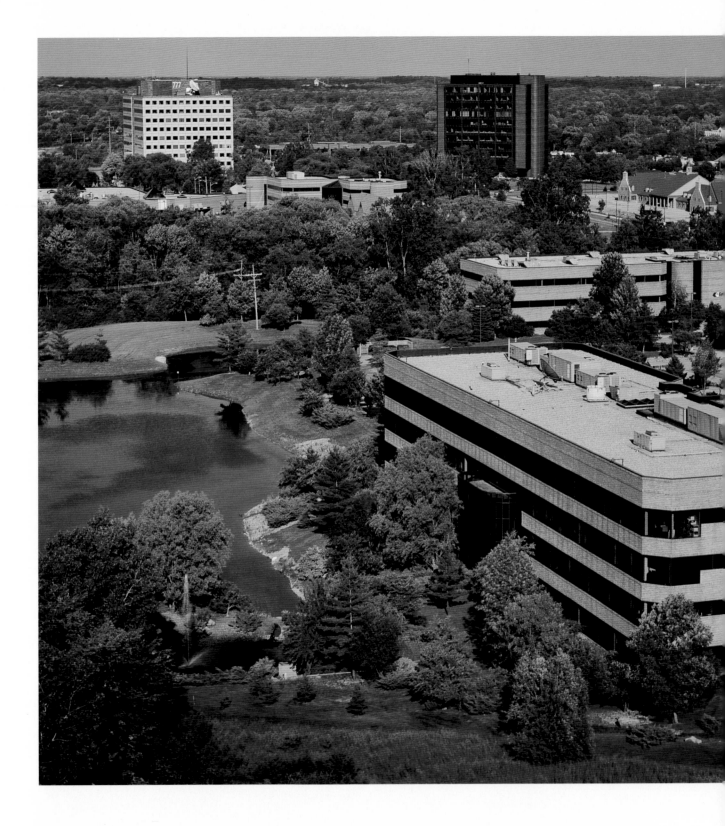

Just three miles south of downtown Ann Arbor, the Briarwood area is home to a thriving community of office complexes and professional buildings, housing tiny single-employee businesses to global-market companies. U-M Medical Center offers a variety of outpatient services in the Williamsburg Square facilities and many U-M administrative departments are now located in Wolverine Tower. Added to the extensive mix of hotels, restaurants, retail shopping and personal services near Briarwood and also Ann Arbor-Saline Road are a plethora of condominiums, apartments and single-family housing developments, making the southwest sector one of Ann Arbor's fastest growing regions.

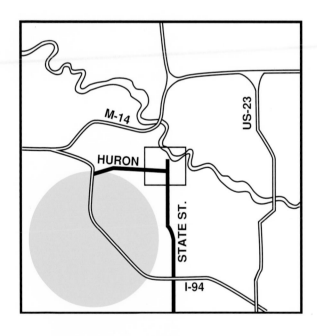

Southwest

"As lifelong residents of Ann Arbor we tend to expect and accept the special quality of life that exists here. However, we are truly fortunate to be able to raise our children in a 'small' town that offers the diversity of experiences found in Ann Arbor. I believe this is the greatest strength of our city. It is a lasting benefit that our children will carry with them wherever their lives may lead."

Dave Hirth
Co-owner, M-Den

Ann Arbor Airport *(opposite and above)* is a 24-hour municipal facility handling executive, charter, and private planes as well as significant helicopter traffic from business, television and air ambulance activity. The 700-acre operation offers hangar and tiedown facilities and is home base for flight instruction, ground school services and flying clubs. The Goodyear blimp operates from here on special Ann Arbor occasions and, during U-M home football games, the airport accommodates as many as 15 banner-towing aircraft along with regular airport traffic. Utilizing a single hard-surface runway and an intersecting turn runway, Ann Arbor air traffic controllers oversee an average of 105,000 single-engine, twin-engine, turboprop, small jet and helicopter flights each year from their control tower commissioned in June, 1973 *(opposite)*.

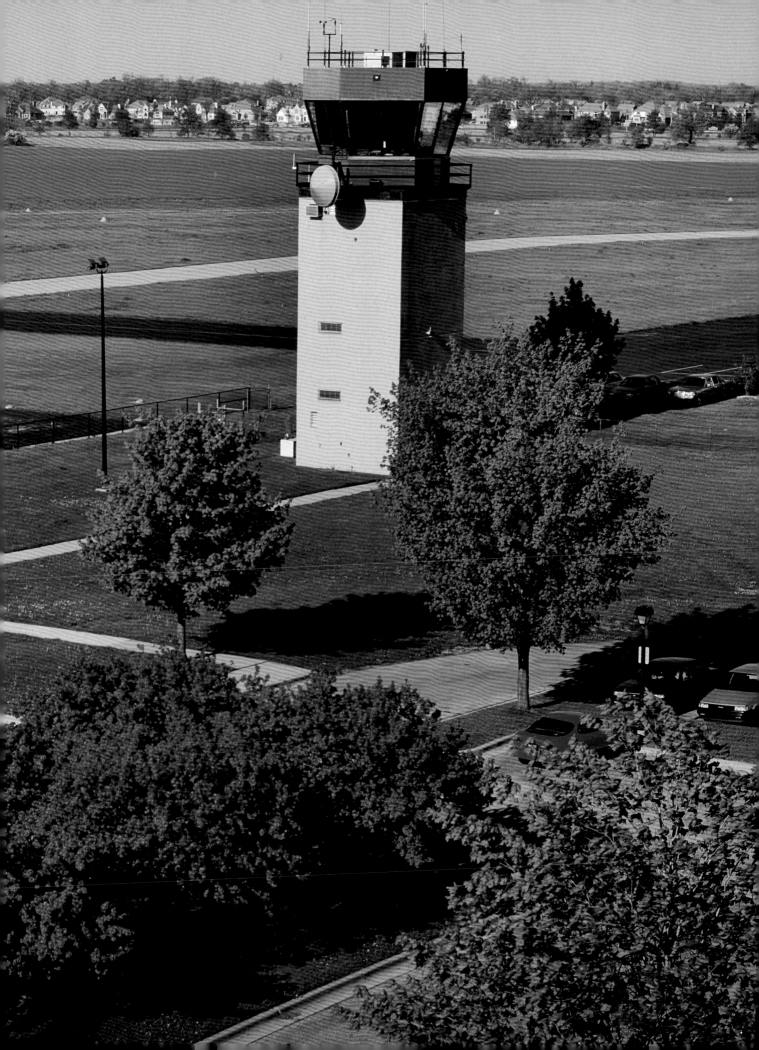

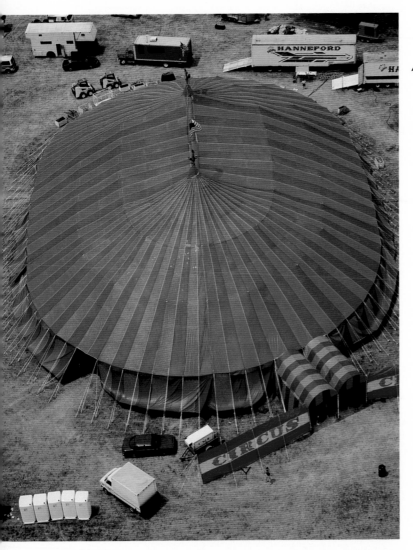

"The Ann Arbor Public Schools serve a community dedicated to learning and instructional excellence. Students achieve outstanding levels of academic performance in this exceptional academic environment, with five institutions of higher learning within a ten-mile radius. Our student population mirrors the community in diversity, offering a rich spectrum of racial/ethnic groups with varied interests, concerns and socio-economic backgrounds. The entire educational community benefits from the superb resources that are readily available here, including intellectual, cultural and recreational activities typically found only in major metropolitan areas."

John O. Simpson,
Superintendent,
Ann Arbor Public Schools

For more than 30 years, the Ann Arbor Jaycees have sponsored their annual four-day carnival and midway *(opposite)* at Pioneer High School to raise funds that enable them to sponsor and support a wide range of community service programs throughout the year. Carnival attendance tops 15,000 each year, making it the organization's single largest money maker.

Fun and fundraising have been the dual purposes of St. Joseph Mercy Hospital's Circus Weekend *(above)* since the annual event's inception in 1985. Three days of merriment begin with an old-fashioned circus parade through downtown, featuring professional circus performers, animals and some of Ann Arbor's own volunteer circus-type talent. A gala black-tie dinner and kickoff performance, followed by two full days of public performances under the Big Top, raise thousands of dollars each year to support various units at the Hospital. An excellent example of public/private partnership, Circus Weekend rallies community volunteers in support of an eminently worthwhile cause while providing entertainment for children of all ages.

(Overleaf) Pioneer High School opened in 1956 on 177 acres at the intersection of S. Main and W. Stadium, continuing the tradition begun a century before with the Union School, subsequently renamed Ann Arbor High School and housed in what is now the University's Frieze Building. With nearly 2,000 students and numerous additions and renovations since it opened, Pioneer is Ann Arbor's largest secondary school. Ann Arbor schools emphasize student achievement and they consistently have more National Merit finalists and Michigan Math Prize winners than any other district in the state. In 1994-95, Pioneer High School had the most National Merit semifinalists of any Michigan school and ranked eighth in the nation.

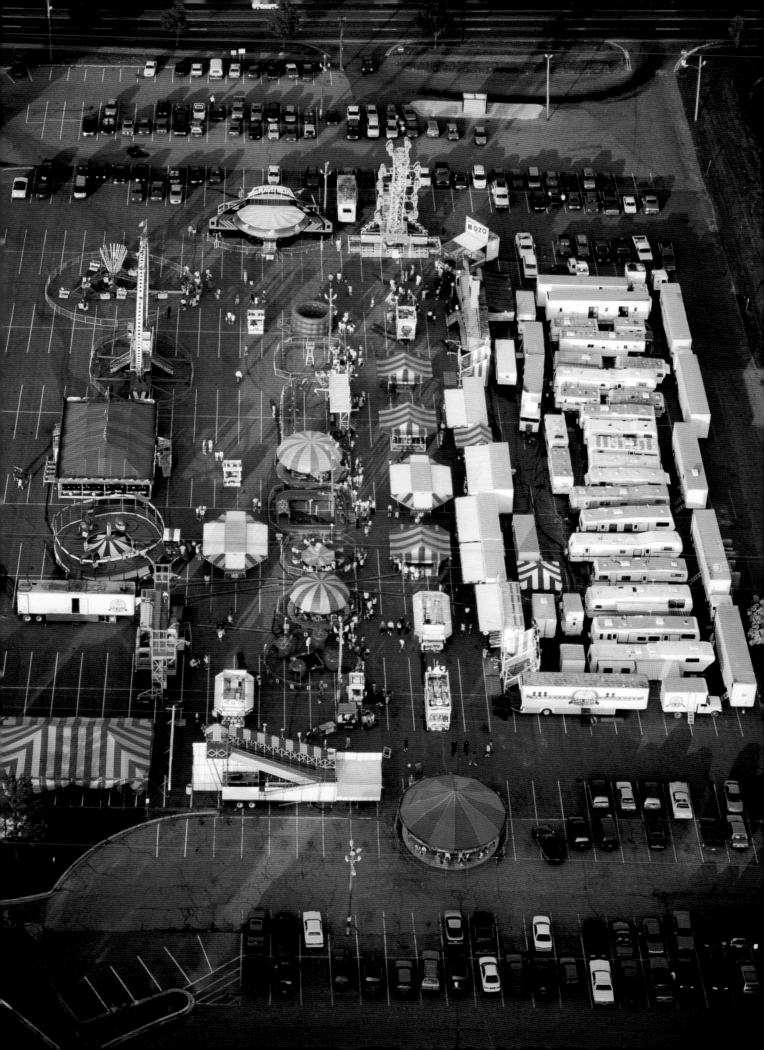

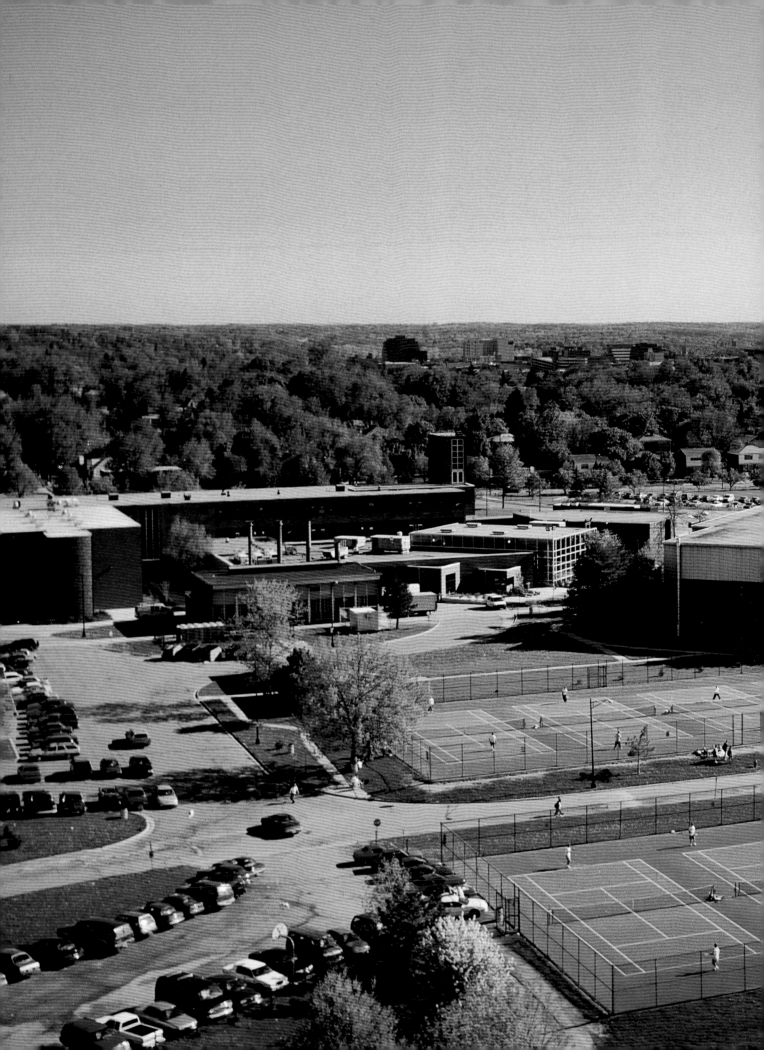

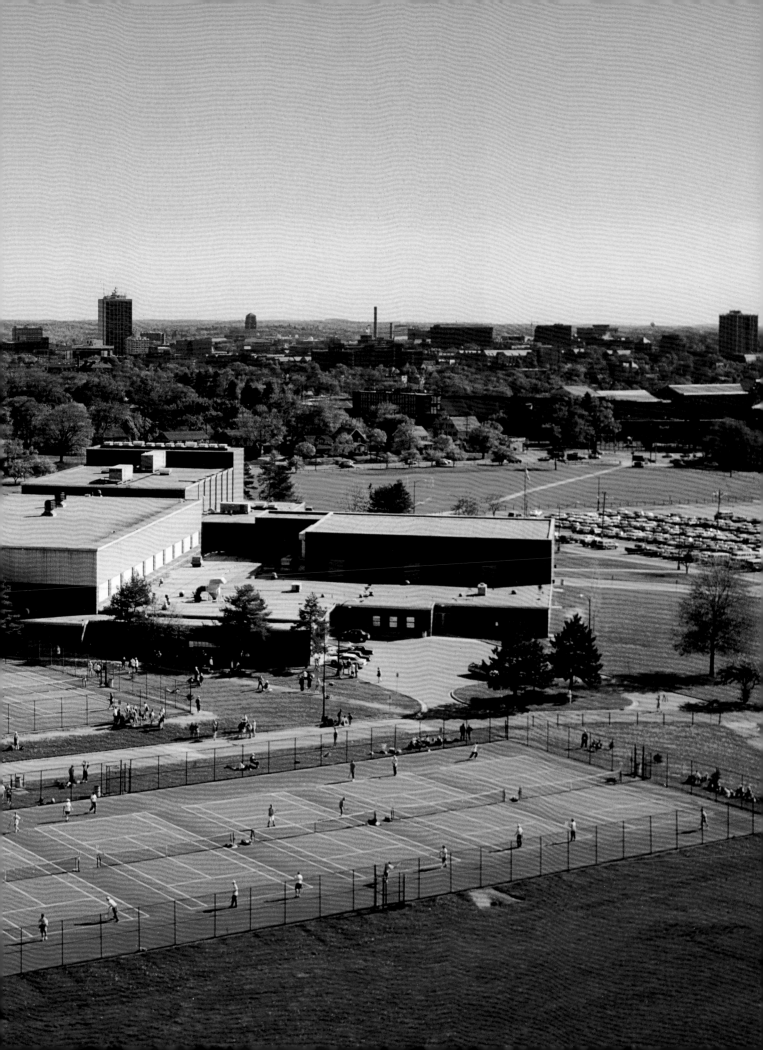

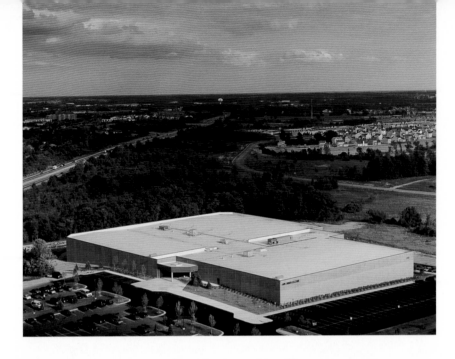

"Look around this place and you'll find farms and suburbia, health food and ice cream, universities and home-schooling centers. There are sports and the arts, and medical centers and midwives. You'll meet people from every culture and background—there's something for *everyone* in Ann Arbor!"

Martha Morgan
VA Medical Center

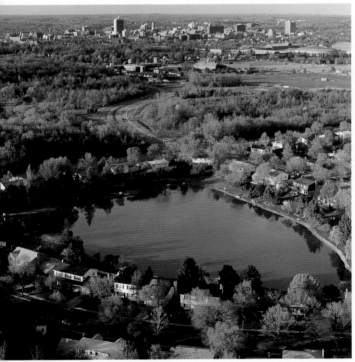

Drive out any major road from downtown Ann Arbor and, within minutes, you'll be surrounded by rolling countryside, farm fields, barns and livestock, such as this area off Scio Church Road *(opposite)*. Many area farmers sell their fresh produce, baked goods and flowers at Ann Arbor Farmer's Market in Kerrytown, allowing them to enjoy both a tranquil rural life and the advantages of the city.

In addition to Ann Arbor's many urban neighborhoods, residents have many other choices just minutes from the city, from suburban developments nestled in the serenity of rolling countryside, to water's edge sites near lakes, ponds and streams. Lans Lake *(left)* is such a location, quietly situated off Scio Church Road yet within sight of downtown Ann Arbor.

Michigan's premier ice and fitness facility, the Ann Arbor Ice Cube *(above)*, opened in the winter of 1995, offering year-round recreation and training for individuals of all ages and skill levels. Two regulation NHL-size rinks serve men's and women's hockey leagues, clinics, camps and classes. Personal training and professional instruction for figure skating and short-track speed skating, as well as public skating, are held on the Olympic-size rink. A Pro Shop, MedSport sports medicine facility, fitness center and full service restaurant complete the amenities at the new sports center.

(Overleaf) Briarwood Mall, one of southeast Michigan's prime shopping centers, opened in 1973 and continues to attain new sales levels each year. Anchored by such retail giants as Hudson's, JC Penney and Sears, in 1993 the mall also became home to Jacobson's, formerly located in downtown Ann Arbor since 1924. With nearly a million square feet of retail space, 7,000 parking spaces and an accessible location at State Street and I-94, Briarwood offers a mix of shopping, restaurants, entertainment and personal services.

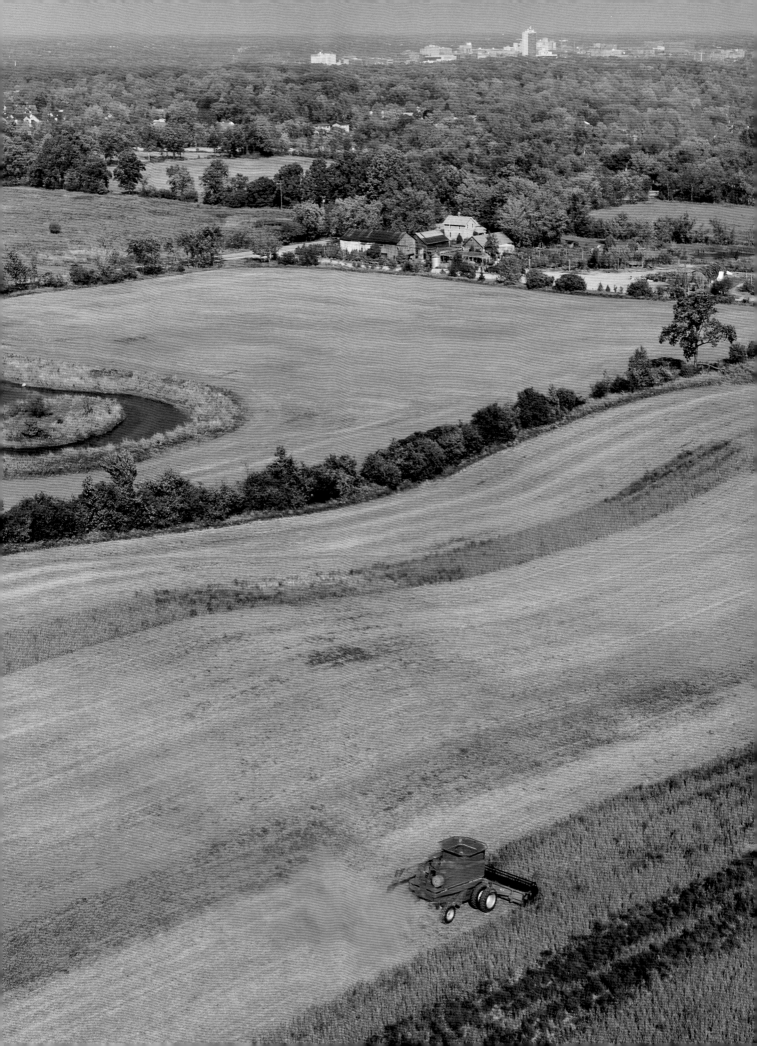

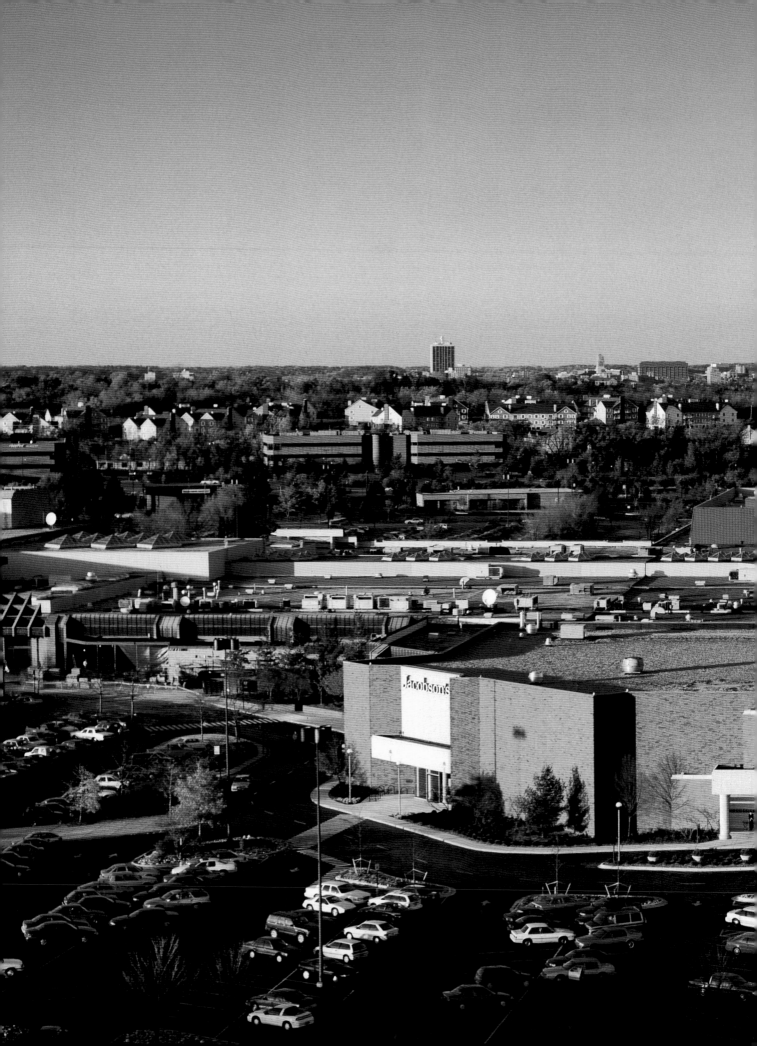

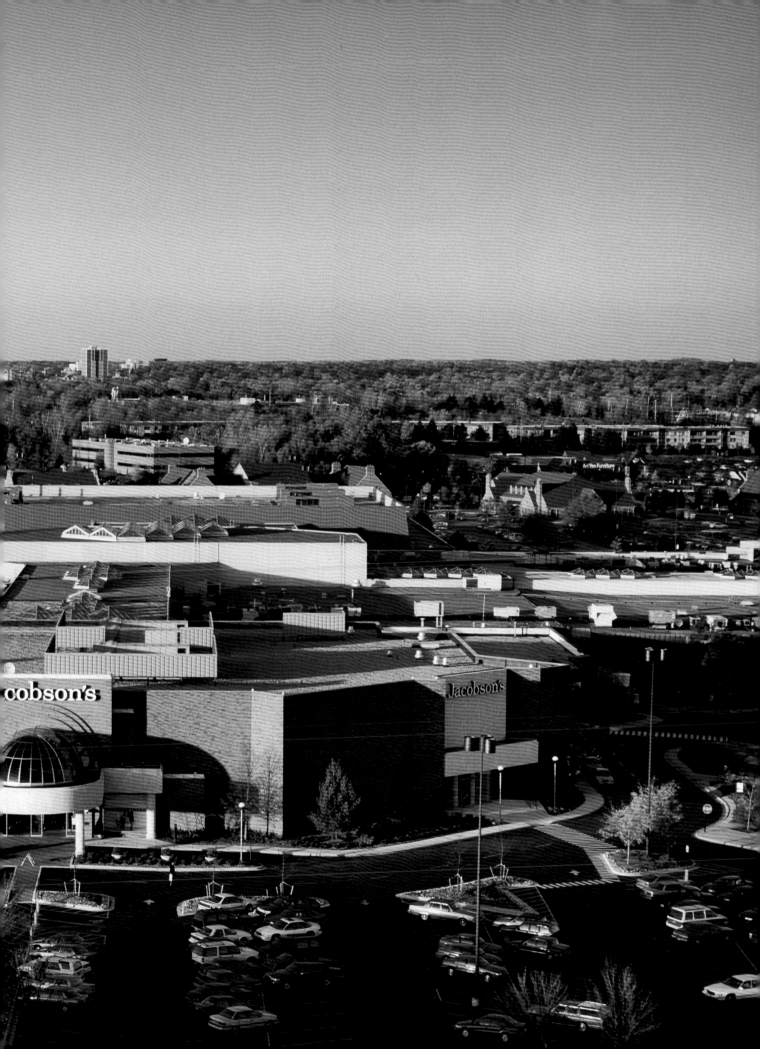

"Ann Arbor has an incredible park system. The City's Parks and Recreation Department is dedicated to making this community a wonderful place to work and play. Visit any other community this size and you will realize we truly are a tough act to follow. I'm proud to be a part of it."

Irene Bushaw
Marketing Specialist,
Ann Arbor Parks & Recreation
Department

Allmendinger Park *(opposite)*, developed in the early 1900s and one of the city's oldest neighborhood parks, was named for the Allmendinger Family who owned a significant amount of property on the west side of Ann Arbor. Generations of Ann Arborites have played softball, basketball and tennis there in the shadows of Michigan Stadium, just two blocks to the east. Residents of the surrounding quiet family neighborhood also enjoy access to the 8.5-acre park's picnic areas and natural ice rink.

In the 1920s, the King-Seeley Company, manufacturers of a hydrostatic gas gauge for cars, was begun in a small Ann Arbor garage by two U-M professors. Rapid growth led to the company's purchase of an 1830s leather tannery at 315 S. First Street *(above)*. Over the next several decades King-Seeley grew and changed with the times until 1982 when three employees bought the manufacturing plant and its diesel engine governor business and formed G.T. Products. Today, G.T. Products produces engineered plastic and metal components in the 127,000-square-foot expanded and updated facility that goes back to Ann Arbor's earliest years.

The Moveable Feast *(also above)*, Ann Arbor's award-winning French-accented American restaurant, features seasonal menus served in a restored 1870s mansard-roofed brick home built in the Second Empire style.

The neighborhood near E. Madison and S. Fifth Streets *(below)* has undergone many changes but much remains as it has for decades. Dale Fisher's childhood home is there, still occupied by his father, Charlie, and so is Fingerle Lumber, in its same location since 1929. The red brick building at Packard and Division that was Perry Elementary School, however, now houses University classrooms and faculty offices.

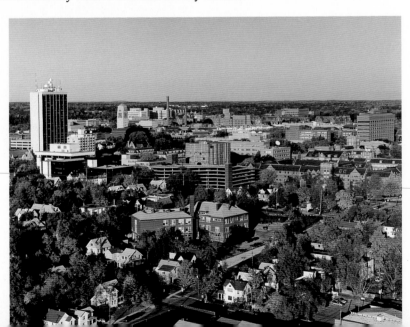

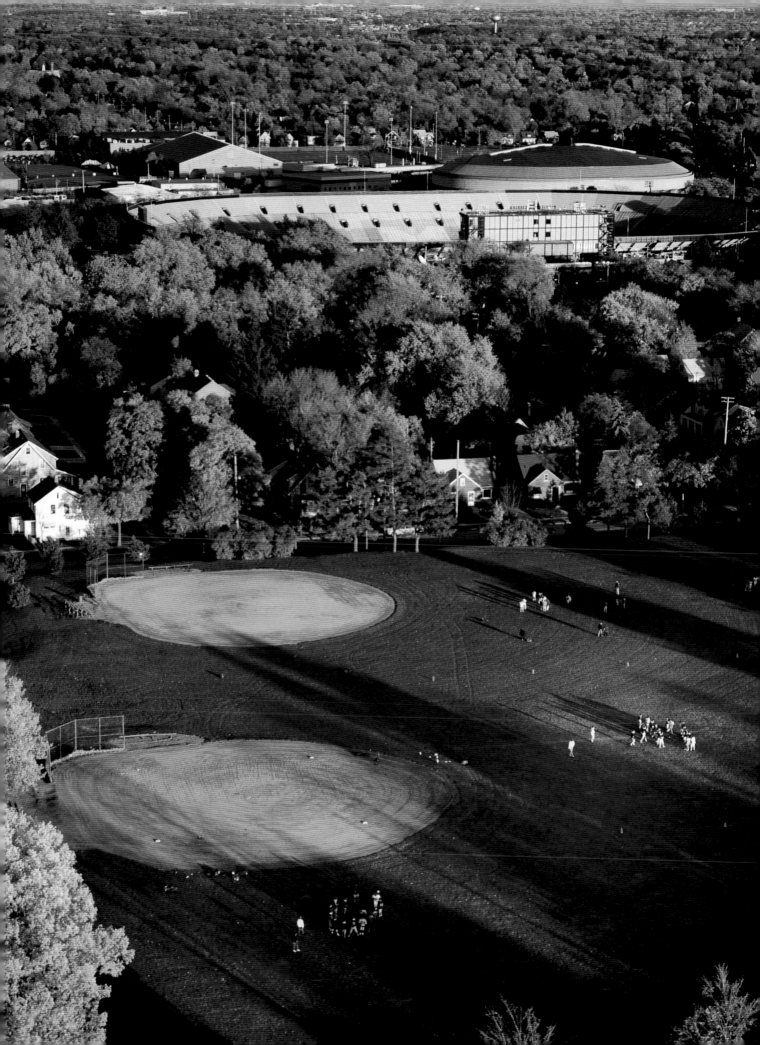

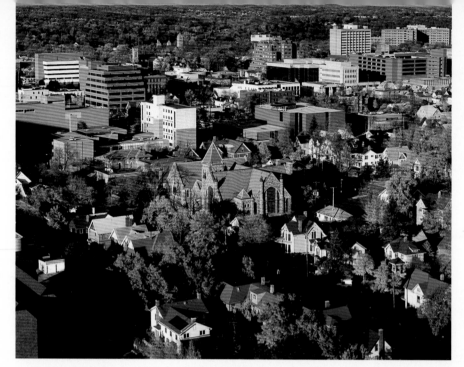

"I was born and raised in Ann Arbor and have been a member of Zion Lutheran Church all of my life. My grandfather was part of the original Zion congregation and the Otto family has enjoyed spiritual renewal and growth at Zion, along with many friendships and support, for more than a century."

Marion Otto McCallum
Ann Arbor

The Colonial-style Zion Evangelical Lutheran Church on W. Liberty Street *(opposite)* was designed and built by the George Mason Company in 1958 in what was then the outskirts of Ann Arbor. An offshoot of the original German church founded in 1833, Zion Church was organized in 1874 by Pastor Friedrich Schmid. Zion outgrew two churches, first the old Congregational Church at the corner of Fifth and Washington Streets, and then a larger building on the same site, before moving to its current home on Ann Arbor's far west side.

The oldest German church in Michigan, Bethlehem United Church of Christ *(above)* was organized in 1833 for Ann Arbor's early German settlers, also by Reverend Friedrich Schmid. The congregation occupied two churches prior to building the current native fieldstone edifice designed by Detroit architect Richard Rasemann in a Richardsonian Romanesque style with Gothic features.

The Westminster Presbyterian Church *(right)*, organized in 1956 by 87 charter members, today serves a membership of 465 in a contemporary facility completed in 1969. An intimate sanctuary seats 350 in an octagonal open worship space and a 1991 expansion provides space for fellowship, community ministry and Christian education activities.

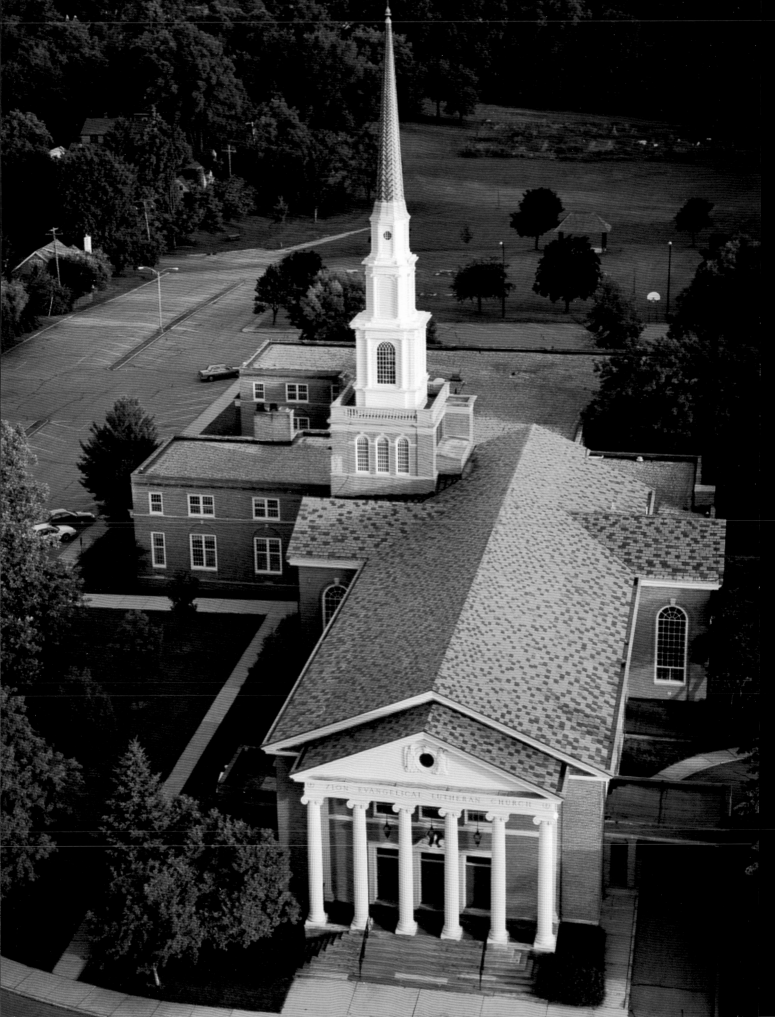

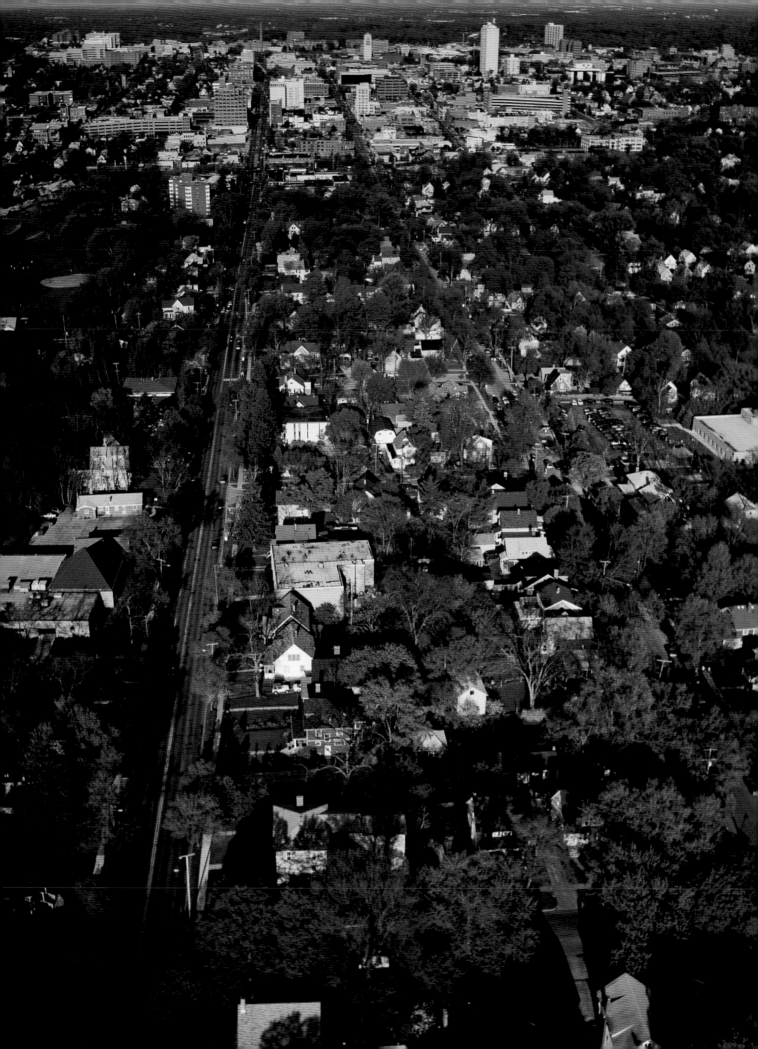

"I grew up on Ann Arbor's west side where we could walk in 30 minutes or less to anywhere that was important to us, including downtown and Michigan Stadium. Sportsman Softball Park, school playgrounds, Eberwhite woods, Klager's pond and the Fairgrounds were all part of my world. And what is now Virginia Park was just an empty piece of land that a bunch of neighborhood kids would mow (and sometimes burn) to make their own 'Field of Dreams' for a spring, summer and fall of athletic endeavors. Except for Stadium Boulevard and a few more houses, it still looks pretty much the same. It was a great place to grow up."

Jim Taylor
J and J Advertising

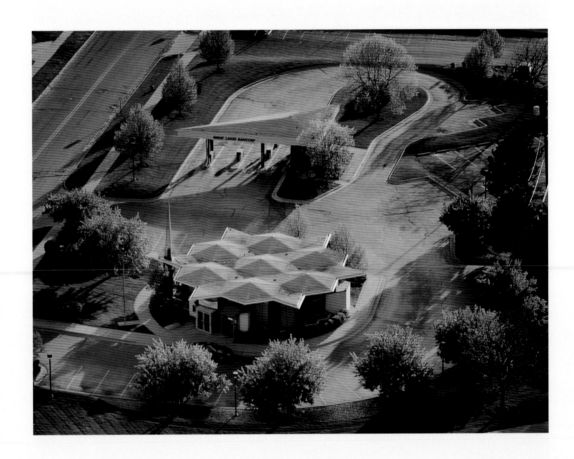

West Huron and West Washington Streets *(opposite)* are in the heart of Ann Arbor's Old West Side. Lurie Terrace, a senior citizen apartment complex, the Senior Citizens Guild, several small businesses and medical offices share this section of West Huron Street with lovingly-restored historic homes, newer townhouses and condominiums. One block to the south, West Washington Street is the site of Slauson Middle School, one of five intermediate schools in Ann Arbor's award-winning public school district. Built on 12 acres in 1937, today Slauson serves more than 700 students in grades 6-8, focusing on the academic and social growth needs of these adolescents as they make the transition from elementary to high school.

The branch office at Pauline and W. Stadium of Great Lakes Bancorp *(above)* was designed in 1959 and built in 1962 by W. T. Anicka & Associates in an architectural style popular in the 1950s. The unique circular building opened as the first neighborhood office of Ann Arbor Federal Savings and Loan, formally renamed Great Lakes Bancorp in 1982.

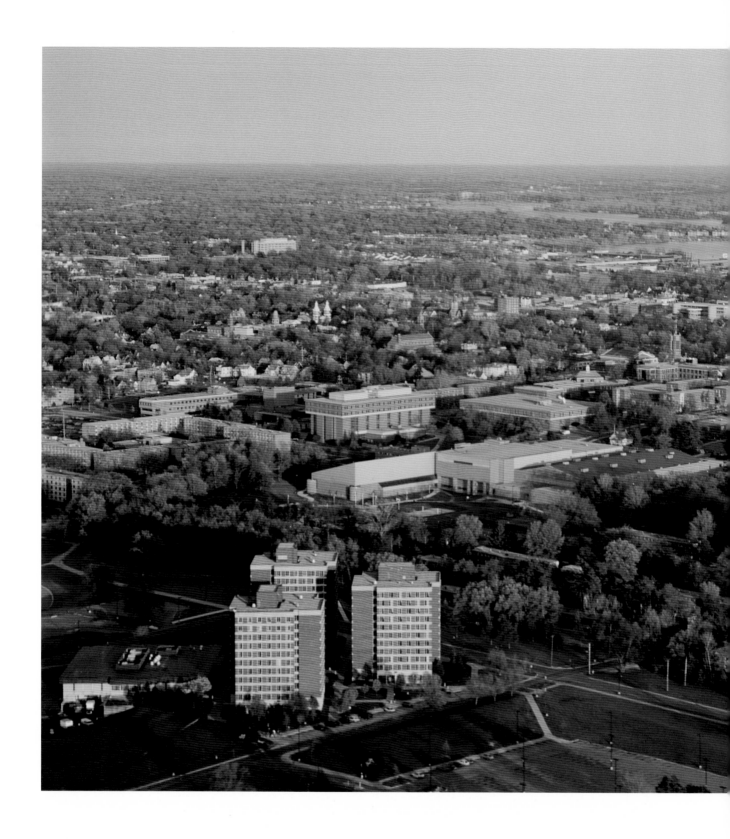

Ypsilanti, named for a Greek general who was a hero in the battle for Greek independence against the Turks, was platted by Detroit judge Augustus Woodward in 1825. The city and township of more than 70,000 share a border and the Huron River with Ann Arbor. Eastern Michigan University is located in Ypsilanti, with its 220-acre main campus and College of Business complex in the city and a nearly 200-acre athletic complex, Corporate Education Center and 18-hole championship golf course on the outskirts of town. Founded in 1849 as Michigan State Normal School, the institution was the first teacher training college west of the Allegheny Mountains. Today, EMU is the fifth largest university in Michigan, preparing more professional educators than any other institution in the country.

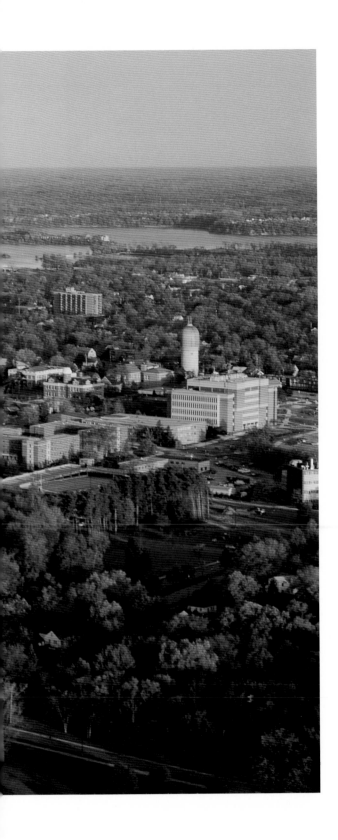

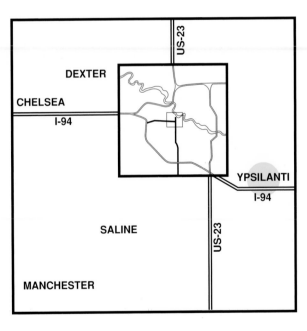

Ypsilanti

"When I moved to the Ypsilanti-Ann Arbor area seven years ago, I was struck by the legacy created in the two communities to support an exceptional learning environment. Eastern Michigan University shares with its neighbors a commitment to meet the emerging educational needs of our region. Higher education is one of Michigan's greatest assets, and we are fortunate to have numerous higher education institutions in this area of such quality and diversity."

William E. Shelton, Ph.D.
President,
Eastern Michigan University

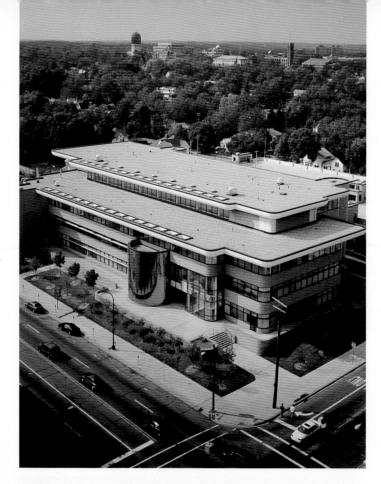

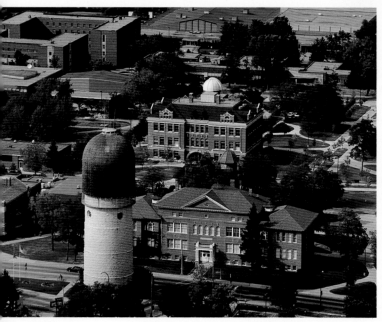

Eastern Michigan University *(opposite and this page)* **offers more than 180 undergraduate and graduate programs in five colleges: Arts and Sciences, Business, Education, Health and Human Services and Technology. Ninety percent of the University's more than 23,000 students are Michigan residents, with the balance from other states and more than 70 foreign countries. Consistently an innovator in physical education, EMU was the site of the first modern intramurals department and Coach Lloyd Olds invented the striped referee shirt during his years on campus—an American tradition that remains today. Adjacent to Bowen Field House** *(opposite)* **is University Park, featuring 10 acres of recreational facilities including the Lake House, lighted basketball, tennis and volleyball courts, an amphitheater, horseshoe pits, picnic tables, jogging trail and lifesize chess board.**

EMU's campus blends century-old historic buildings *(left)* **with state-of-the art facilities. Some of its oldest buildings are the Romanesque Revival style Starkweather Hall (1896), Georgian Revival/Victorian Romanesque Welch Hall (1896) and Sherzer Hall (1903). The 1890 Ypsilanti Water Tower, a campus landmark, was the only tower in the city's water system until 1956.**

Completed in 1991, the 120,000-square foot Gary M. Owen College of Business building *(above, top)* **provides the latest technology for undergraduate and graduate students in the College's four departments. Eastern's Business College alumni include Chrysler-Europe President Timothy Adams, Discount Tire Company Chairman/CEO Bruce Halle and Hudson's President Dennis Toffolo.**

(Overleaf) **Rick Rasnick enters the 1996 football season after a phenomenal first year as Eagles' head football coach, directing his 1995 team to a whopping 43 school records. The mighty Eagles play at the 30,200 seat newly renovated Rynearson Stadium, named for Elton H. Rynearson, EMU football coach for 26 seasons.**

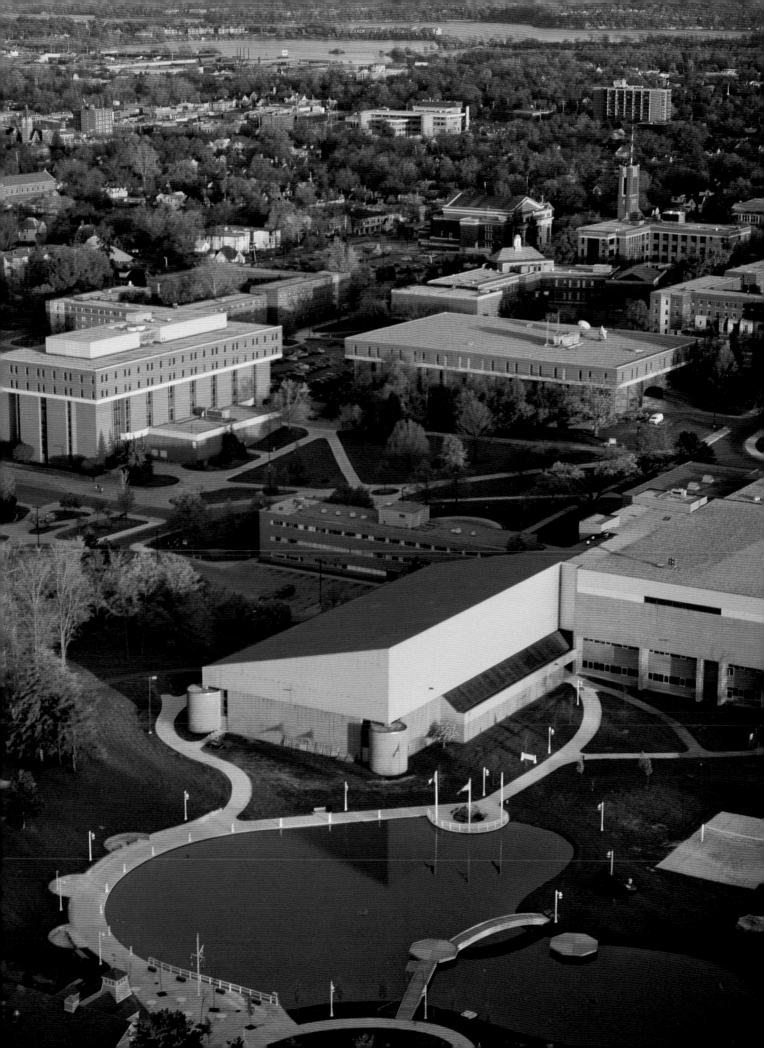

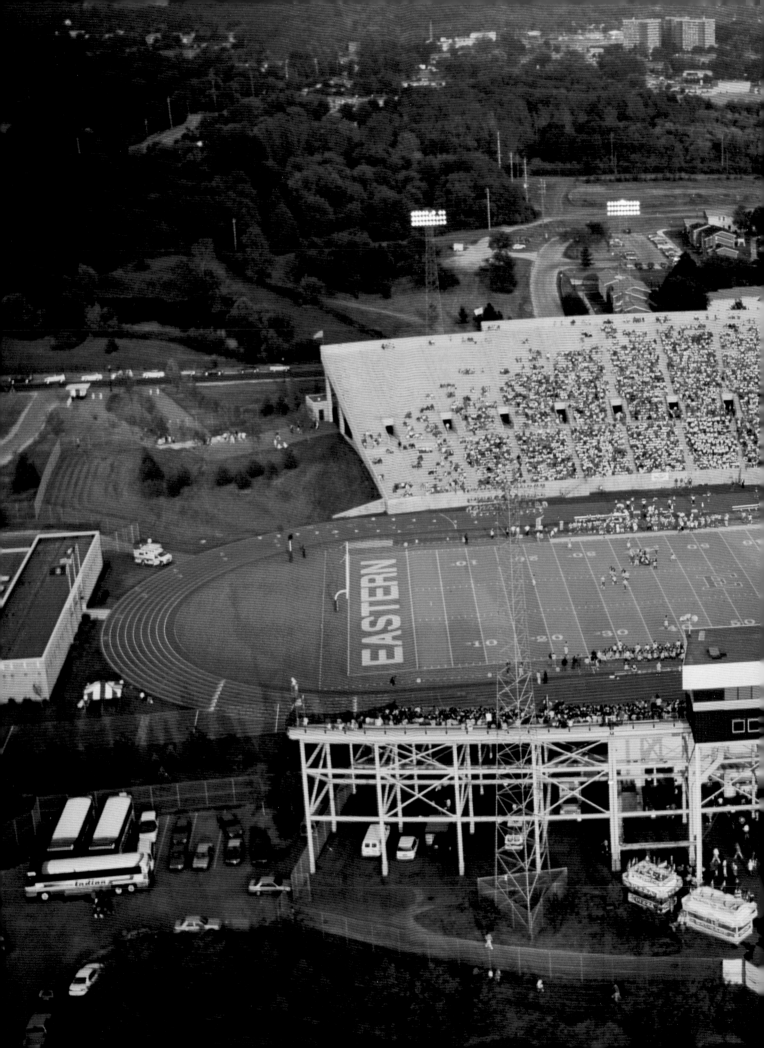

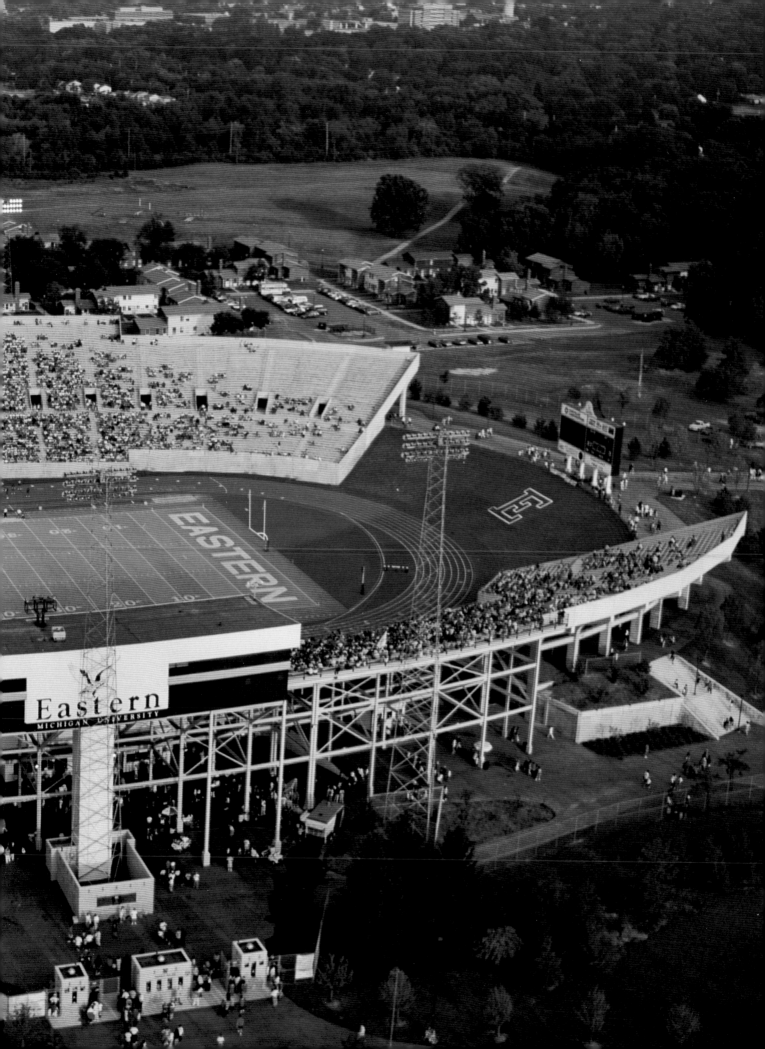

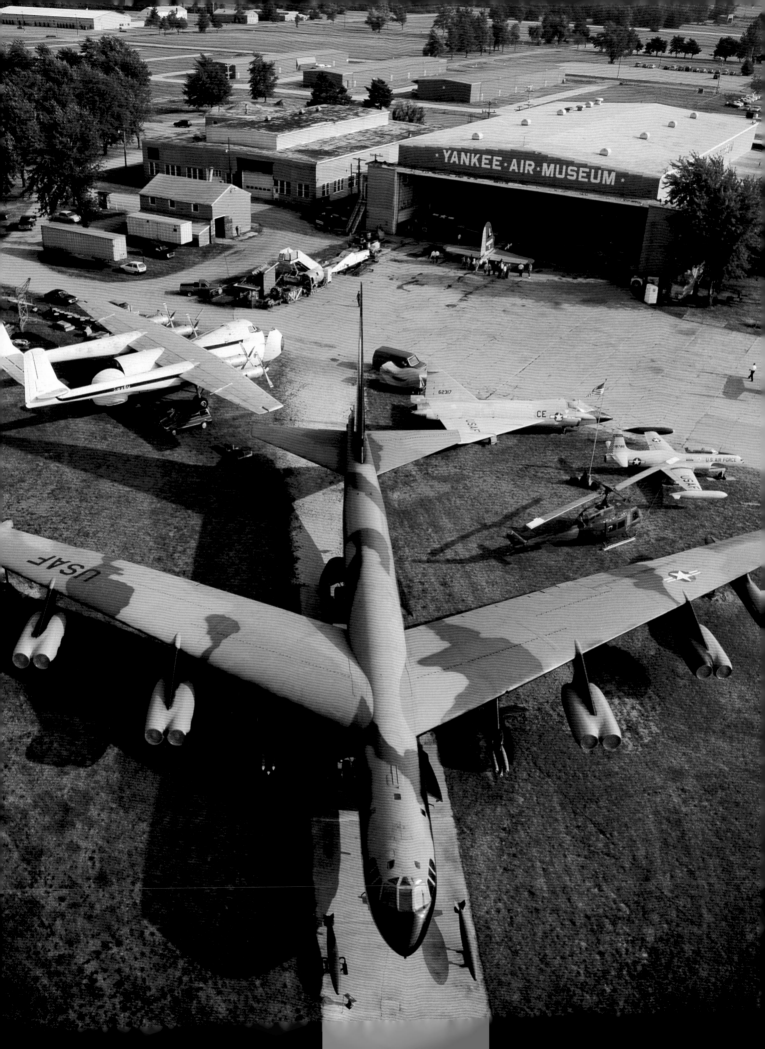

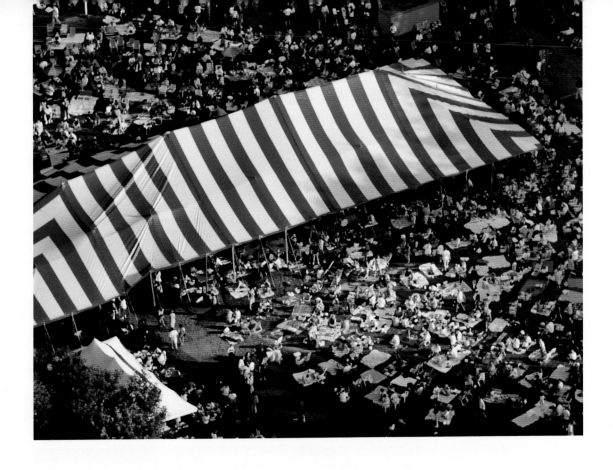

"Music at The Ark in Ann Arbor has been my life for nearly three decades. For all of that time our mission has been to preserve and present all kinds of cultural identities through their music. In 1989 we took over production of the Frog Island Music Festival which I like to think of as the greatest musical block party anyone could attend. The Festival's outdoor setting allows us to bring in bands, which we weren't able to do in The Ark until recently, and gives the audience a chance to dance to all different kinds of music, from jazz, blues and Latin to zydeco, Cajun and worldbeat."

David Siglin
Director, The Ark, Ann Arbor

During World War II, Ypsilanti became home to the Willow Run Bomber plant employing 100,000 workers. The Yankee Air Museum *(opposite)* at Willow Run Airport preserves some of the history-making military aircraft from World War II through Vietnam, many of which are still fully operable. Featured exhibits include a C-47 transport and B-52 "Stratofortress," artifacts from World Wars I and II and a Women in Aviation display.

Ypsilanti's Frog Island Music Festival *(above)* began in 1981 and has been sponsored since 1989 by The Ark, Ann Arbor's world-renowned music club. Nearly two dozen bands converge on Frog Island each June to entertain thousands of music lovers with a veritable smorgasbord of sound during the three-day jamboree. With folding chairs and picnic baskets in tow, audience members listen raptly, or participate by dancing, to a broad range of roots music. The Ark, a vital part of this region since 1965, relocated in September 1996 to a much larger and improved facility on Ann Arbor's Main Street, greatly expanding its ability to present music and storytelling that relate directly to the audience of various cultural backgrounds, from ethnic and minority groups to women, children and students.

ANN ARBOR

"There is a vitality to the Ann Arbor-Ypsilanti area that is unique in all the Midwest. For more than 80 years, St. Joseph Mercy Hospital has been part of the community, proud to contribute to what makes living here special."

Garry C. Faja
Chief Executive Officer, St. Joseph Mercy Hospital

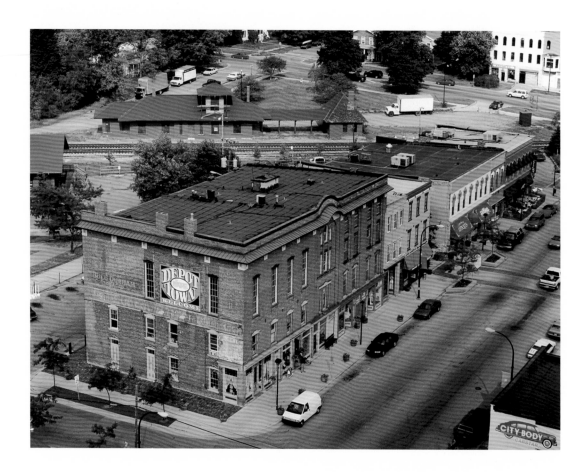

Ypsilanti's Michigan Avenue was site of the 200-year-old Sauk Indian Trail to Fort Detroit and, in 1824, became the first road between Detroit and Chicago. When the railroad arrived in 1839, two distinct business districts developed: one near the Detroit-Chicago road, now the downtown area, and the other near the railroad, today's historic Depot Town *(opposite and above)*. Housed in lovingly preserved and restored architectural treasures, antique shops, vintage clothing stores, local eateries and nightspots line three blocks of E. Cross Street near the Huron River. Depot Town highlights also include the Freight House, home to the Ypsilanti Farmer's Market, and Miller Motor Sales, the country's last and only Hudson auto and parts dealership. Each summer during the third week of August, some 300,000 visitors celebrate Ypsilanti's past during the Heritage Festival which educates and entertains with a living history encampment, an old-fashioned circus, antique auto show, historic home tours and jazz concerts.

(Overleaf) Founded in 1911 by the Sisters of Mercy, St. Joseph Mercy Hospital has evolved into a large network of facilities located today on Huron River Drive in Superior Township. In addition to the 581-bed acute care hospital, the medical campus includes the Reichert Health Building which houses more than 120 physician offices and nine clinics; the Robert H. and Judy Dow Alexander Cancer Care Center; the Michigan Heart & Vascular Institute; the Towsley Senior Health Building; and facilities for mental health and chemical dependency programs. St. Joe's has joined with Providence, Saline Community and McPherson hospitals to form Mission Health, a community-based network that offers patients access to more than 40 outpatient and specialty care centers which all share the same mission, vision and values.

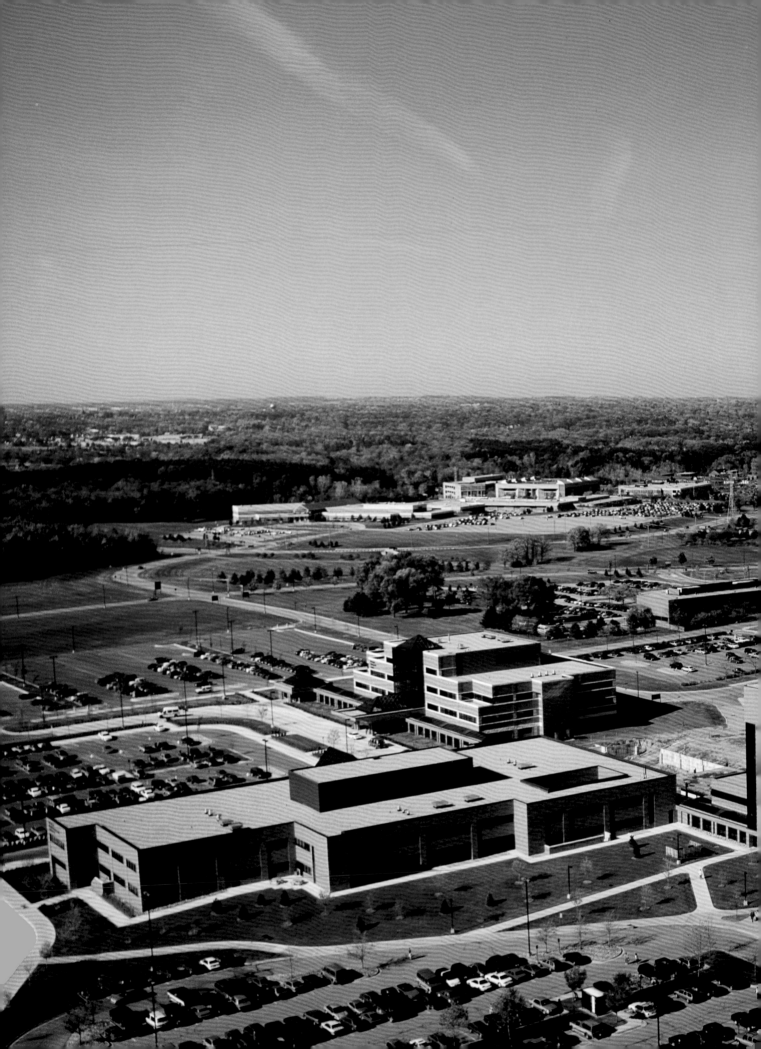

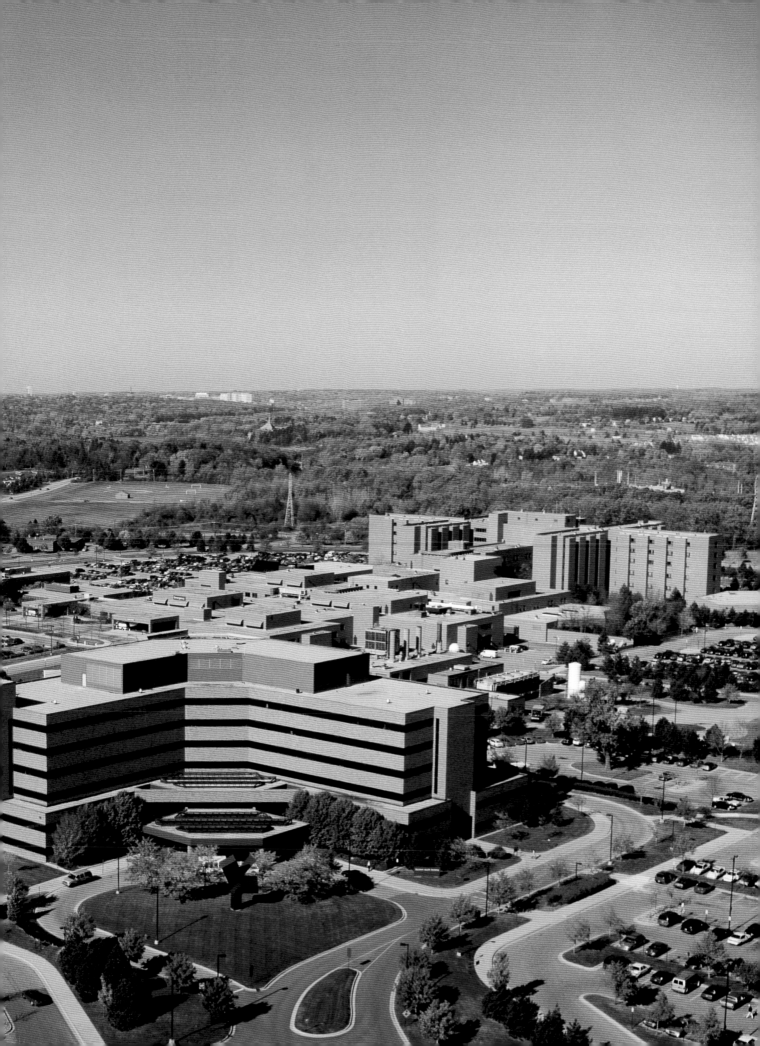

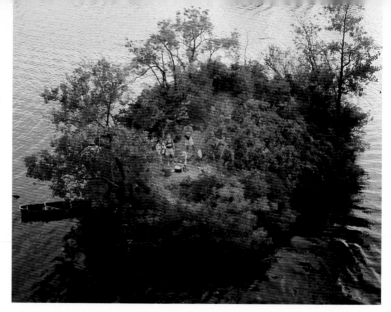

"The community college was a new idea when citizens voted WCC into existence more than three decades ago. Since then, population growth and increased commerce have dramatically altered the area's economic and social landscape. WCC has had to continually reinvent itself in order to serve the community's changing needs. As a result, the college has matured into an institution with a rich history and a bright future—much like the community it serves. Yet, it's still what it was in the beginning: An expression of this community's love for learning, and of its commitment to educational opportunity for all."

Gunder A. Myran, Ph.D.
President, Washtenaw Community College

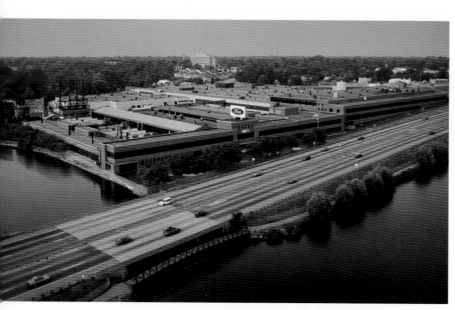

A series of picturesque interconnected bridges and islets *(opposite and above)* make Ford Lake Park a favorite destination for cyclists and joggers alike, offering a peaceful setting surrounded by the waters of Ypsilanti's largest lake. With 110 acres of wooded and open space and a half-mile of shoreline, the park is the perfect setting for a variety of year-round outdoor activities from sailing, power boating or canoeing to a private island picnic ground in summer, to cross-country skiing, snowshoeing and sledding in winter.

Situated on 68 acres just across I-94 from Ford Lake are the production development/engineering center and impressive manufacturing facility of Ford Motor Company's Electrical and Fuel Handling Division (EFHD). Opened in 1932, the one-million-square-foot Ypsilanti plant *(above left)* is the Division's oldest, but continuous modernizations have made it one of the most technologically advanced facilities of its type. EFHD's 1,250 employees produce 13.5 million units of starter and ignition products each year.

(Overleaf) From initial discussions in 1959 by the Ann Arbor Board of Education, to offering its first classes in September 1966 to 1,200 students in the former Willow Run Village, to the 1970 unveiling of its permanent campus on the former site of the 235-acre Huron Farms apple orchard midway between Ann Arbor and Ypsilanti, Washtenaw Community College has been the result of visionary leadership and the hard work of several hundred members of the community. Ann Arbor's Chamber of Commerce analyzed occupational needs and employment opportunities; representatives from the county's ten school districts assisted in developing occupational and technical programs; and voters passed a charter millage and elected a board of trustees. Today, seven main buildings serve 20,000 students, including those pursuing Associate degrees, working people seeking professional growth or taking part in employer-sponsored training and citizens attending seminars and workshops to enhance their personal lives. In addition, more than 100,000 people come to the campus each year for training, special events and other activities sponsored by the College or community organizations and local businesses.

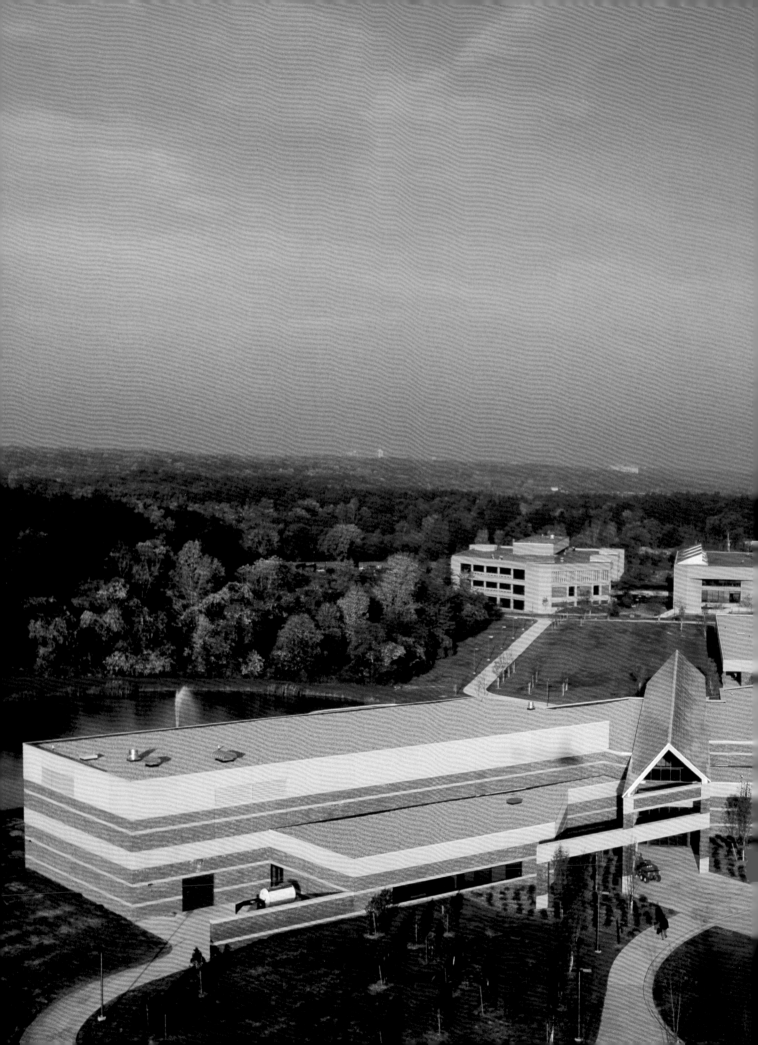

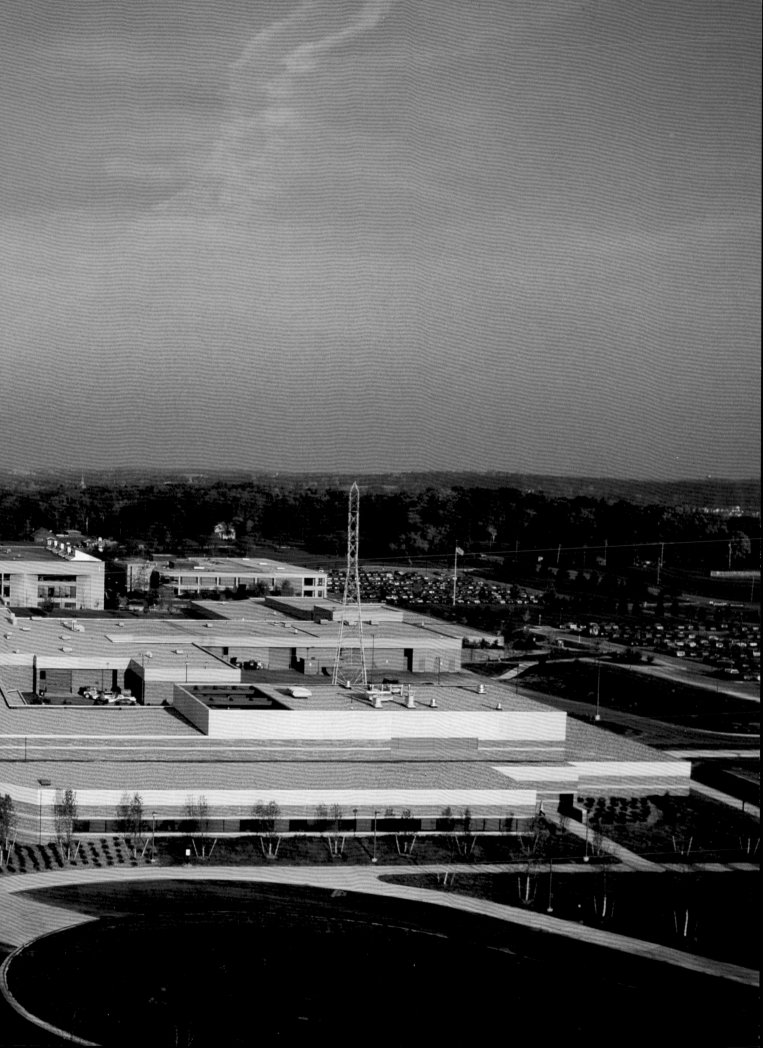

Chelsea began around 1830 when Cyrus Beckwith settled on land that was to become Sylvan Township. Originally called Davidson Station and then subsequently Gunntown and Kedron, Chelsea is but one of several villages and hamlets located minutes from Ann Arbor that preserve their identity and rich history. Each has built a strong community and proudly guards its quaint old-fashioned country flavor. Although only four are featured in this book, a leisurely drive in any direction from Ann Arbor will lead to fresh discoveries of other lively communities that have treasures of their own to share.

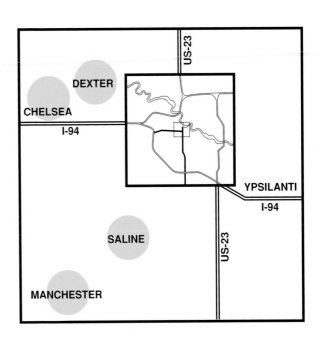

Ann Arbor Environs

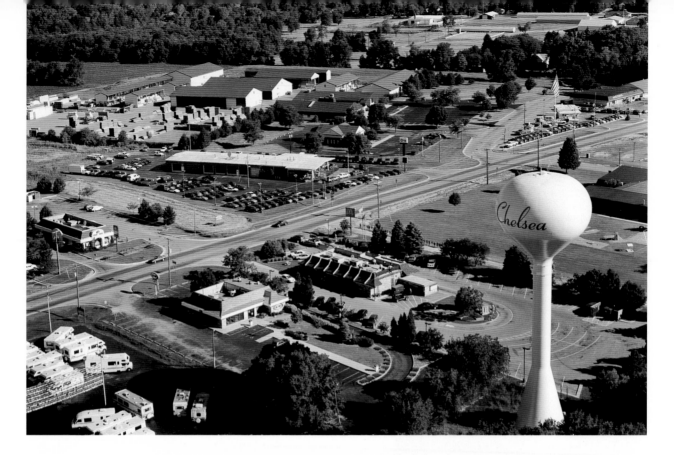

"There are so many aspects of Chelsea that make it a unique community. The preservation of its downtown buildings as they originally appeared and the restoration of its many gracious Victorian homes is extraordinary. Chelsea's location just west of the major cultural center of Ann Arbor, as well as being surrounded by beautiful lakes and state land such as the Waterloo Recreation Area, give it a quality of life that is hard to match. And, best of all, the people of Chelsea identify so strongly with their community, working together with a level of loyalty and cooperation that I have not experienced anywhere else."

Bob Daniels
President, Chelsea Lumber Company

From the original 1901 Chelsea State Bank, now a District Court facility, to the turn-of-the-century Glazier Stove Works brick factory buildings affectionately known as the "Tower Building," "Welfare Building" and the "Spring Plant" *(opposite)*, history is everywhere you look in downtown Chelsea. These village landmarks blend perfectly with their more contemporary neighbors, including a variety of retail shops and boutiques, one of the area's outstanding restaurants, The Common Grill, and the acclaimed Purple Rose Theater founded by actor-resident Jeff Daniels. Chelsea's highly-respected Community Hospital has affiliations with both the University of Michigan Medical Center and St. Joseph Mercy Hospital, providing residents with advanced health care just minutes from their homes.

Chelsea Milling Company *(also opposite)* is owned and operated by the Holmes family who have been milling wheat for nine generations. The village's largest business has been producing and selling its Jiffy-brand baking mixes for more than 65 years, now filling more than a million boxes a day of its 17 popular mixes which account for about seven percent of nationwide retail boxed baking mix sales.

Progress has continued throughout Chelsea's history and several other major businesses also play a significant role in the community's life. Chrysler Corporation's Proving Grounds is here and Federal Screw Works and Hatch Stamping have operations in the area. Building supplier Chelsea Lumber Company *(above)*, Palmer Ford, Michigan's oldest Ford Dealer, and complete book and journal manufacturer Bookcrafters are also located around the village.

ANN ARBOR

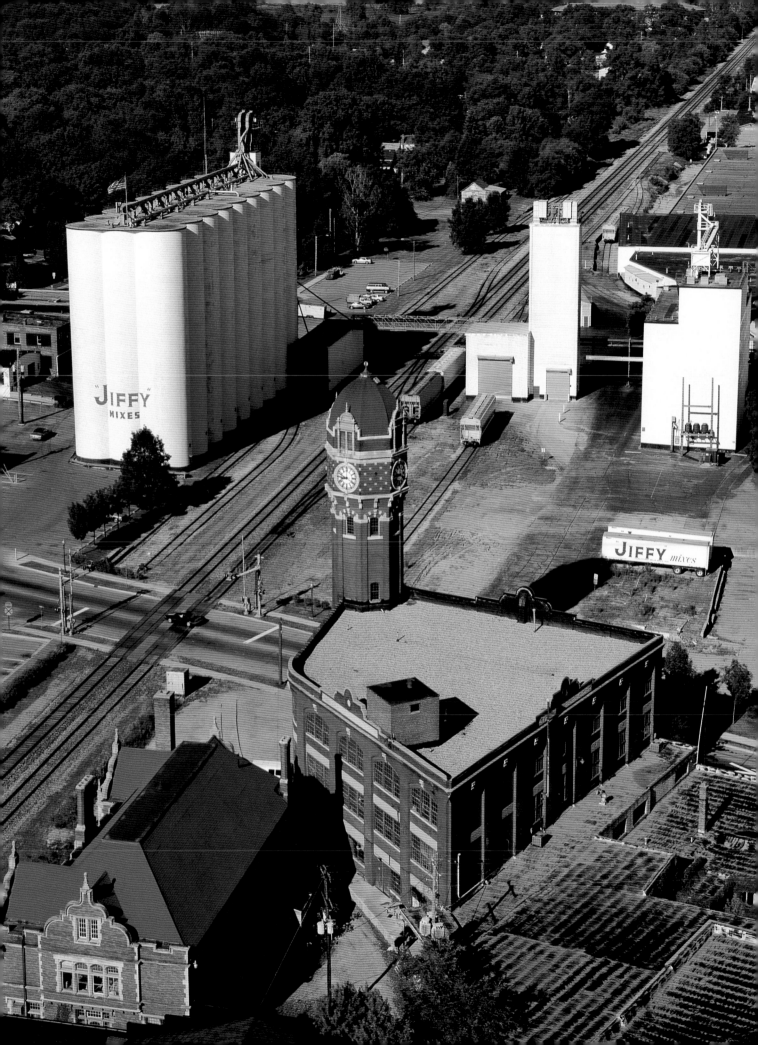

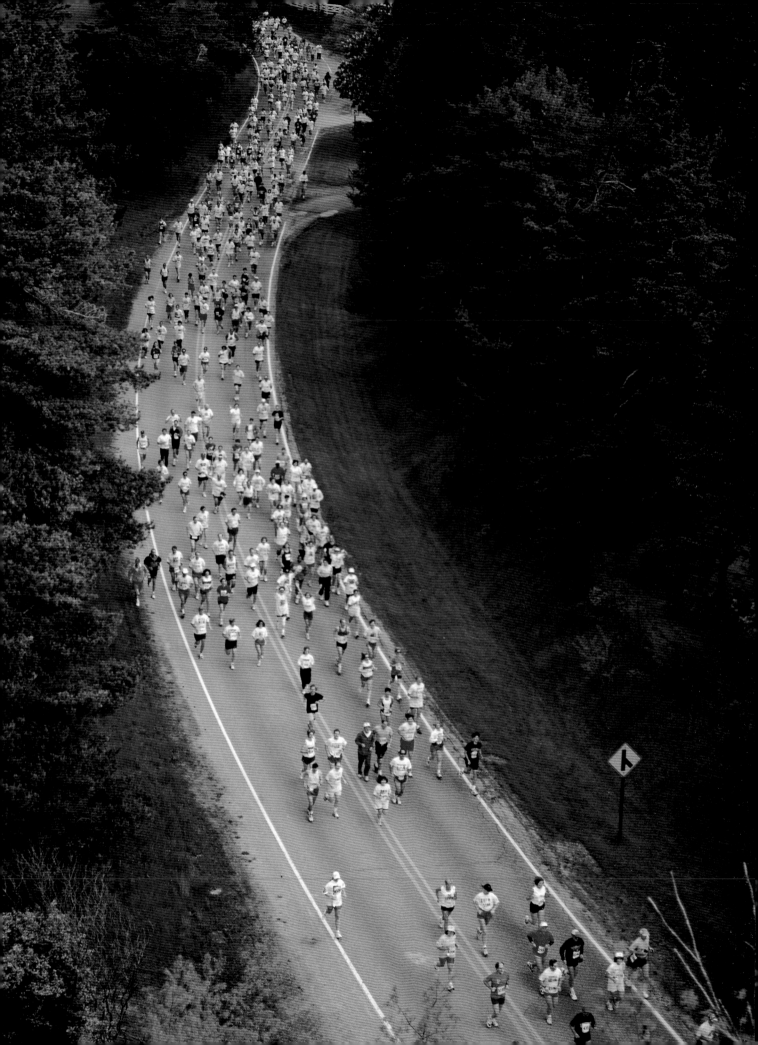

"My favorite things about Ann Arbor? The Dexter-Ann Arbor Run, the Summer Festival, the Art Fair, home football games, the 4th of July parade down Liberty, Farmer's Market on Saturdays and eating at the Main Street cafés! Ann Arbor— what a *cool* town!"

Kim Byers
VA Medical Center

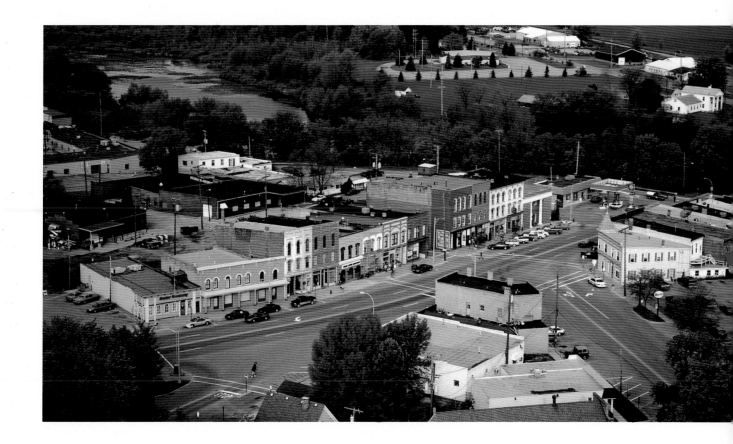

Sponsored by First of America Bank and beginning in downtown Dexter *(above)*, the annual Run to Ann Arbor *(opposite)* draws some 4,000 enthusiasts to their choice of a 13.1-mile or 10-kilometer (6.2 mile) course through the area. The runners wind their way east along Huron River Drive, passing through Dexter-Huron Metropark and Delhi Mills before reaching their destination in downtown Ann Arbor.

With a village population of nearly 2,000 and approximately 11,000 township residents, Dexter *(above)* is a quiet community about a 15-minute drive northwest of Ann Arbor. Home to Michigan's oldest continuously operating cider mill (1886) and the popular gourmet restaurant, Cousins Heritage Inn, Dexter is becoming a favorite place to live and work as more and more businesses locate in the area.

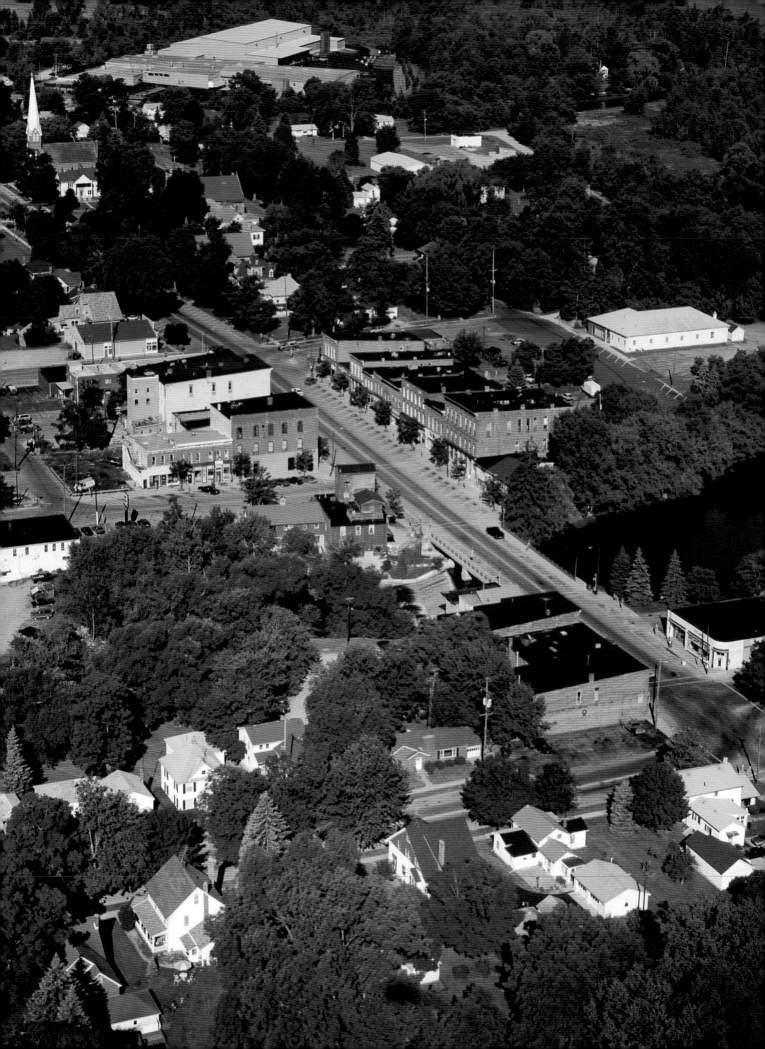

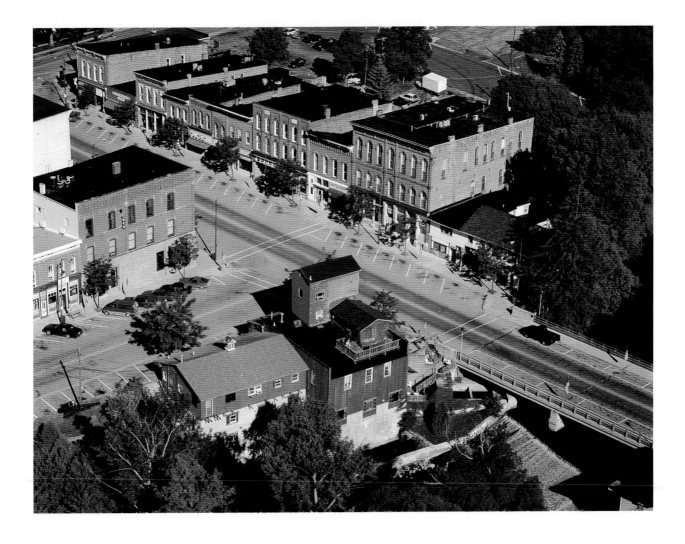

"Our organization takes great pride in its involvement in the building of the Ann Arbor area and its development and organized growth. We have more than 95 years of participation in helping to make communities of which we can all be proud."

Don House
Business Manager, Plumbers & Pipefitters Local 190

The village of Manchester *(opposite and above)* was developed by Major John Gilbert of Ypsilanti who saw that the site on the banks of the River Raisin was favorable for building up his interests. The partially-restored grist mill *(above)*, constructed for Gilbert in 1832 and originally powered by the river, still stands and is today the site of a popular antiques mall. Surrounded by farmland and small inland lakes, Manchester is southwest of Ann Arbor and just a short drive from Adrian, Chelsea, Jackson and Saline, drawing thousands from those communities each July to the famous Manchester Chicken Broil. Since 1953 a cadre of village organizers has mobilized volunteers to assist in seasoning the fresh chicken halves in a special sauce, charcoal broiling them to perfection and serving them with a secret-recipe coleslaw.

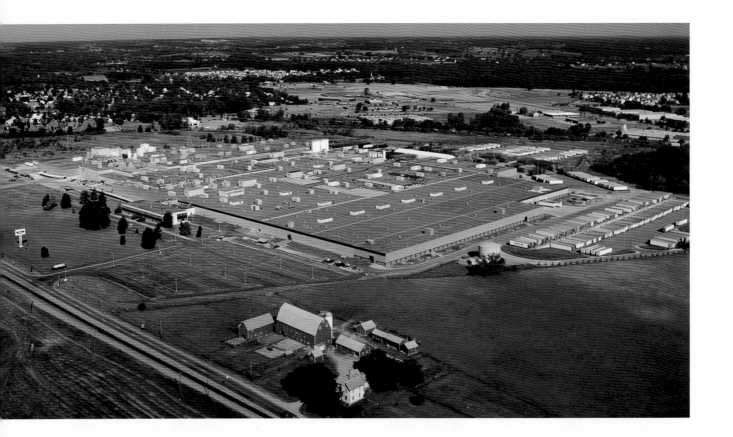

"The people of Saline are truly a community, working together to provide for others. Saline is a blend of past and present, commerce and industry, education and recreation. First settled by Europeans in 1824, the city was built along ancient Indian trails that later became the principal roadway between Chicago and Detroit. Saline enjoys a rich past and a vibrant future. Each year brings more people to the community, providing diversity within the populace yet maintaining the values of caring and sharing."

Patrick J. Little
Mayor, City of Saline

ANN ARBOR

188

Located along the Saline River and US-12 just ten miles south of Ann Arbor, the city of Saline is growing rapidly. The thriving community has its own 82-bed acute care community hospital *(opposite)* with more than 150 physicians on staff. Affiliated with the Mission Health network, Saline Community Hospital includes a new 24-hour emergency services area and an attached 274-bed long-term care facility. The downtown business district has some of the area's finest antique shops and nearby Weller's Carriage House *(opposite, background)* is a favorite site for wedding receptions.

In 1966 Ford Motor Company built a 1.6-million-square-foot manufacturing plant *(above)* in the midst of Saline Township's working farms. Today, the Saline Plant's nearly 2,700 employees produce instrument panels and floor consoles for the automaker, with last year's production topping 5.2 million units (1995).

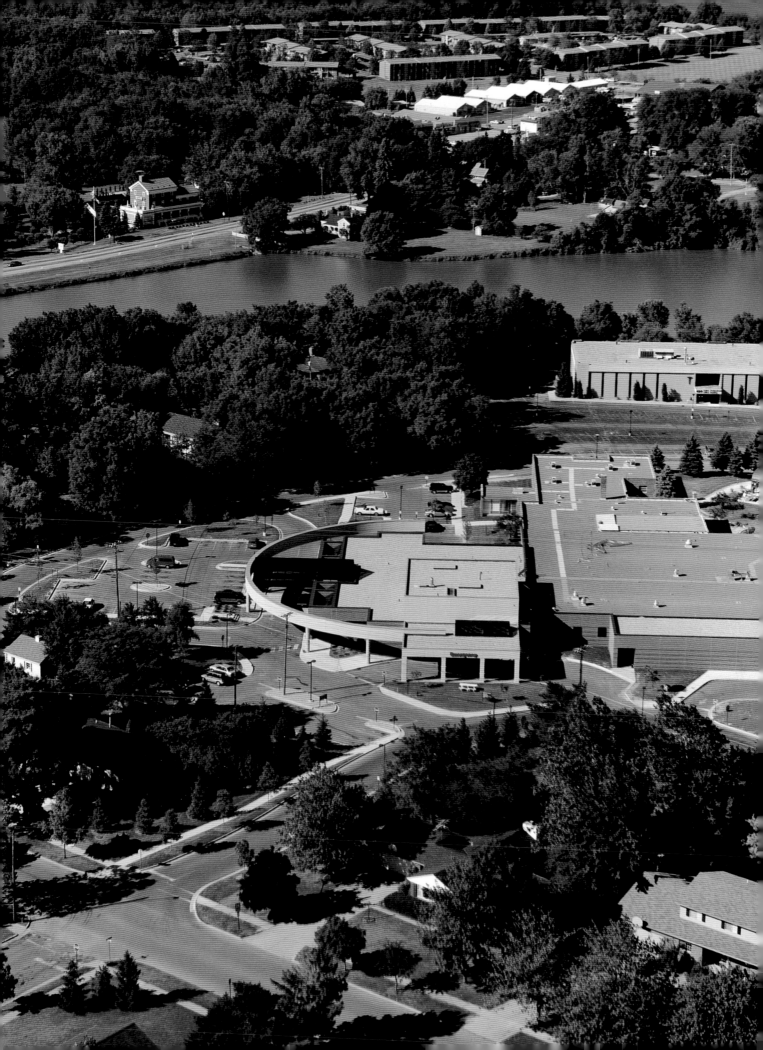

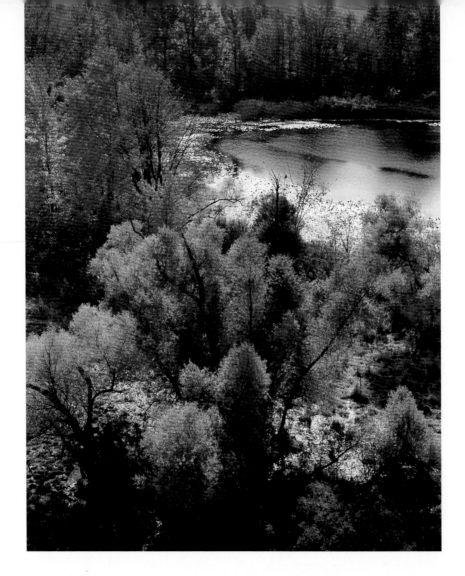

"For me, the best reason for living in this area is that I can be out in the country, surrounded by my own piece of heaven and maintaining my privacy, but still within fifteen minutes of the wonderful, eclectic city of Ann Arbor. I have easy access to its restaurants, museums, learning and cultural opportunities whenever I desire them, but I can enjoy my horses on a daily basis, riding them, watching their grace and beauty and laughing at their funny antics."

Linda McMahon
Spruce Creek Farm

The glaciers that retreated 15,000 years ago, etching the land with lakes, rivers, ponds and streams, produced Ann Arbor's beautiful surroundings. Today, tens of thousands of nature lovers and outdoor enthusiasts pay homage to this legacy throughout the year. In early spring, as crocuses push skyward they, too, come out of hibernation. On summer's bright sunny days they celebrate with family and friends. When local orchards press fresh cider on crisp fall days, they reflect on the past and prepare for what lies ahead. And as winter's snow blankets the resting Earth, they explore a quiet world on snowshoes and skis. Like the changing seasons, the area's open spaces, waterways and woodlands provide a kaleidoscope of life.

Turn in any direction for a glimpse of the diversity we call Ann Arbor: horse farms within minutes of a vibrant city, crops growing near sites of new construction, cyclists and joggers sharing streets with luxury cars and minivans. Liberal...conservative; urban...rural; cosmopolitan...provincial; avant garde...traditional are just a few of the living contradictions that describe this fascinating city. From world-class education and medical facilities to small town charm and history, Ann Arbor has them all. Its residents are a unique breed: adventuresome yet practical, proud and fiercely loyal—to their teams, to their causes and especially to their town.

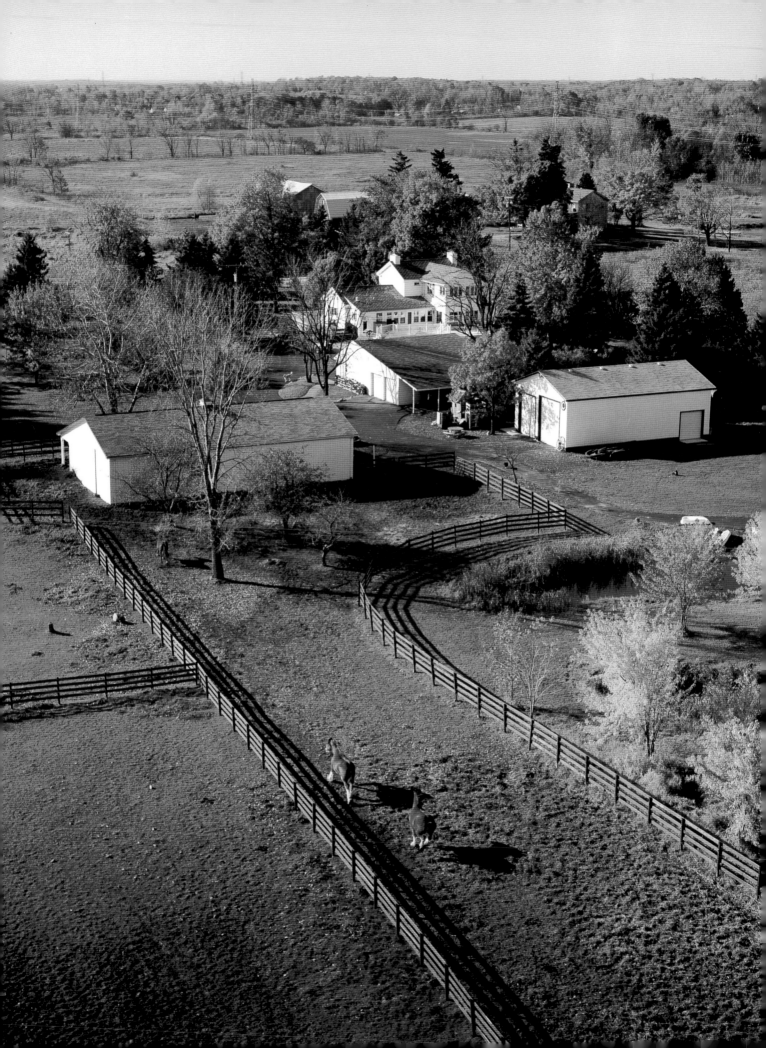

Index